P9-EKD-423

LOW-LIGHT AND NIGHT PHOTOGRAPHY

For D.B.H.

LOW-LIGHT AND NIGHT PHOTOGRAPHY

A Practical Handbook

Roger W. Hicks

*Also featuring
the photography of
Steve Alley and Frances Schultz*

DAVID & CHARLES
Newton Abbot London

For an explanation of the caption credits readers are
referred to the Acknowledgements on page 189.

British Library Cataloguing in Publication Data

Hicks, Roger, *1950–*
 Low-light and night photography,
 1. Low light photography – Amateurs manuals
 I. Title
 778.7

 ISBN 0-7153-9238-7

Text © Roger W. Hicks 1989
Photographs © Photographers credited in captions

All rights reserved. No part of this
publication may be reproduced, stored
in a retrieval system, or transmitted,
in any form or by any means, electronic,
mechanical, photocopying, recording or
otherwise, without the prior permission
of David & Charles Publishers plc

Typeset by Typesetters (Birmingham) Ltd
Smethwick, West Midlands
and printed in Portugal
by Resopal
for David & Charles Publishers plc
Brunel House Newton Abbot Devon

CONTENTS

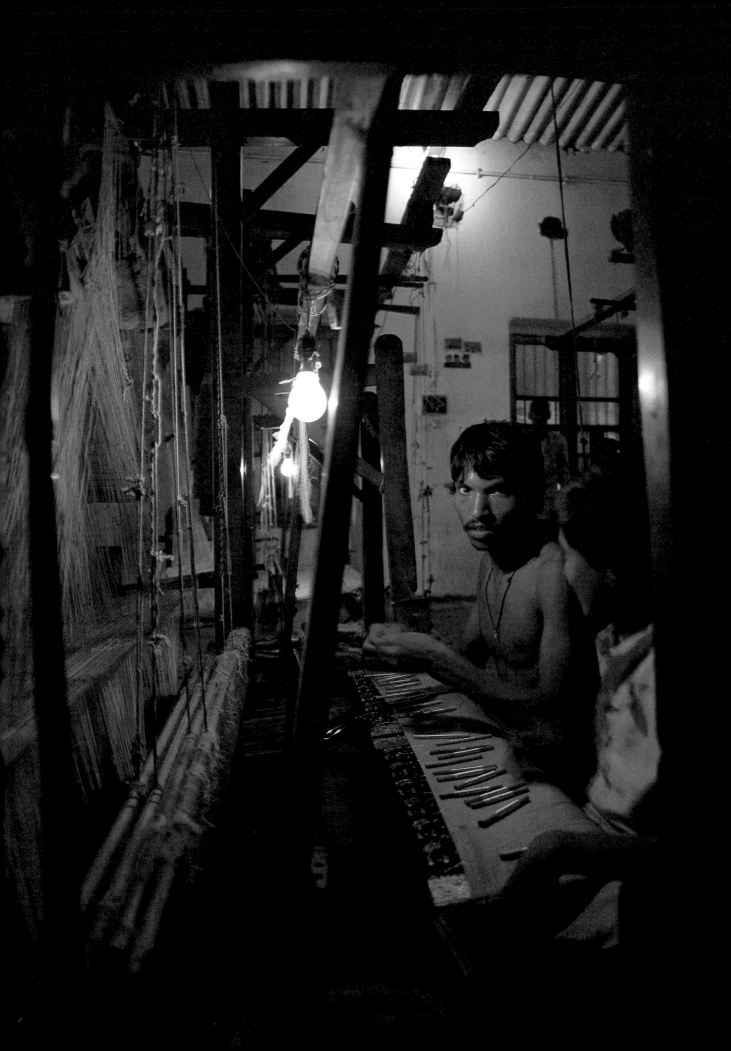

1
THE DYING OF THE LIGHT

Dylan Thomas was almost certainly *not* thinking about photography when he wrote the poem 'Do not go gentle into that good night', and it may be flippant of me to steal his words as the title for this chapter; but I couldn't resist it. I have been trying to take photographs with insufficient light ever since I have been interested in photography, and more than once I have raged against the dying of the light.

'Insufficient light' is of course a relative term; there are no absolute limits. You can buy faster and faster lenses; you can buy faster and faster films; you can use longer and longer exposures. Even when you are using the fastest lenses and films available, and you dare not use a longer shutter speed for fear of subject movement, you have not reached the limits: image intensifiers will allow you to take pictures by moonlight or even starlight, and thermal imaging systems will record minute temperature differences even if there is no visible light.

There are however questions of finance and practicality. 'State-of-the-art' fast lenses are shatteringly expensive, and even their prices pale beside those of image intensifiers and thermal imaging systems. Ultra-fast films are not only more expensive

1 Silk weaver, Benares
For me, this picture is one of the strongest arguments for low-light photography. The silk-weaver's face haunts me; the photograph sums up the cramped, hot factory lit by intermittent bare bulbs. The ultra-wide-angle lens, equivalent to 21mm on 35mm, draws you into the loom (*FES: tripod-mounted Mamiya 645: ER: Mamiya 35mm f/3.5: 1/15 @ f/3.5*)

2 Fourth of July
The Fourth of July firework display at Cayucos, California is spectacular, but the very best pictures are when the sunset is a backdrop to the fireworks. Steve Alley shot this with a tripod-mounted Nikon F3 with a 50mm f/1.8 Nikkor on Kodachrome 64, exposing at f/16 'until it felt right' – several seconds, probably eight or ten (*SRA*)

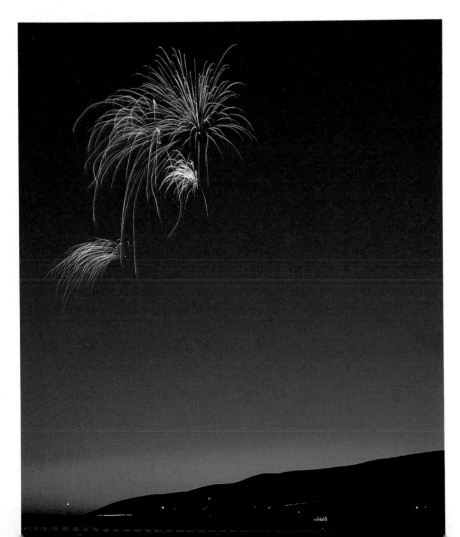

than their slower brethren; they are also coarser-grained, and often they cannot deliver the same maximum black. There are endless trade-offs between lens speed, film speed, and shutter speed. This is basically a book about these trade-offs.

It is also a book about making low-light pictures succeed *as pictures*. The technical difficulties of taking pictures in poor light are easily solved by throwing money at them; nowadays, any fool can get pictures in next to no light if only he or she is willing to spend enough. This is very different from the way things used to be: in the 1930s, for example, the mere technical achievement of taking a picture in poor light was so great that people justly expected praise, and a brief history lesson for photographers brought up on modern film and lenses will show why.

Before World War II, most 35mm photographers were well pleased with an f/3.5 lens, which was at least one stop faster than most other lenses and a couple of stops faster than many. A few went to f/2.8, while f/2 lenses were the equivalent in price and prestige of the f/1.4 lenses of today. The very fastest lenses, at f/1.5, were the equivalent of the f/1 lenses of today.

At about the same time, the fastest readily available films were under ISO 200, and even then, they were expensive special-application films corresponding to a modern ISO 1600–3200 emulsion; the average fast film, such as Perutz Peromnia or Kodak Super Speed Pan, was the equivalent of ISO 100. For comparison, a fine-grain film (which most 'miniaturists' used) such as Panatomic-X was about ISO 16.

In other words, imagine taking available-light pictures using microfilm and a macro lens . . . No wonder there used to be more mystique to low-light photography than is justifiable today.

Even in the 1960s, when I first became interested in photography, film speeds (especially in colour) were laughable by modern standards. The fastest films available were 400 ASA, and they were of course black and white. The fastest colour-slide film was Kodak's High Speed Ektachrome at 160 ASA, and the fastest colour print films were 64 ASA.

In the 1970s and (especially) in the 1980s, film speeds became dramatically faster. The change was so dramatic, in fact, that photographers have not yet fully adjusted to the idea that the fastest film available is for colour *prints*, rated at ISO 3200.

On the other hand, it is possible to overrate the importance of modern super-speed films. They are expensive, and they are unquestionably grainier and less sharp than slower films. The old advice, always to use the slowest film you possibly can, still holds in most cases: we shall come back to this.

By the same token, the average professional photographer is no more of a spendthrift than the average amateur. Most of us, professional and amateur alike, have to watch the pennies. To be sure, professionals can afford to spend a *bit* more; but they can't throw money around in the way that a newspaper does. On the other hand, a professional has to recognise where money *has* to be spent, and then to grit his (or her) teeth and spend it. There are, therefore, two intertwined threads running through this book: how to get the best possible results, and how to get the best possible results on a limited budget.

8

What I have not addressed yet is *why* people want to take pictures in poor light. This is because the answer seems to me to be self-evident. It is that we do not live our lives outdoors in good light. A lot of the time, we are indoors, and the light is such that most people would either use a flashgun or simply not take pictures. Likewise, even if we are outdoors, the light is not always good. Many of my favourite pictures have been taken in the half-light at dawn or dusk, and I do not want to stop shooting just because night has fallen. I assume that you feel the same way. To let the light dictate when we can or cannot take pictures seems quite unreasonable; if we can master the photographic process, then we can make the decisions. It's as simple as that.

I should also warn you about what is *not* covered in this book. For a start, there is next to nothing on surveillance photography. This has been omitted for three reasons. One is that surveillance photography is something which the average photographer is never likely to have to do. The second is that surveillance photography is simply concerned with getting a recognisable image, not a worthwhile picture. In other words, in conventional photography it is simply a matter of fast lenses, fast film, and letting the shadow detail go hang because all you are interested in is highlight detail in the faces. The third is that conventional photography is hopelessly *passé* in professional surveillance. Even where silver-based photography is used, automatic remote-controlled cameras are commonplace, and silver-based photography is often not the preferred technology in any case: high-gain video cameras are usual, and image intensifiers and thermal

3 Actress in dressing-room
Shooting at light-levels like this is difficult enough anyway; shooting a mirror shot is downright masochistic. The foreground was another problem; in printing, it had to be 'burned down' considerably to stop it being a too-light area of tone. Nevertheless, the result is excellent – a strong argument for not giving up just because things were difficult (*SRA: Nikon FM: Tamron SP 35–80mm f/2.8: Tri-X rated at EI 800, developed in HC110 replenisher: 1/8 @ f/4*)

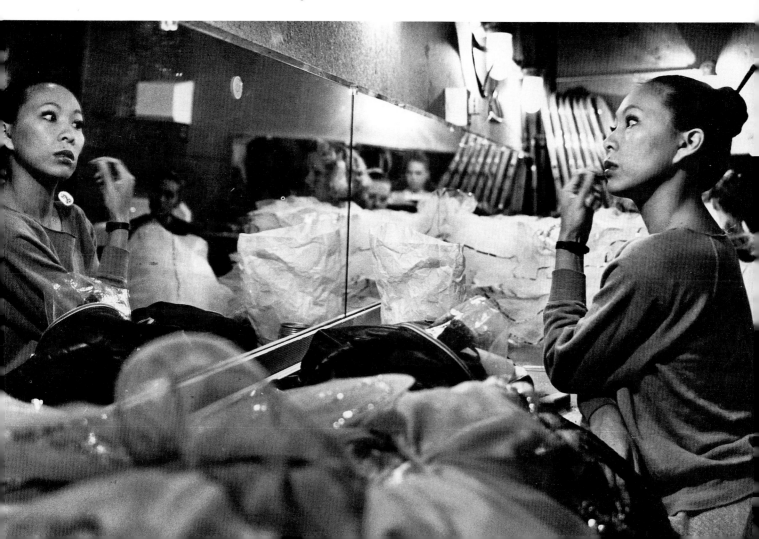

4 Sky and hill, Wales

One of my favourite pictures, an illustration of the virtues of simple equipment: my Old Faithful 1936 Leica with its 50mm f/3.5 Elmar and 3M 50 ASA film, hand-held with a guessed exposure – about 1/40 wide open (*RWH*)

5 'Zipper' carnival ride

The effects of long exposures at night are not always 100 per cent predictable, but they are often dramatic. This was half a second at about f/8 (*SRA: Nikon FM, tripod-mounted: 50mm f/1.8: Kodachrome 64*)

6 Disneyland

As Alan Coren said, 'the technology is post-Einstein, the psychology pre-teen'. There are however many opportunities for dramatic (if somewhat schmaltzy) pictures in the evening (*FES: Nikon F, supported on a wall: 50mm f/1.2 with starburst screen; Ektachrome 200; 1/60 @ f/1.4*)

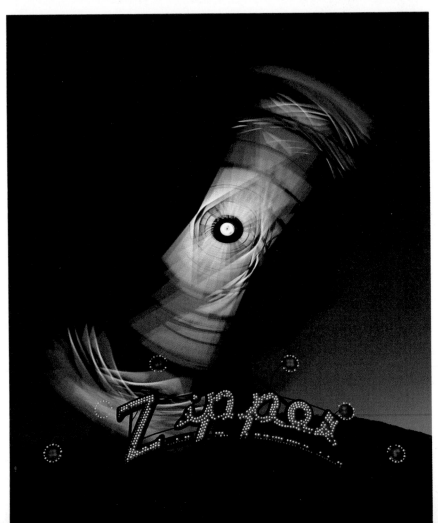

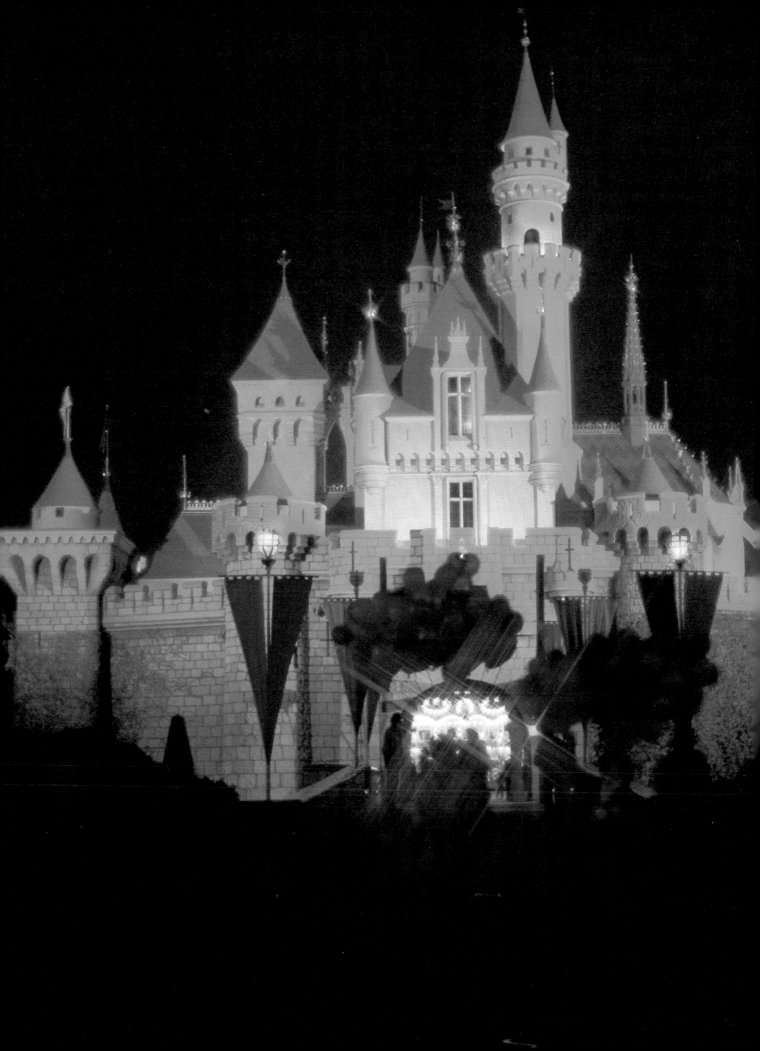

imaging systems are not too unusual.

Likewise, there is nothing on natural-history photography. This is because the only reasons for shooting at night are to capture nocturnal species or night-flowering blooms, and in order to shoot these, you need to be a biologist first and a photographer second. The photographic techniques required mostly involve fairly straightforward use of flash, as covered in Chapter 7, and there is no space in a book like this to cover the biology you need. Either get one of Heather Angel's excellent books, or simply apply the techniques in this book to your own knowledge of biology.

Finally, there is no 'sky at night' chapter. I thought long and hard about this, and came to the conclusion that the modest amount of information on page 80 (about stars and the moon recording as streaks) is about all that concerns most photographers. If you want to get into astronomical photography, using telescopes and equatorial mounts, a book on astronomy will serve you better than a book on photography. Besides, pictures of the constellations (especially in monochrome) are rarely very exciting except to other astronomers, and as I have already made clear, this book is more concerned with attractive pictures than with empty technique.

2
CAMERAS FOR AVAILABLE LIGHT

There is much more to choosing a camera for available-light photography than just getting one with a fast lens. You need to consider the ease with which it can be focused; its freedom from vibration; the ease with which it can be held still; its format; and (for many applications) its quietness. Unfortunately, as we shall see, the ubiquitous 35mm SLR ranks very poorly when judged by any of these criteria *except* the ability to accept a fast lens.

On the other hand, it is perfectly true that absolutely any camera can be used for low-light and available-light photography, and that the shortcomings of the 35mm SLR can, to a large extent, be overcome. Also, if it's what you have got and you are happy with it, there is little sense in changing to a camera which some 'expert' tells you is theoretically better, at least until you are absolutely sure that you want to make the change. The advice of an 'expert' is useful, but it is far from infallible, so follow your own feelings as far as you think is appropriate.

The reason I put 'expert' in inverted commas is that many of the self-appointed 'experts' at camera clubs and in shops are actually pig-ignorant about the subject on which they hold forth.

7 Girls skating
A fast film (HP5 rated at EI 650), a fast lens (58mm f/1.4 Nikkor) and fast reactions (mine!) are essential if you are shooting on a skating rink. In a situation like this, it is not particularly important which camera you use; it is more important that you should be totally familiar with it, so that you can focus and compose almost instinctively – and then you need to anticipate the right moment, so that you catch the expression at its peak (*RWH: Nikon F, about 1/60*)

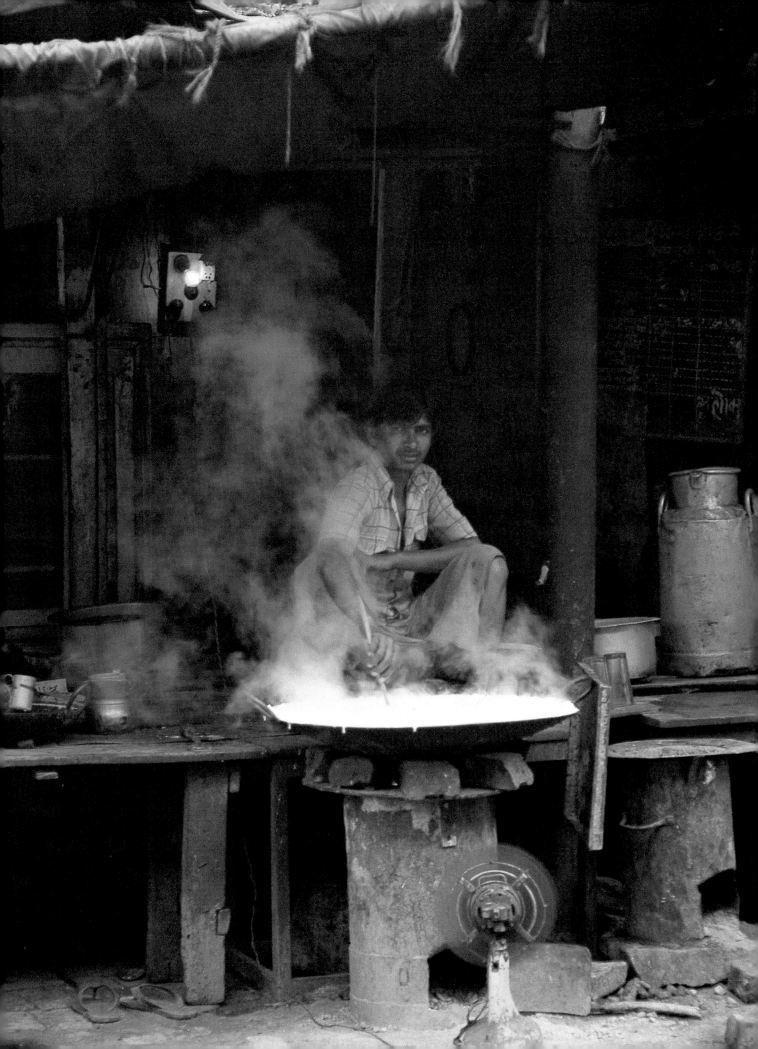

Also, with due humility, I have to admit that I am holding myself out as an 'expert' in this book, and that I don't expect you to believe everything I say, purely on my say-so.

EASE OF FOCUSING

The problem with reflex focusing is that it is basically a question of finding the 'least worst' point of focus; you see-saw to and fro, trying to find the sharpest image. Even where you have some sort of a focusing aid built into the screen – a split-image 'rangefinder' or a microprism screen – you are at a considerable disadvantage when compared with the positive superimposed-image or split-image focusing of a true rangefinder camera. In poor light, the problem is exacerbated; and with wide-angle lenses, with their inherently large depth of focus at a given image distance, focusing a reflex can be very difficult indeed.

If you have one of the major-league system cameras with interchangeable screens, you will however find that there are special screens designed for low-light focusing, often matched to specific focal lengths or ranges of focal lengths. Typically, they consist of an all-over microprism array, and they really do make life easier.

Incidentally, if you use an old SLR, you may be amazed when you look through one of the newer generation of cameras: screen design has advanced enormously, and most modern screens are both brighter and contrastier than old ones. Beware of too-bright screens, however; there is a point at which a screen begins to allow so much light through that it has no real 'ground-glass' (or etched

8 Milk-wallah, Agra
'Low-light' does not necessarily imply night. The narrow alleys of the old bazaar in Agra are dim enough on an overcast day; when in addition you are trying to photograph a murky shop-interior under an awning, you can run into surprisingly long exposures. It is very much easier to have a camera that you *know* you can hold still (*RWH: Leica M: 35/1.4 Summilux: 1/60 @ f/2*)

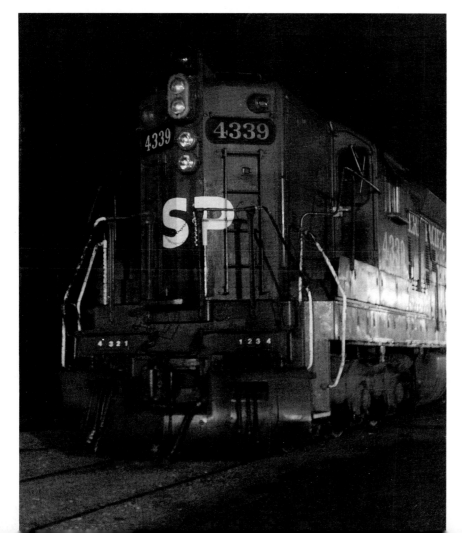

9 Locomotive
Even an old Box Brownie can be used for low-light photography – but this was a two-*minute* exposure using the only emulsion still available in 620, Kodacolor 200. My father bought the camera in 1948; this is probably the first roll it has had through it in almost a quarter of a century. The fearsome scratches on the image are a strong argument for *not* using old box cameras, particularly ones which were left on the beach when the tide came in! (*RWH*)

plastic, nowadays) on which to focus, and you are back to the see-saw method of trying to find focus again.

The other thing you can do to make it easier to focus a reflex is to use a wide-aperture lens, the wider the better. This, rather than any great advantage in picture-taking, is why it may be worth getting a 50mm f/1.2 rather than an f/1.4. With the shallower depth of field and depth of focus, plus a brighter screen image, everything is just a little bit easier.

Also, for purely mechanical reasons of rangefinder coupling, together with the ineluctable geometry of rangefinder base-lengths, you will have to use a reflex if you want to use lenses much longer than 90 or 100mm. It is true that there is a rangefinder-coupled 135mm f/2.8 for the M-series Leica, but this is hardly a speed king in the first place, and it is at the absolute limit of what can be reliably and accurately coupled to a rangefinder.

If you do experience difficulty in focusing wide-angles on an SLR, there is an easy but unconventional solution. Buy a separate, uncoupled rangefinder. These are rarely very expensive, because they are (and always were) extremely inconvenient to use, but there are still relatively large numbers of them swilling around from the 1950s, when few people could afford coupled-range-finder cameras. The long-base versions are extremely accurate, and even the short-base versions are markedly better than a reflex screen. You can carry them independently, or mount them in the accessory shoe, and you simply transfer the reading on the rangefinder to your lens.

10 Leica M6
The Leica M6 is a current state-of-the-art Leica. Externally very similar to the M2-3-4 first introduced in 1954, the M6 offers the reassurance of a fully mechanical camera body with limited-area through-lens metering available at the touch of a button (*Courtesy E. Leitz (Instruments), Luton*)

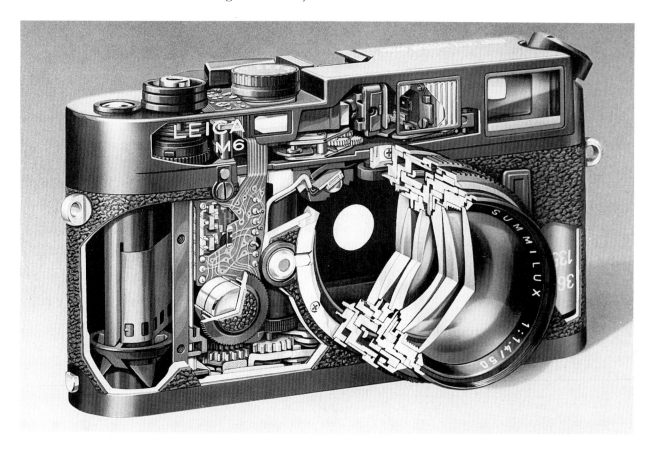

Automatic Focus

One thing I have not mentioned so far is automatic focusing. This is because I have grave doubts as to its usefulness – doubts which are shared by the majority of other professionals, apart perhaps from the 'point-and-shoot' pressman – and these doubts are based on a number of practical and theoretical objections.

First, autofocus cameras focus only on the centre of the picture. This is at best inconvenient: 'focus locks' are rarely the handiest things in the world.

Second, there is undoubtedly a spectacular delay in some designs between pressing the shutter release and taking the picture. With a non-reflex, manual-focusing camera this 'temporal parallax' is typically well under 1/50 second; with an autofocus camera, as much as 1/10 second can elapse between pressing the button and opening the shutter, and a great deal can happen in 1/10 second. Just think of the speed at which a child's expression can change, or how fast a toddler can move.

Third, many 'compact' autofocus cameras focus in zones (near, middle, far) rather than focusing precisely on the subject. If you are using flash, which you usually are with a modern 'auto-everything' compact camera, depth of field will cover this up. Without flash, focusing may not be sufficiently accurate.

Fourth, 'what ain't there, can't go wrong'. Electronics are inherently more reliable than mechanical systems. But with a good mechanical camera, you are dealing with the very finest mechanical systems available, and *if* anything is going wrong, you usually get some warning in the form of roughness, funny noises, and so forth. If an electronic camera dies, it usually dies suddenly and completely. What is more, if you are desperate, a local camera repairer can usually fix your mechanical camera anywhere. The parts for a modern electronic wonder may simply not be immediately available, and finding a camera repairer who is familiar with electronics is likely to be much more difficult than finding one of the old school.

FREEDOM FROM VIBRATION

Any mechanical contrivance with moving parts will vibrate. The vibration may be almost imperceptible, like the ticking of a watch, or it may shake the earth, like the big diesels in a railway locomotive.

In order to minimise vibration, you need as few moving parts as possible; to keep those moving parts small and well-balanced; to have them moving fairly slowly; and to fit them to one another as smoothly as you can.

The cameras which vibrate worst are the ones which break all these rules: an old rollfilm SLR with a focal-plane shutter is a very poor bet, because the mirror introduces a lot of vibration and the focal-plane shutter (which involves some pretty substantial moving parts in a rollfilm camera) does nothing to damp them. If the camera is supported on a flimsy tripod, the worst vibration problems (even with a 35mm camera) can be in the 1/30–1/60 range; at higher speeds, their frequency is long enough not to be a problem, and at lower speeds, the vibrations have time to die away.

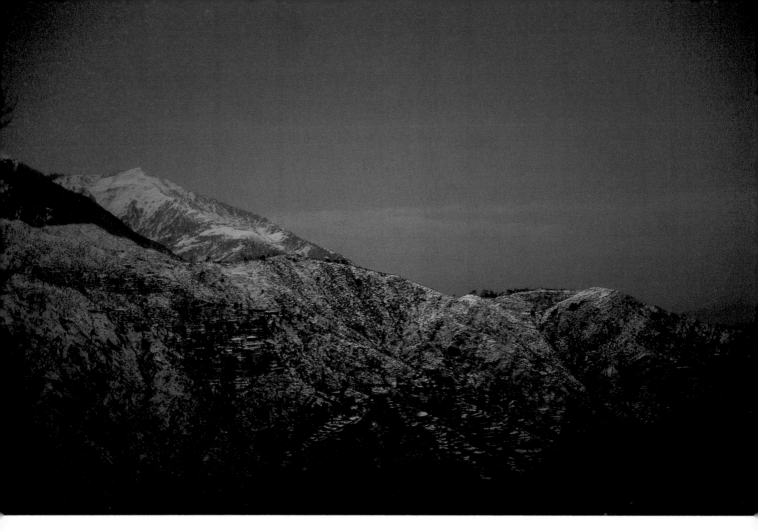

11 Himalayas
Taken with the cheapest camera in the Nikon line-up (the EM, now discontinued) and the standard 50mm f/1.8 E-series lens. Exposure was automatic, about 8 sec at full bore – another triumph for simple, automatic equipment (*RWH: PKR*)

A modern focal-plane shutter is usually better balanced than the old ones, and the main reason why so many rollfilm SLRs use leaf shutters is for flash synchronisation at all speeds (see page 105) rather than to cut down on vibration. To minimise mirror-induced vibration, though, most modern rollfilm SLRs offer a 'pre-release', which closes the shutter, flips up the mirror, and (if applicable) opens the back shutter. The release itself merely trips the shutter.

The cameras which vibrate least are non-reflex leaf-shutter cameras. Obviously, cutting out the mirror cuts out a major source of vibration, and leaf shutters are better balanced and have smaller moving parts than focal-plane shutters, even if those parts do move extraordinarily quickly. The winners for vibration, therefore, are TLRs and leaf-shutter non-reflexes. If you use the pre-release on a leaf-shutter rollfilm SLR such as a Hasselblad or a Mamiya RB67, you effectively convert them to this sort of camera.

Unfortunately, there are no modern 35mm leaf-shutter non-reflex cameras with really good, fast lenses. They used to exist, and it is still worth looking for them second-hand: the old Retinas were available with the f/2 Xenon, and Voigtlander's Prominent could be found with a surprisingly good f/1.5 Nokton as well as a superb f/2. Most modern 'compacts' are content with f/2.8 or f/3.5 lenses, and although a few faster ones have been made, I am not aware of any current models that can muster even an f/2.

Second in the vibration stakes are non-reflex cameras with

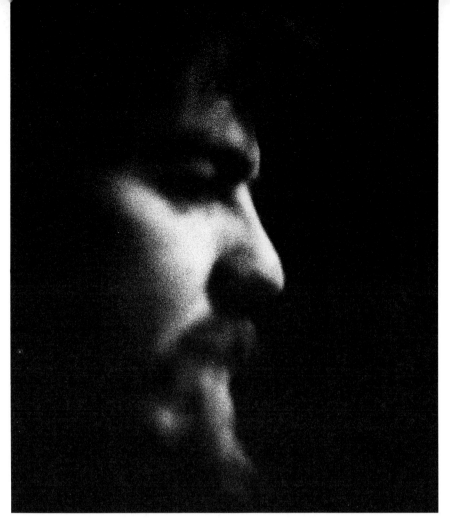

12 Pinhole photograph
Once again, proof that you do not need highly sophisticated equipment to take available-light pictures. I was much younger when I persuaded my brother to take this picture with a pinhole mounted on the front of a Pentax; the effective aperture was probably f/90–f/128, and any slight movement during the five- or ten-second exposure was more than concealed by the inherent soft focus of a pinhole camera (*Jeremy Hicks: HP4 rated at about EI 3200*)

focal-plane shutters. Now, of course, the principal representative of this breed is the M-series Leica. What is more, the Leica uses a comparatively slow-running cloth focal-plane shutter, which is superlatively well assembled – two of our major criteria for vibration reduction. There are alternatives, including second-hand Contax, Canon and Nikon rangefinder cameras, but these are increasingly becoming 'collectible' and besides, they are getting fairly old. If you live in Europe, there are also the Russian interchangeable-lens cameras, the screw-thread Zorkii and Fed and the Contax-lookalike Kiev. The lenses for these are however 1930s Zeiss designs, which win no prizes either for resolution or for contrast nowadays.

If you use the mirror-lift on a modern SLR, you effectively convert it to a non-reflex focal-plane camera, but you lose both focusing and the viewfinder. Also, because most modern shutters are much faster-moving than the somewhat leisurely Leica M-series shutter, shutter-induced vibration is that much greater.

HOLDING THE CAMERA STILL

There are two entirely separate questions here, ergonomics and continuous viewing.

Ergonomics are largely a personal matter, but there is no doubt that some cameras (and some sorts of camera) are much easier to hold still than others. The TLR, on a neck-strap, is one example: ladies with ample bosoms, or gentlemen with well-padded corporations, can often get away with 1/5 second or even

19

longer exposures, simply by breathing out and pausing momentarily during the exhalation. Shooting during exhalation is a useful trick with any camera.

Continuous viewing is a more contentious point. With an SLR, some people find the blacking-out of the viewfinder during the exposure very disorienting; certainly, if you have some form of continuous viewing, either a TLR or a viewfinder camera, it seems psychologically easier to hold the camera still for long exposures. This is particularly true if you can brace your elbows or the camera in some way, because you can actually *see* how badly you have moved (if at all) during the exposure. From personal experience, I reckon that continuous viewing is worth one or even two steps on the shutter-speed scale. Thus, while 1/30 is right at the limit for hand-held exposures with an SLR and a 50mm or 35mm lens, it becomes perfectly feasible with a non-SLR such as a Leica and the same lenses; I will cheerfully risk 1/15 or even 1/8. For *really* long exposures, 1/8 second and longer, continuous viewing not only lets you check camera shake: it also means that you can watch for subject movement.

Provided you have not already fitted a rangefinder into your accessory shoe (see above), you can use a viewfinder with your SLR to get continuous viewing. The best sort is something like the TEWE illustrated, as it allows continuous 'zoom' framing from 35mm to 200mm, though most models stop at 135mm. Alternatively, individual finders for 35mm, 50mm and other focal lengths can be found, as well as 'turret' finders covering a range of focal lengths.

13 Mamiya 645 with 80mm f/1.9 lens

If you are in the fortunate position of being able to select a new camera system, check out both the availability of fast lenses and their price. The Mamiya 645 is obtainable with the fastest production lens available for any rollfilm camera, the 80mm f/1.9; an impressive bottle by anyone's standards. The prism is a virtual necessity with the rectangular format, but if you want a compromise between the fast handling of 35mm and the sheer quality of rollfilm formats, the 645 warrants serious consideration (*Courtesy Johnson's of Hendon*)

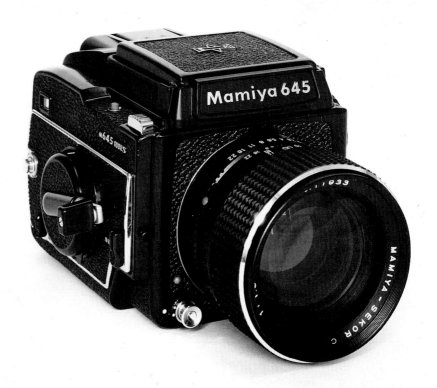

Detachable viewfinders are available for a vast range of focal lengths and in a wide spread of qualities, as were the cameras for which they were originally made, mostly in the 1950s. With the exception of the Big Names, notably Leitz and to a lesser extent Zeiss and Nikon, they are rarely expensive. Finders for lenses wider than 35mm are also rare, and command a premium.

FORMAT

Using larger formats brings two advantages. First, you can use faster films, and second, you can get away with longer shutter speeds. Both are consequences of the same thing, the reduced magnification of a larger-format image when it is reproduced.

In order to fill a page of a book like this, a 35mm slide or negative has to be enlarged some 8x. A 6x7cm rollfilm image needs to be enlarged about 3.5x, and a 5x4in image needs to go up about 2x. Obviously, you need to use much finer-grained images with the smaller formats in order to end up with the same perceived graininess on the page. Very roughly, you would need to use ISO 50 material with the 35mm camera to equal the graininess of ISO 200 material in rollfilm or ISO 1000 material on 5x4. This means that an f/2.8 lens on a rollfilm camera, used with ISO 200 material, delivers much the same quality as an f/1.4 lens on 35mm used with ISO 50 material. With ISO 1250 Royal-X Pan film in a 'five-four', a common-or-garden f/4.5 lens is fine.

Camera shake is also dependent on magnification. Small formats are magnified more than larger ones, along with any blur that is recorded on the negative. As a rule of thumb, you can get

14 Tewe finder
The beautifully made Tewe finder mounted on this Canon was introduced in 1953, when it cost a staggering £21:10s:0d. It offers a continuous zoom range from 35mm to 200mm, with marked stops at 35–50–75–85–90–100–135–150–180–200mm and unmarked lines which correspond (I think) to 38mm, 90mm and 127mm. They can be used to promote a steady camera, as described in the text, or as a convenient way of checking which focal length you need for a particular shot

15 'Talk To A Naked Girl'

I spotted this improbable offer in one of the sleazier areas of San Francisco; the original was shot in colour. Things like this, little once-seen gems, are a strong argument for always carrying a camera with you. I had a Leica, loaded with Kodachrome (this was converted to monochrome by the printers) but I cannot remember any exposure details (*RWH*)

16 Queen Mary

Unless you can afford some *very* specialised lenses, such as the 105mm f/2.8 Zeiss Planar for the 6×7cm Linhof, anything larger than 6×6cm really demands a tripod. This was shot with a 50mm f/4.5 lens on a Mamiya RB67; you can see that the tripod allowed me to stop well down, even at dusk, for a 1-second exposure. The water looks a little oily, which is usual with long exposures; notice also the 'starbursts' created by reflections from the diaphragm leaves at small apertures (*RWH*)

away with one extra step on the shutter-speed dial when switching from 35mm to rollfilm, and another step when going from rollfilm to 5x4: 1/30 to 1/15 to 1/8, other things being equal. This is discussed at greater length on page 00.

Unfortunately, there are five countervailing arguments against the use of larger formats. The first is that lenses are generally much slower, as discussed in the next chapter. The second is that the cameras themselves are generally bigger, clumsier, and slower-handling than 35mm. The third is that the depth of field on the small 35mm negative is inherently greater than it is on bigger negatives, simply because the image is smaller. This translates into a greater margin for error at a given aperture, or the possibility of using still wider apertures.

The fourth objection is the availability of film stocks; this is more properly the subject of Chapter 4, but it is worth mentioning here that the fastest films are mostly available in 35mm, simply because of demand. There is a good choice of fast black-and-white films for both rollfilm and cut film, and rollfilm users are not too badly supplied with middling-fast colour films, but cut-film users have problems if they want to shoot available-light colour. The fifth and final objection is that it is much more difficult to 'shoot for the percentages' with bigger cameras.

Shooting for the Percentages

Some old-fashioned photographers decry 'shooting for the percentages'. They reckon that you should be able to go out with (say) half a dozen plate holders and come back with twelve (or at

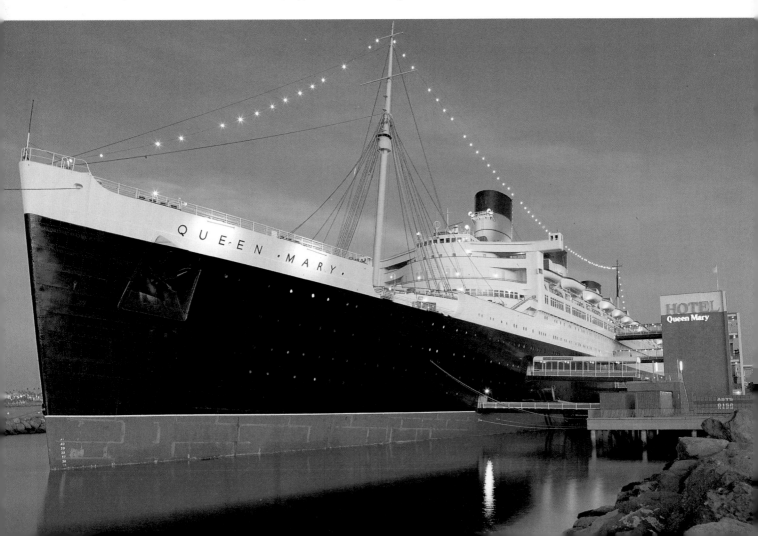

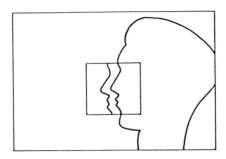

Fig 1 Split-image rangefinder image
Some people apparently find it difficult to 'work' a split-image rangefinder, but it is simple enough. When the image is out of focus, there is a double image like this. When the image is in focus, the two images fuse (*A/w by FES*)

17 John Drewer
If you want to use differential focus, a reflex is essential; you can hardly frame a rangefinder camera reliably enough, let alone visualise the focus effects (*RWH: Pentax SV: 55/1.8: FP4, rated EI 200: about 1/30 wide open*)

least six) good negatives. Well, for certain kinds of photography, they are right. In landscapes, for example, you should be able to get it right first time; with still-lifes, there should be no question about it. Even with portraits, you should not need to use too much film. But with low-light photography, there is always the risk of something going wrong.

Camera shake is the most obvious danger: if you are working with long shutter speeds, you are more at risk. Poor focus, as a result of working at large apertures, is another possibility. You may also need to bracket exposures (page 61), and if the light is changing (for example at a rock concert), your only option is to shoot plenty of film in the knowledge that some of your frames are going to be failures.

QUIETNESS

This is by no means always important, but for reportage and anywhere else you want to be unobtrusive, it can be crucial. Once again, leaf-shutter cameras win easily, but the M-series Leica comes a very fair second. Among SLRs, it is a general (but by no means infallible) rule that the more expensive the camera, the quieter it will be.

It is also a fair general rule that focal-plane shutters with high synch speeds will be noisier than shutters which stop at 1/1000. This is because the only way to get these high synch speeds is to increase the speed of travel of the shutter blind, resulting in a real slam-bang noise; the shutter is also lighter and more fragile, in many cases. It is worth noting that M-series Leicas only synch at 1/50 second, while the original Leicaflex synched at a mere 1/100 second despite its 1/2000 second top speed.

CONCLUSIONS

At this point, I must return to what I said at the beginning of the chapter. *Do not* change your existing system just because I or anyone else may advise you to do so. Wait until you are good and ready, and balance up everyone's advice before you make your choice.

Having said this, it must be fairly obvious by now that 35mm cameras are generally the best bet for low-light work. Despite the theoretical shortcomings of the 35mm SLR, it is still a very useful camera, especially with the right screen. With an accessory direct-vision finder, as described above, long exposures are even easier. Furthermore the 36-exposure loading allows you to shoot 'for the percentages'. For most people, this is probably the best all-round camera, especially as they are likely to own one already.

24

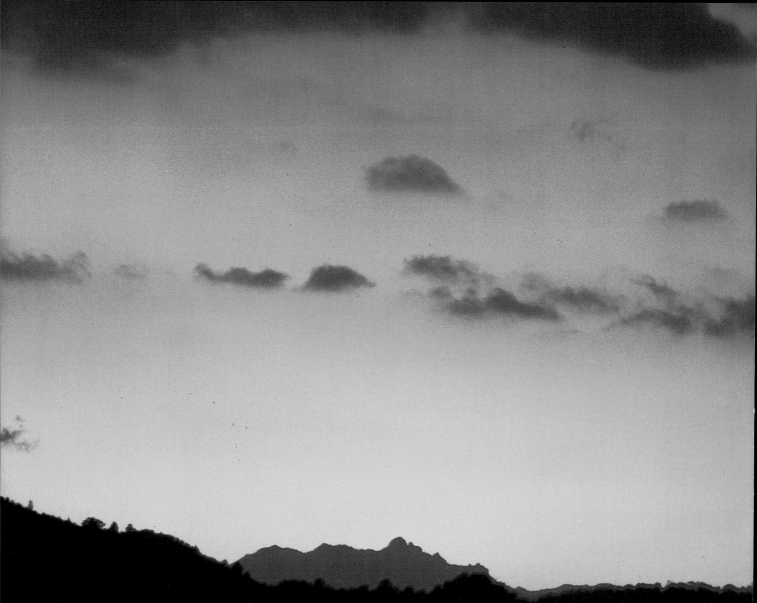

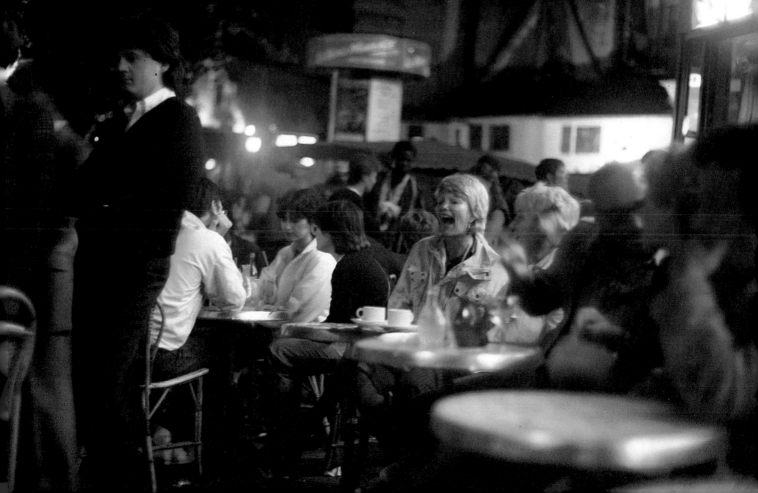

18 Mountains, Arizona
Some pictures you see and grab; others you have to wait for. If you want to shoot mountains at twilight, you have to find a likely looking mountain, and *wait*. Frances Schultz shot this with a 200mm f/3 Vivitar Series One on a tripod-mounted Nikkormat (*FES: Kodachrome, no exposure details*)

19, 20 Boulevard St Michel, Paris
Sometimes you have to shoot fast, and shoot often; the mood in this • group changed dramatically when the girl suddenly found something amusing. I probably shot five or six pictures in this area (*RWH: Leica M: 50mm f/1.2: Kodachorme: 1/60 @ f/1.4 or so*)

If you can afford it, though, a Leica is arguably the perfect camera for most kinds of hand-held low-light photography. Not only will it accept a range of superb fast lenses (of which more in the next chapter): it is also easy to focus, easy to hold still, and very quiet. The Leica is extremely expensive, it is true, but it loads the percentages in your favour, and if you take your low-light photography really seriously, you ought to consider one. You need not buy new, and indeed I have only ever bought one Leica new: my M2 and M3 Leicas are over a decade old.

If you cannot (or do not want to) afford a Leica, take a look at some of the other, less popular, rangefinder cameras. Canons and Nikons have now achieved 'collector' status, so consider a 1950s or 1960s leaf-shutter camera such as the Retina IIIc or IIIC (and put a Leitz 5cm finder on top – the standard viewfinders are awful), or a Voigtlander Prominent or Vitessa.

You will be stuck with a standard lens only – those leaf-shutter cameras that did have interchangeable lenses tended to be damnably inconvenient – but this is not necessarily disastrous. The advantage of any good, old leaf-shutter camera is that you should be able to find one at a price which means you can add it to your outfit, instead of replacing your existing cameras. They are quiet, easy to hold still, free from vibration, less attractive to thieves, and extremely unobtrusive: because most serious photographers today use SLRs, you can get away with using them when you might otherwise attract unwelcome attention.

Whatever camera you use, you should be sufficiently familiar with it that you can set the shutter speed, and change lenses, by touch. You may not be able to remember verbally, but ask yourself which way you turn the shutter-speed dial; imagine you have the camera in your hands. Then go and get the camera, and check it . . .

21 Tessina
At the other extreme from the Speed Graphic, the tiny Tessina delivers a 14×21mm image on standard 35mm film (albeit reloaded into non-standard cassettes) and is the favoured camera of spies everywhere. I used to use HP4 in mine; if I were to buy another, I should probably switch to XP-1 for surprisingly good image quality and extraordinary portability (*Courtesy Carl Heitz, New York*)

22 Radio announcer
Remarkably, this was shot with a 4×5in Speed Graphic. The 135mm f/4.7 Xenar was wide open, and even on Tri-X, an exposure of about 1/8 second was called for (*SRA*)

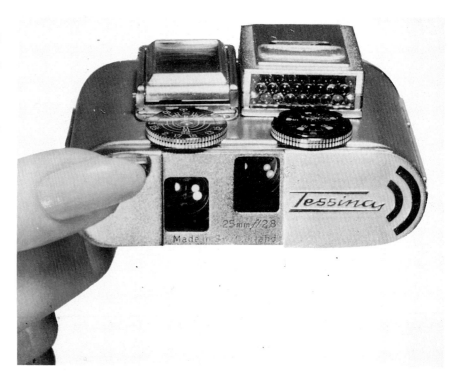

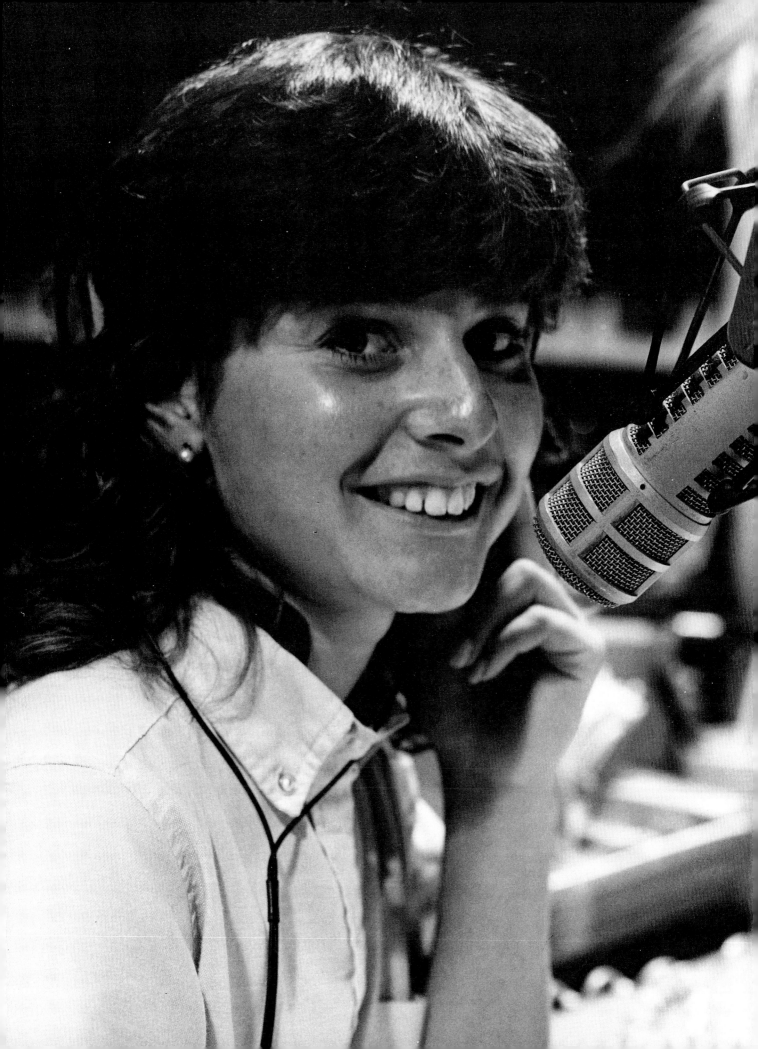

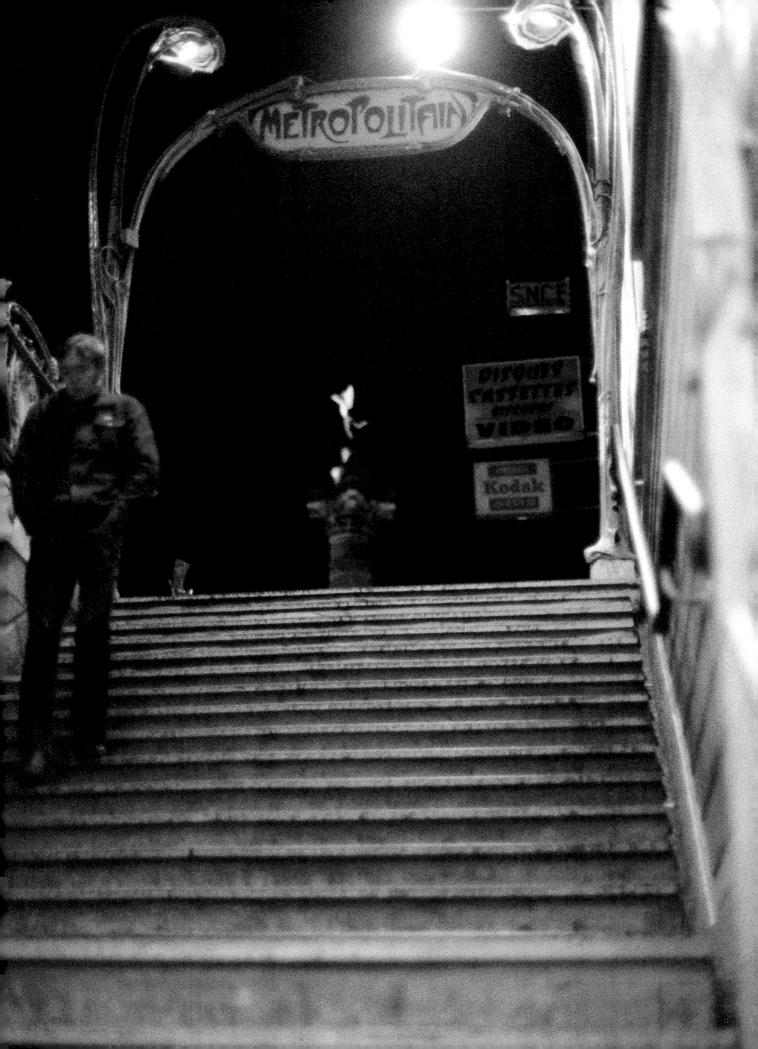

3
LENSES: HOW FAST IS TOO FAST?

There is no doubt that fast lenses are highly desirable in most types of low-light photography, but there are several factors to consider before you buy one.

The first is simply availability. If you want an f/1 lens, you are going to need either an M-series Leica or a Canon. Likewise, if you want a 24mm f/1.4, Canon is your only choice. A related point is that some cameras not only offer a better range of fast lenses; they also offer them cheaper. Often, the reason for this is simple: the cheaper lens is inferior. But if the manufacturer is committed to a range of fast lenses, *and* is big enough to be able to produce and sell them in large numbers, you may get lucky. An obvious example is Nikon/Canon. Both make first-class lenses, with very little to choose between them when it comes to quality, but Canon's fast lenses are significantly cheaper.

After availability comes price, at least for most people. Speed costs money: increasing the maximum aperture of a standard lens by a single stop (or even half a stop, in some cases) can easily double the price of a lens. With long lenses, the differences can be really spectacular. At the time of writing, the 'basic' 300mm Nikon lens was an f/4.5. Going to the f/2.8 meant buying an EDIF (extra-low dispersion internal focusing) lens, at something like seven times the price. Going to f/2 doubled the price again! By the same token, the 200mm f/2 was about eleven times the price of the 'cooking' 200mm f/4.

To a large extent, though, this is a non-photographic problem. You decide whether you really want the lens – that is, whether it is suitable for the kind of pictures you want to take – and then you decide whether you can afford it. Then you start wondering what you can sell to raise the money . . .

The other factors to consider are the relationship between speed and focal length; the image quality obtainable with fast lenses, as against the image quality that slower lenses can deliver; and consistency or uniformity across a range of lenses. These are rather more complex photographic questions.

SPEED AND FOCAL LENGTH

The fastest lenses in any manufacturer's line-up are normally around the 'standard' focal length: 50mm for 35mm, 80–100mm on rollfilm, and 150mm on 5x4in. Anyone who wants fast lenses for larger formats than 5x4in is going to have serious problems! In what follows, I shall confine myself to 35mm until towards the end of the chapter, where there is a section on fast lenses for larger formats. Furthermore, the differences between reflexes and rangefinder lenses are also significant, so I shall look at reflex lenses first.

23 Métro, Paris
The elderly 50mm f/1.2 Canon lens which I used to take this picture is described in the text. Combined with super-grainy 3M film (640T) it gives the kind of soft, romantic image which is the way I see Paris – but it is not sharp, by any stretch of the imagination. No exposure details (*RWH*)

31

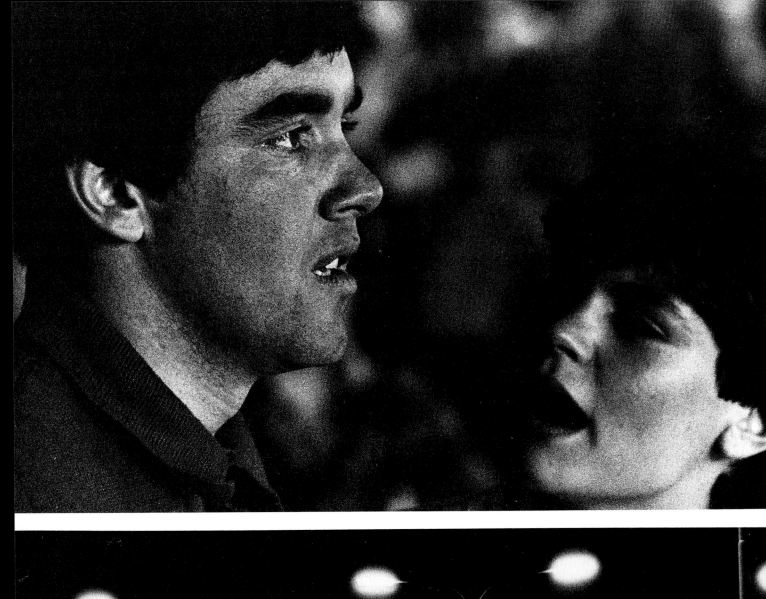

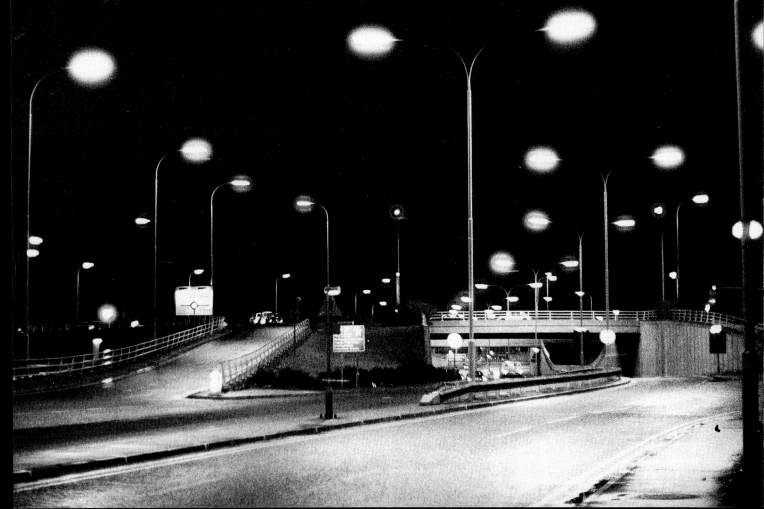

In 35mm, even the 'cooking' standard lens is likely to be f/2 or f/1.8; the odd 1/3 stop difference between the two is largely cosmetic. As a matter of interest, the 1/3 stop gaps between the 'standard' apertures are as follows: **f/1** (f/1.1, f/1.3); f/1.4 (f/1.6, f/1.8); **f/2** (f/2.2, f/2.5); f/2.8 (f/3.2, f/3.5); **f/4** (f/4.5, f/5); f/5.6. The half-stop rests are f/1.2, f/1.6, f/2.4, f/3.4, f/4.8.

The next faster standard lens, the f/1.4, is likely to cost you 50–100 per cent more than the f/1.8 or f/2. For reasons which are explained later, the f/1.4 lens is probably the best buy for most people.

If you want to spend even more money, you can pay three or four (or more) times the price of the f/2 or f/1.8, and buy an f/1.2. The last step, beyond f/1.2, has only ever been available for three full-frame 35mm cameras, and one of those is extinct. Canon used to make an f/0.95 for their rangefinder cameras, which were discontinued in the late 1960s. In the early 1980s, this lens was still available for television use, but it lacked the rangefinder coupling cam. Anyone who can guess-focus an f/0.95 lens at maximum aperture is a better man than I am, Gunga Din.

In the realms of the actually available, Leitz has offered the f/1 Noctilux for the M-series Leica for some years, and at the time of writing Canon had just returned to the fray with an f/1 for their Eos, which has the distinction of being the first-ever production f/1 for a reflex camera.

What happens, though, if you prefer longer or shorter focal lengths? The simple answer is that you are in trouble. The 50mm 'standard' focal length represents an ideal compromise for the

24 Couple
The 58mm f/1.4 lens was one of my favourites for low-light photography; to this day, I suspect that the slightly longer-than-normal 'standard' lens is ideal for many applications, but I cannot afford a 75mm f/1.4 for my Leicas, and 50mm lenses are a tad too short. Check the instruction book for your camera to see if any fast, 'long standard' lenses were sold for your camera, then comb the second-hand stores (*RWH: Nikon F: 58/1.4: about 1/60 @ f/1.4*)

25 End of M32 motorway, Bristol
Even quite recent fast lenses show their defects when faced with extreme conditions. This is the 58mm 1/1.4 Nikkor again: it was designed in the very late 1950s. Just look at the flare – but the road sign remains readable, which the contemporaneous 50mm f/1.2 Canon *rangefinder* lens would have been unable to manage at a comparable aperture (*RWH: HP5, EI 650: about 1/60 @ f/1.4*)

26 Cath Milne
Motorcyclists say 'Ride what ya brung': any motorcycle is better than no motorcycle. I had borrowed a fish-eye Nikkor and shot this portrait of Cath Milne building a table; it shows that you can take available-light pictures with almost any camera/lens combination (*RWH: Nikon F: Fish-eye Nikkor: HP5 at EI 650: about 1/15 @ f/2.8*)

27 Poetry group, Bristol Arts Centre
I have always had a weakness for ultra-wides, partly because I like the images and partly because you can often hand-hold them at 1/15 or even 1/8 and get away with it. This was shot with a 21mm f/4 Nikkor, which required the mirror on the camera to be locked up (a separate viewfinder was available), but the quality is still superb. I used an interesting technique here, pre-focusing the camera and then shooting without looking through the viewfinder; the horizons may be tilted, but the result is undoubtedly candid (*RWH: Nikon F: HP5 rated at EI 650: 1/15 @ f/4*)

28 'Jabeur'
'Jabeur' is a street musician on the Boulevard St Michel, a short walk from Notre Dame de Paris. These pictures were shot with the 50mm f/1.2 Canon lens referred to in the text; the quality, under these near-ideal conditions, is extraordinary (*RWH: Leica M4-P: 50/1.2 Canon at f/1.4: PKR: about 1/50 sec*)

lens designer: coverage is no problem, and speed (within reason) is easily achieved. In practice, slightly longer focal lengths are even easier to design, which is why so many early 'standard' f/1.4 and faster lenses were actually 55mm, 58mm or even 60mm.

With anything much over 85mm, while coverage is no problem at all, ultra-wide apertures make the lens unmanageably large: a 105mm f/1.4, for example, would require a front glass some 3–4in (75–100mm) in diameter, and it would weigh a ton. With shorter lenses, the problems are rather different.

With wide-angle lenses for reflexes, the main difficulty is retrofocus design. Any lens with a focal length of less than about 45–50mm has to have a negative (dispersing) group in front of the main image-forming group in order to give enough back-focus to clear the flipping mirror. This is also true of extremely fast lenses (f/1.4 or faster) of 'standard' focal length.

Retrofocus design inevitably degrades image quality, when compared with a non-retrofocus design of similar focal length, and increasing speed means that the designer's headaches are increased dramatically. The net result of this is that ultra-fast standard lenses, or fast wide lenses for reflexes, tend to cost more than comparable lenses for rangefinder cameras; also, because of all the glass in them, they tend to be disproportionately large. The difficulties are indicated by the prices: at the time of writing, Canon's 50mm f/1 was comparable in price with the Leitz 50mm f/1 Noctilux. Admittedly it was an autofocus, but most Canon lenses are very much chapter than most Leica lenses: the Leitz 50mm f/1.4 was about twice the price of the Canon f/1.4, and the

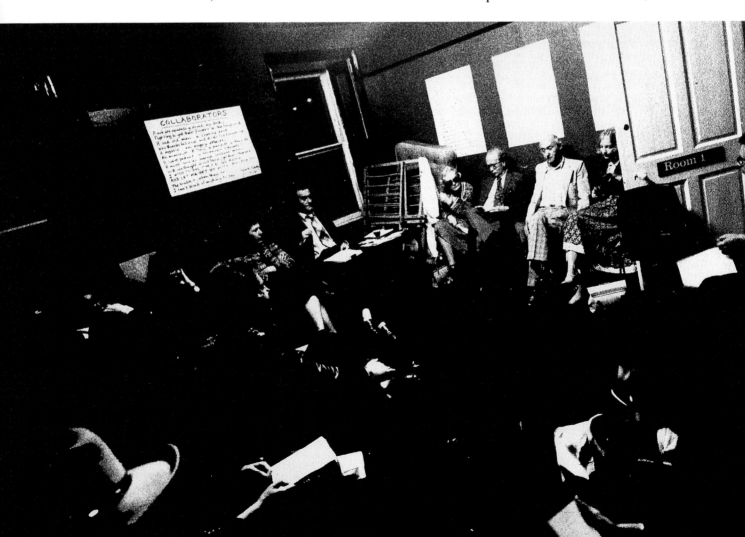

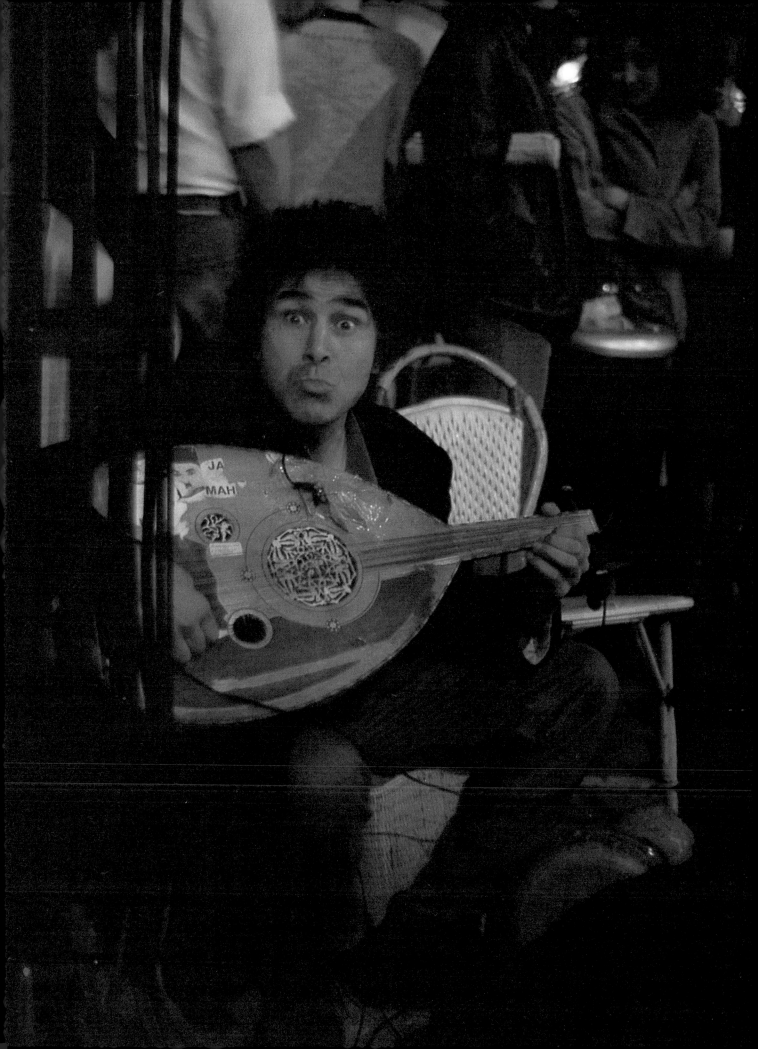

29 Noctilux 50mm f/1
The fastest production lens for a
35mm camera at the time of writing
was f/1. The price was staggering,
the depth of field negligible, and the
performance less than overwhelming
– but if you really want speed, Leitz
can provide it! (*Courtesy E. Leitz*)

30 Canon 24mm f/1.4
I must confess to lusting after one of
these; as I have already said, I love
ultra-wides, and the combination of a
24mm focal length and an f/1.4
maximum aperture is a dream. The
price is however terrifying (*Courtesy
Canon Camera Co*)

f/2 for the Leica was about ten times the price of Canon's f/1.8.

It is possible, therefore, to draw up a table of focal lengths with 'normal' maximum apertures, 'fast' maximum apertures, and 'silly money' maximum apertures, as shown in the box. Remember, though, that a great deal depends on demand, so that (for example) 24mm lenses are not just relatively cheaper and faster than 20–21mm; they are disproportionately cheaper, because 24mm is a more popular focal length. Also, individual manufacturers may buck the trend, but the trend is still there.

FOCAL LENGTH AND APERTURES AVAILABLE IN LENSES FOR 35MM SLRs

Focal Length (mm)	Standard	Fast	'Silly Money'
20–21	f/3.5–f/4	f/2.8	–
24	f/2.8	f/2	f/1.4
28	f/2.8	f/2	f/1.4
35	f/2.8	f/2	f/1.4
50	f/1.8–f/2	f/1.4	f/1–f/1.2
75–85	f/1.8–f/2.5	f/1.4	f/1.2
90–105	f/2.5–f/2.8	f/1.8–f/2	–
135	f/2.8	f/2	–
180–200	f/4	f/2.8	f/2
280–300	f/4.5–f/5.6	f/2.8–f/4	f/2
400–500	f/5.6–f/6.3	f/4.5	f/3.5
560–600	f/8	f/5.6–f/6	f/4
800 and up	f/8–f/11	f/6.3	–

There is, moreover, an additional consideration when you are looking at the relationship between focal length and speed. It is depth of field, and its twin brother, depth of focus.

Depth of field is the zone either side of the object plane which is acceptably sharp, while depth of focus is the zone either side of the image plane which produces an acceptably sharp image. For a given aperture, both are dependent purely on the image size on the film – and the question of 'acceptability' is one about which you can argue. But the point is this: at very wide apertures, especially at close distances, both depth of field and depth of focus are extremely shallow.

With a standard lens, anything faster than f/1.4 is likely to lead to unacceptably shallow depth of field when the lens is used at full bore; at 3ft (1m), an f/1 lens can just about hold an eyelash in focus from front to back. What is worse, the degree of precision required in making the camera mount, and in registering the focusing screen with the film plane on a reflex, is likely to make

depth of focus a problem too: only the very finest cameras and lenses can be relied upon to give a truly sharp image.

With wider lenses, nothing faster is available anyway, so the question does not arise. Even so, because most people use wide-angle lenses at the same sort of distance as they use standard lenses, the image size on the film is usually smaller. In other words, a 35mm f/1.4 lens will give more depth of field *in typical use* than a 50mm f/1.4.

With longer lenses, on the other hand, people tend to want a magnified image, and we all know, from personal experience, that this means less depth of field. This means that an ultra-fast long-focus lens can have a laughably small depth of field.

Logically, therefore, the 'silly money' fast lenses may actually be *less* useful than their slower brethren, even when they are of equal optical quality; and this is what we shall come to next.

SPEED AND OPTICAL QUALITY

There are two ways of making a faster lens. One is to do it properly, and design it from scratch. It may bear a family resemblance to slower lenses, but it is almost certain to be more complex, to use more highly specialised glasses, or (especially in the case of wide-angles) to involve deeper curves. All of these come expensive. Also, there is likely to be less demand than there would be for a slower lens, partly because most people do not need the extra speed, and partly because they cannot afford it even if they want it. This means that the manufacturer loses the economies of scale in manufacturing, which again bumps up the price.

The second way to make a fast lens is to 'stretch' an existing design, trading off a slightly (or considerably) diminished performance at maximum aperture in return for more speed. The gain is mainly in marketing: you can boast that you have an f/1.7 lens instead of your competitor's f/1.8. In extreme cases, you can go beyond the technology you can handle, and produce a lens which is next to useless at full bore.

Because manufacturers are constantly updating lenses, and because some lenses from little-considered manufacturers (such as Konica) are at least the equal of lenses from better-known companies, there is little point in naming names. Besides, I don't want to get sued. Even so, it is a fair bet that you get what you pay for, and with the cheapest cameras and proprietory lenses, you are not paying much.

It is also worth noting that image quality even of a first-class lens is influenced by design philosophy. Some ultra-fast lenses are meant to be used at full bore, while others are meant for use at normal apertures with the maximum aperture as a useful 'reserve' which also provides easier focusing. Most f/1.2 lenses are designed on the latter principle, but the difference between an f/1.2 designed to be used wide open and a 'cooking' f/1.2 is illustrated by Nikon. Their 'cooking' f/1.2 is a superb lens, but at maximum aperture the aspheric-surface 58mm f/1.2 Noct-Nikkor is better. It is also three times the price of the regular f/1.2, or more than ten times the price of the 50mm f/1.8.

While generalisations are dangerous, it is fair to say nowadays

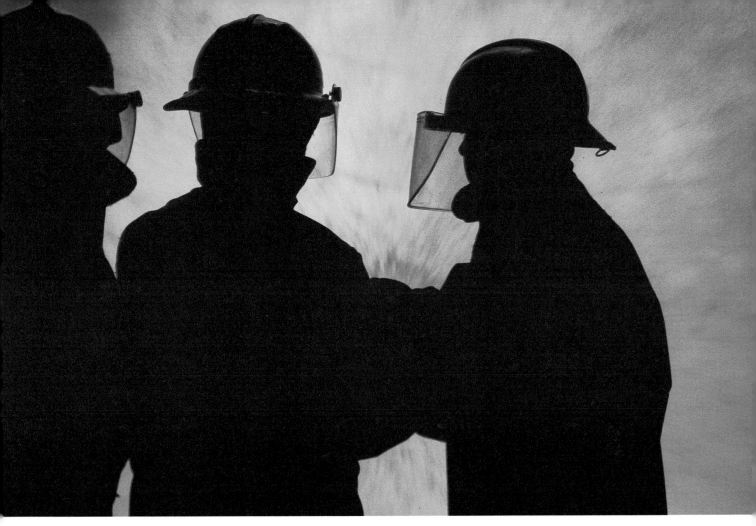

that while lenses from the very top manufacturers (Leitz, Zeiss, Canon and Nikon) will almost invariably be first class regardless of their aperture, the very fastest lenses from lesser manufacturers may well be inferior to their slower counterparts. And even the big names make the occasional lemon; I have never been impressed by the 50mm f/1.4 Summilux, though I have owned two late 35mm f/1.4 Summiluxes, and both have been stunners.

The dangers with ultra-fast lenses are loss of sharpness, flare (resulting in degraded colour, even if the effect is not immediately evident), distortion (usually 'barrel' distortion, where lines near the edge of the frame bow outwards) and field curvature.

All of these dangers are even greater if you use old lenses. The 58mm f/1.4 Nikkor was one such: the current 50mm f/1.2 is incomparably better in every way. It is only fair to say, though, that the flare in fast, old lenses is worth half a stop to a stop; indeed, you have to under-expose in order to get a recognisable image, so you can rate ISO 1600 film at ISO 3200 and get quite a fair picture. Also, the resolution of ultra-fast films (ISO 650 and over) is often sufficiently poor that the deficiencies of old lenses at full bore are masked by the lack of resolution on the film. The same is also true if you want to use slow zooms with fast film (see page 48).

UNIFORMITY

One more point which has not previously been addressed is that if you want to use more than one focal length, you will do well to

31 Firefighters
These firefighters are actually at a training ground, learning how to deal with liquid-gas fires. The technical quality is surprisingly good, considering the fact that it was shot with a zoom on ISO 400 film with a hand-held camera! (*SRA: Nikon F3: Tamron 80–210mm f/3.8 zoom at or near maximum focal length: Ektachrome 400: 1/60 at f/4*)

39

stick with lenses from a single manufacturer. There are three reasons for this: focusing direction, aperture rings, and colour signatures.

Most lenses focus anticlockwise (viewed from the camera eyepiece) to reach infinity, clockwise for nearer distances. Some (notably Nikons) focus 'backwards'. If you mix the two, it can slow you down.

Potentially more serious is the question of whether you go clockwise or anticlockwise for maximum aperture. With most SLRs, you can check with the depth of field control, but it is better if you *know* instinctively which to use, especially in the dark. Again, marque lenses will generally stick to a given convention.

All lenses have their own colour 'signatures', and the marque manufacturers take great care to ensure that all their lenses are consistent. As a general rule, too, Japanese lenses tend to be much warmer (ie to deliver a more golden result) than German ones. In my opinion, this warmth creates the impression of less sharpness, though this may well be subjective.

RANGEFINDER LENSES

Rangefinder lenses require no auto-diaphragm mechanisms or other links to the camera body, and consequently can be smaller, lighter and cheaper than their reflex counterparts. What is more, wide-angles do not have to be of retrofocus design, and can therefore be both simpler and of higher quality than reflex lenses.

On the other hand, there is little point in using a rangefinder camera for anything much longer than 90mm (see page 16), and

32 Nikon 300mm f/2.8 lens
From the wide to the long: this monster is not even the fastest 300mm lens available for Nikons, but it is as much as anyone would want to carry. The 300mm f/2 is quite beyond belief: unless you are shooting from a fixed position, such as a press box, ultra-fast long lenses soon become self-defeating because of sheer bulk (*Courtesy Nikon UK Ltd*)

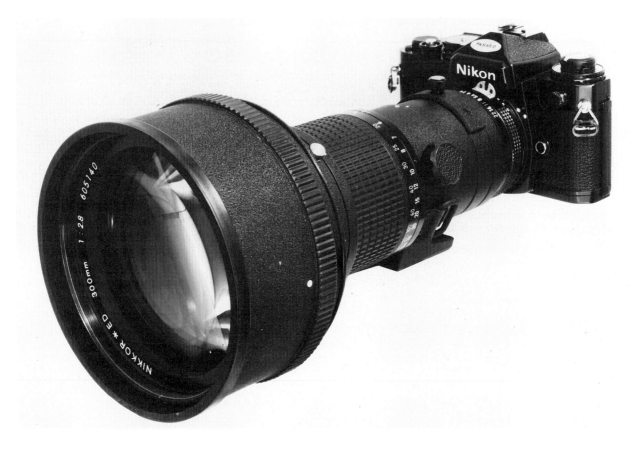

because Leitz is the only manufacturer left producing modern rangefinder lenses, prices are high. The full range consists of a 21mm f/2.8; a 28mm f/2.8; two 35mm lenses, f/2 and f/1.4; three 50mm lenses, at f/2, f/1.4 and f/1; a 75mm f/1.4; two 90mm lenses, f/2.8 and f/2; and a 135mm f/2.8. All are excellent, and the 35mm lenses are particularly compact.

Among older lenses, anything faster than f/1.5 or f/1.4 (postwar) or f/2 (prewar) should be regarded with suspicion, though Nikon's 50mm f/1.1 was better than Canon's 50mm f/0.95. Fast lenses of other focal lengths are both rare and suspect; even with Leicas, the early 90mm f/2 was not a patch on the current design. In all fairness, my Russian 85mm f/2 is just about tolerable wide open, and amazingly good at f/5.6 and below, but it is still not exactly world-class.

LARGER FORMATS

In rollfilm the standard lens is normally f/2.8, and only a few manufacturers offer anything much faster. Pentax manage half a stop with their f/2.4 for the 6x7, Hasselblad manage an f/2 (at 110mm), and the 80mm f/1.9 for the Mamiya 645 is the fastest production lens available for any rollfilm camera. The keen-eyed will have noticed that both 110mm and 80mm are 'long' for their respective formats, which reflects the point already made about coverage and fast lenses for 35mm: it is easier to build a slightly longer-than-standard fast lens for any reflex. Outside the more-or-less standard focal lengths, there is absolutely no hope of any really fast lenses: f/3.5 is regarded as pretty quick by most manufacturers, and the 180mm f/2.8 for the Pentacon Six (it can be adapted to a number of other cameras) represents a rare departure from orthodoxy.

For 5x4, most lenses are in the f/4.5–f/5.6 range, and the only significantly faster standard lenses are the 150mm (6in) f/2.8 Xenotar and Planar; the latter is now discontinued. Even second-hand, both are very expensive, and they are *big*. Nevertheless, an f/2.8 lens used with ISO 1250 Royal-X Pan is the equivalent of FP4 rated at 160 and exposed at f/1, or Tri-X rated at 650 and exposed at f/2.

CONCLUSIONS

With a fast lens, you can do one of two things. Either you can use slower films at a given shutter speed, or you can combine fast lenses and fast film to take pictures in ever-poorer conditions. The attractions of the latter are obvious, but the former cannot be ignored: a first-class fast lens, plus slower film, will almost invariably give better results than a slower lens of equal quality and a faster film (though film is the subject of the next chapter).

As an aside, if you shoot a lot of film, you may find that your fast lens slowly but surely pays for itself. Fast lenses are much more expensive than slow ones, but fast films are also more expensive than slow films; this argument is also pursued further in the next chapter.

On the contra side, the main disadvantage of fast lenses (apart from the price) is that you can have too much of a good thing. Only the very finest ultra-high-speed lenses can match their

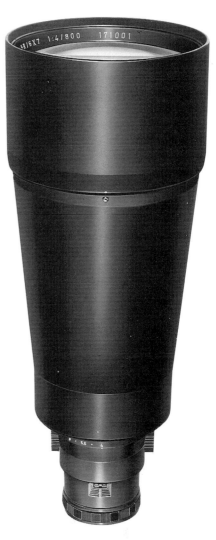

33 Pentax 800mm f/4
The sheer size of this lens is not really apparent until you realise that it is for the Pentax 67. Such speed at this focal length is staggering, but it is a *huge* lens (*Courtesy Asahi Pentax*)

34 Basketball
Very few zooms are fast enough for available-light photography, but a 'standard zoom' can be extremely convenient *if* it is fast enough. This was shot with a 36–82mm Zoomar on a Voigtländer, the first production zoom ever made for a 35mm full-frame camera; something like the Vivitar Series One 35–85mm f/2.8 Varifocal would be even better (*SRA*)

35 Funfair
This is an example of a photograph taken with the 80/1.9 for the Mamiya 645 (page 20). One would normally use 35mm for this sort of photography, but the lenses for the 645 make it a realistic alternative. Even with ISO 64 film (Ektachrome), you can shoot hand-held pictures reliably (*FES: Plymouth: about 1/30 @ f/1.9*)

36 Mountain-bike rider, sunrise
With wide-angles, you can get away with smaller maximum apertures than you would need for longer lenses, though few people would want to go back to the days of the 35mm f/3.5, which is what this was shot on. The quality is excellent, but the lens is just slow (*SRA: Nikon FM: no other technical data available*)

slower counterparts: somewhere, you are going to have to compromise.

In other words, if you *must* have the ultimate in speed, go for 'state of the art' lenses, and be prepared to pay a fortune for them. Alternatively, if you can live without the extra stop (or even half stop) you will almost certainly save a great deal of money and get a better lens into the bargain.

If you use a 35mm camera, which seems logical, the 35mm f/1.4 seems to me to be a near-universal lens for most applications. If you can possibly afford one, or even borrow one, try it; you will see what I mean. Failing that, try a 35mm f/2. They are expensive, but they are worth it.

Of course, if you habitually *need* longer lenses, you will have to look at those, but I suspect that we are looking at very specialised applications here. If I did more theatre photography, I would buy a 75mm f/1.4 because I use Leicas; for reflex users, an 85mm f/1.4 might be more appropriate. A medium-long f/2 is the second choice, which is what I use; it is half the price of the 75mm. Again, sports photography begs for a 180mm or 200mm f/2.8 if you can afford it; I have an old Vivitar Series One 200mm f/3. At 200mm, anything much faster than f/2.8 is likely to land you in very serious difficulties with depth of field: the same is true of still longer lenses with a maximum aperture greater than f/4.

If you favour wider lenses, you will again have problems. Most of the better manufacturers offer a more-than-acceptable 28mm f/2, usually at about two to three times the price of their

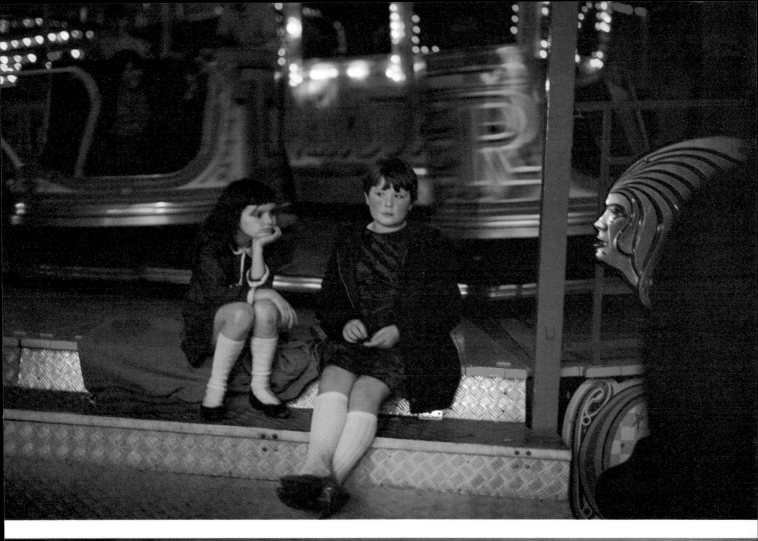
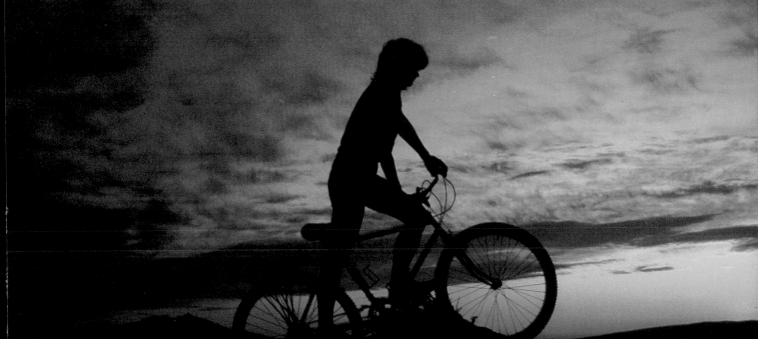

28mm f/2.8, and several offer a 24mm f/2 at about twice the price of their 24mm f/2.8. Canon even manages a 24mm f/1.4, which is reputedly surprisingly good, but which costs about five times as much as the basic 24mm f/2.8. At 20 or 21mm, f/2.8 is probably the realistic limit. Of course, with *really* wide lenses such as 15mm, camera shake is not much of a problem and even f/3.5 is quite fast enough. Look at the prices of these lenses, though!

Devotees of zooms will notice that I have not even mentioned their favourite lenses in this chapter. There is a good reason for this. For a start, I was talking about fast lenses, and most zooms are deadly slow. Secondly, zooms have far too much glass in them to be really contrasty: all those glass–air surfaces are bad news, even with modern lens coating. Finally, they are heavy and hard to hold still. There was once a zoom that I used for available-light photography – the 35mm to 85mm f/2.8 Vivitar Series One varifocal – but even that was right on the edge of acceptability for professional use. Then it was stolen, and I discovered that I must have had a good one: the replacement was unacceptable. Admittedly, I bought the original new, and the replacement second-hand (they were off the market by then), but I couldn't use it professionally. I passed it on to a friend who only ever shot colour prints (where the slight loss of quality was not evident) and she loved it. There are some surprisingly good modern f/2.8 zooms about, at a price, but fixed focal lengths are faster and deliver better image quality: even a cheap second-hand 135mm f/2.8 will usually outperform an expensive zoom, and anything you can name at a shorter focal length is likely to be faster.

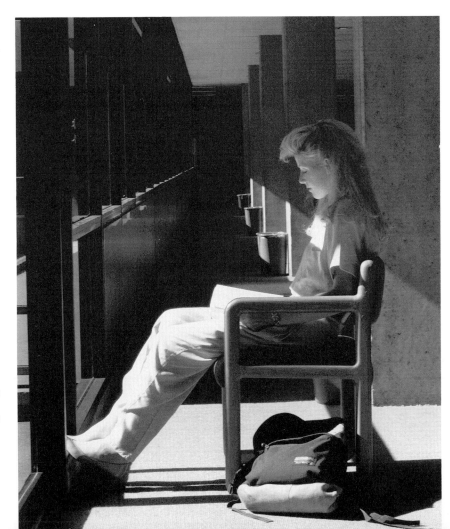

37 Melissa
Melissa Ritter (who appears in several places in this book) was caught studying in the University library by Steve Alley. He photographed her on Ilford XP-1 rated at EI 800 using a Canon A-1 with a standard lens (*SRA*)

4
FILMS: HOW FAST DO YOU WANT TO GO?

Nowadays, fast film may seem to be the quickest and cheapest route for the low-light photographer. It is certainly cheapest in terms of one-time capital outlay. But fast films cost more than slow ones: at the time of writing, with ISO 50–100 films as the baseline, ISO 200 was about 30 per cent more expensive; ISO 400 was 50 per cent more expensive; and ISO 1600 was close to twice the price.

In other words, a faster lens can save you money; there is a film speed/lens speed tradeoff. You can work out the figures for your system and what you pay for your film; what follows was based on the relative prices of Canon lenses.

To get an extra stop, you could use either a one-stop faster lens or a one-stop faster film – in other words, ISO 200 instead of ISO 100, or f/1.3 instead of f/1.8. Unfortunately, there isn't an F/1.3 lens, but f/1.4 is only 1/6 stop slower, which is not significant. Twenty rolls of ISO 100 film at f/1.4 would cover the difference between the prices of the f/1.8 and f/1.4 lenses.

To get two extra stops, you could use ISO 400 at f/2 or ISO 200 at f/1.4. Thirty rolls of ISO 200 at f/1.4 would cover the difference in cost between the two lenses.

To get three extra stops, you would need to buy something like Fuji P-series film with the F/2: that gives you the option of ISO 800–1600–3200. Alternatively, you could use ISO 400 at f/1.4. The slower film would once again pay the difference between the f/1.8 and the f/1.4 in thirty rolls.

If you want four or more extra stops, you will have to buy the faster film anyway, but you can always rate it one stop slower (which gives smaller grain and better maximum density or D_{max}) *or* use the extra lens speed at the same film speed, thereby getting an extra stop over the slower lens. Once you reach ISO 3200, you are going to have to buy a faster lens in any case, because you have run out of film speed.

Your choice of film for low-light photography is, therefore, dependent on a number of things. The main considerations are as follows:

1 Lens speed
2 Light levels
3 Light source
4 Image quality
5 Black and white, colour negative or colour transparency?

LENS SPEED

Modern super-speed films mean that you can get away with very much slower lenses than you used to need, but even so, there are limits. This is rarely a problem with prime lenses in the

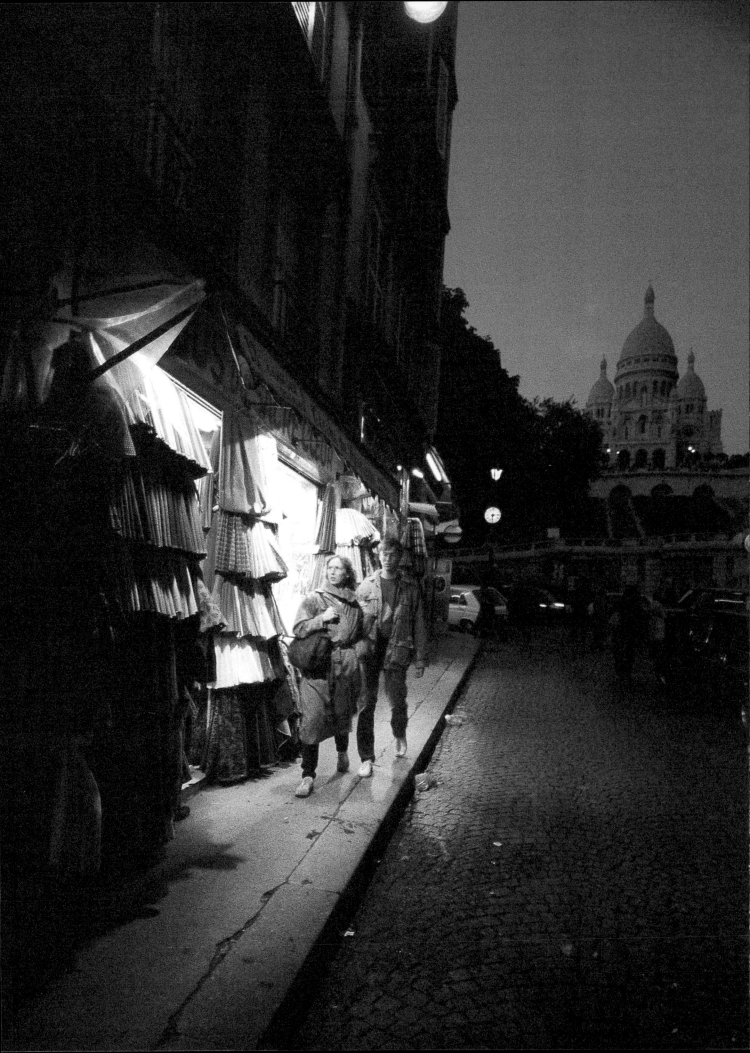

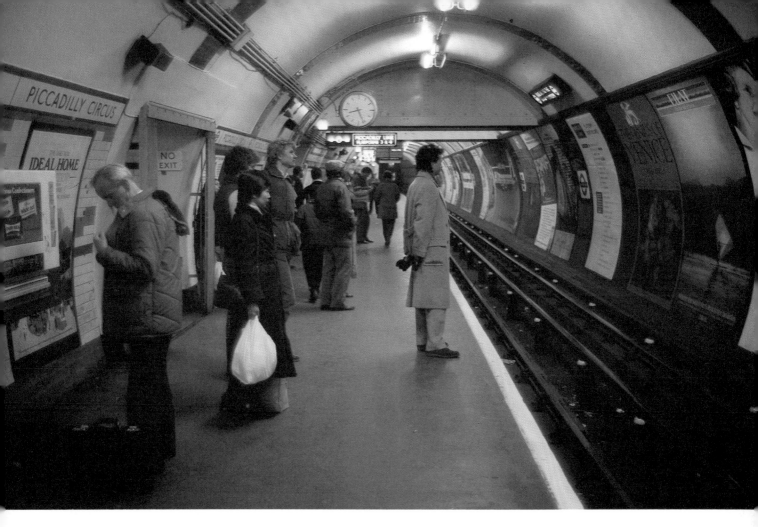

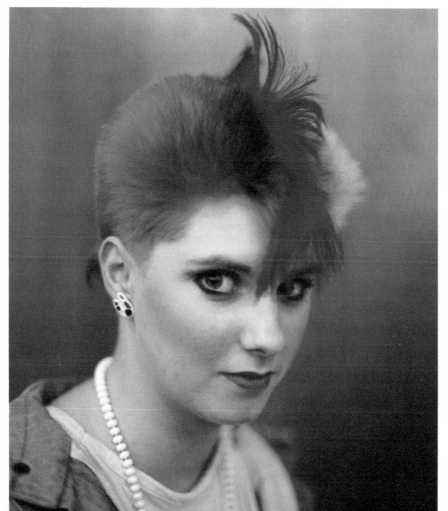

38 Sacré Coeur, Paris
Here, 3M's ISO 640 tungsten-light film shot at dusk has rendered the Sacré Coeur itself as a twilight-blue, while still preserving the warmth of the tungsten lighting outside the shop (*RWH: Leica M: 35/1.4: about 1/60 @ f/2*)

39 London Underground
Photographs like this are an interesting technical exercise, but their real value increases as they get older; they are powerful props for nostalgia. The horrible greenish tint is typical of daylight-balanced colour film exposed under fluorescent lighting: the safest filter to use is a CC30M or an FL-D. Fast films give far less dramatic casts than this, though (*RWH: Leica M: 35/1.4: KR: about 1/60 @ f/2*)

40 Hairstyle
This striking hairstyle was photographed at a show, using available light which was a mixture of tungsten, failing daylight and fluorescent light. The tolerance of ISO 400 colour negative film showed up superbly under these difficult conditions (*FES: Mjamiya 645: 80/1.9: exposure details not available*)

24–135mm range, because f/2.8 is just about fast enough (though you are pushing your luck with a hand-held 135mm f/2.8, even at 1/125), but few zooms meet even this modest requirement. Ideally, you want f/2 or better, as in the following example.

While I was writing this book, my father-in-law and I went to a shopping mall to take photographs. I was using mostly my 35mm f/1.4 Summilux: he was using a zoom with a maximum aperture of f/3.9 (effectively f/4). With ISO 1600 film, he needed to shoot at 1/15 to 1/30 wide open, while I was shooting at a comfortable 1/60–1/125 at f/2.

The other way of looking at it is that with my 35mm f/1.4, used at full bore, I could have used an ISO 200 film where he required ISO 1600, with a corresponding increase in image quality.

There is, however, one area where slower lenses and faster films may be more appropriate. With extreme telephotos, contrast is all-important. This is why Leitz went to the extraordinarily slow f/6.8 (half a stop slower than f/5.6) for their 400mm and 600mm Telyts. These very simple, slow lenses deliver vastly higher contrast than faster designs, but they do call for fast films.

LIGHT LEVELS

If there is next to no light, then you may require ultra-fast films just to get an image at all. On the other hand, if you have the choice, a slower film may be more appropriate. Not only are you likely to get better image quality (see below), but if the light is changing, you do not need to have two camera bodies loaded with different types of colour film. After all, there are times when ISO 1000 or more is an embarrassment, and you need to change films.

To take another personal illustration, I was once shooting Losar (Tibetan New year) ceremonies on the roof of the temple in Dharamsala. They begin before dawn, and continue until the sun is well up in the sky. A couple of hours after dawn, they transfer from the roof of the temple to the murky interior, so you need both fast film (for pre-sunrise shots and interiors) and slow film for the outside shots.

I had three bodies, therefore. One was loaded with 3M's 1000T, for the really low-light shots, but if I had had to use the same film at the end of the ceremony, I would have been running 1/1000 at f/8 or so. The second body was loaded with Koda-chrome 64, which I used from just before sunrise to the end of the ceremony; exposures ran from 1/30 at f/1.2 to 1/250 at f/4. The third contained HP5, at a compromise rating of EI 250 (see below) which I could use all day.

The reason I chose the EI ratings that I did was to allow ease in setting apertures. My meter was set for Kodachrome, ISO 64. For the HP5, I just had to close down a couple of stops (or use a shutter speed two clicks faster), while the 3M material was two stops down again.

In a case where you need a range of film speeds, there is little choice; but if you can compromise on a single, in-between film (perhaps Kodachrome 200) for colour, it obviously makes life easier. Kodachrome 200 wasn't available then, unfortunately, but I would use it now if I possibly could.

ISO, ASA, DIN AND EI

In strict theory, film speeds should now be quoted with both arithmetical numbers (which are the same as the old ASA ratings) and logarithmic numbers (which are the same as the old DIN). As all English-language photographers I have ever met use the arithmetical (ASA system), I have used this throughout. For those who need a conversion table, it is given below. The arithmetical figure is first: a doubling of the arithmetical film speed corresponds to an increase of 3 in the logarithmic film speed.

The difference between EI and ISO is that ISO (International Standards Organisation) is scientifically determined, whereas EI (Exposure Index) is simply a working rating adopted by the photographer.

32/16	320/26
40/17	400/27
50/18	500/28
64/19	650/29
80/20	800/30
100/21	1000/31
125/22	1250/32
160/23	1600/33
200/24	2000/34
250/25	2500/35

41 Downend Photographic Club
Model nights are always popular at photographic clubs, but I wanted to show the photographers, not the model. I rated the HP5 at a conventional enough ISO 650, but developed it for 50 per cent more than the recommended time in Microphen diluted 1+3. The tonal range which the film managed to capture is remarkable. I had to stop down quite a lot for depth of field (*Nikon F: 35mm f/2.8: 1/30 @ f/4*)

LIGHT SOURCE

If you are shooting by artificial light, the additional speed of fast films is obviously welcome. There is, however, another major advantage. Compared with slow films, fast films are very much more tolerant of mixed light sources, and of widely varying colour temperatures.

This is true whether you are using monochrome, colour print or colour transparency. Slow monochrome films (under ISO 125, say) can lose one or two stops in effective speed if exposed by tungsten light. Faster films are unlikely to lose as much as a single stop; half a stop is more common, and with the extended red-sensitivity of many fast films, there is no speed loss at all.

With colour-print films, where tungsten-balance emulsions are rarely available, the improved tolerance of the faster films is obviously welcome. With colour-transparency film, you may have the option of a tungsten-balance emulsion, but if there are mixed light sources (daylight plus artificial light plus fluorescents, for example), something like 3M's 640T is likely to prove a lot more tolerant than Fuji 64T or Kodachrome 40 (which is not readily available in the UK anyway).

IMAGE QUALITY

'Image quality' is a hard thing to quantify. There are certainly occasions when all that is 'worst' in image quality is precisely what is called for: eccentric colours, grain the size of golfballs, and greenish shadows. All these convey a clandestine, reportage, tell-it-like-it-is approach to photography, and the best way to get the

42 Avila Beach
By contrast with the London Underground shot, this picture by Frances Schultz uses the inherently better colour differentiation of a slow film (Kodachrome 64) to accentuate subtle but spectacular colour differences. The only colours Kodachrome does not differentiate well are different shades of green. *(FES: Leica M2: 35/1.4 Summilux: exposure not recorded, but about 1/8 wide open)*

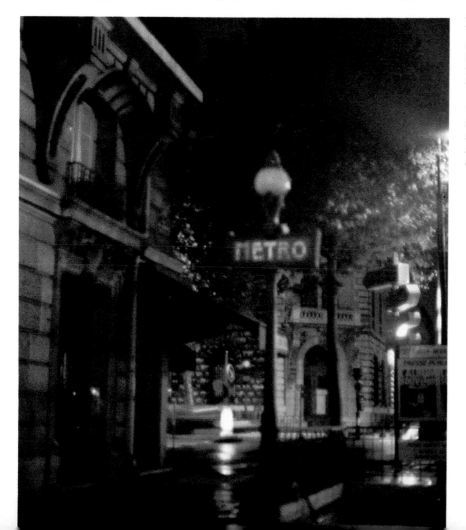

43 Paris
This is another of my soft Parisian shots taken with 3M tungsten-balance film (ISO 640) and the 50mm f/1.2 Canon rangefinder lens. Compare the tones here with those in Plate 44, shot on daylight-balance film, and Plate 45 which was again shot with 640T. The grain of the film, and the softness of the lens, create an impression of considerable depth of field *(RWH: Leica M: 1/60 @ f/1.4)*

effect you want is probably to use fast 3M film and push it one or two stops in processing (see below). With monochrome, push-processing in paper developer may or may not give you much of an increase in speed, but it will most certainly give you plenty of grain.

On the other hand, there are plenty of times when fine grain and believable colours are what you need. In these cases, it is generally best to use slower films, conventionally processed. Of course, 'slower' is a relative term. The very best colour and sharpness unquestionably comes from films like Kodachrome 64 or Fuji 50D, but if these are impractical, you can move on to something like Kodachrome 200 or Fuji 400.

Just to add to the confusion, each film has its own 'signature'. In monochrome it is the size and shape of the grain, in colour print it doesn't matter very much, but in colour transparency, there is graininess *and* colour rendition. The fast films from 3M/Scotch, for example, are very muted and can be used to good effect; but the contrastier, stronger colours of Fuji's ultra-fast materials are equally well suited to other subjects. As a rule, similar films from the same manufacturer show a family resemblance, so that you have the Kodachrome family, the Ektachrome family, the Fuji family, the Agfa family and so forth. Which you prefer is a matter of aesthetic preference, but it is not something which can be ignored.

Choosing Films
Until I started work on this book, I always clung to a principle I was taught when I first started to take photography seriously. It is this: stick to a single film, as far as possible, and use that film almost exclusively. My choices were Kodachrome 64 in colour, and Ilford HP5 in monochrome. This approach means that you can learn *exactly* how a given film will behave under given circumstances, and that you can usually estimate the exposure within 1/3 stop without a meter. I once shot the interior of a *friterie* off the Boulevard St Michel in Paris, 1/30 at f/1.4, and when I checked the exposure I found that I was within 1/3 stop of my Lunasix reading. Given that I had automatically bracketed one full stop either side of my 'guesstimate', this meant that I was virtually guaranteed a good exposure. I shall return to bracketing later in this chapter, and in Chapter 6.

The most notable exponent of the alternative approach – to which I must confess that I now have a sneaking leaning – is Tim Page. He reckons that it is worthwhile to load a whole film just to get a single shot which benefits from the 'signature' of that film. While he has produced a number of stunning pictures this way, I cannot help noticing that the most stunning of them all are usually in the yellow/gold range of the spectrum, which makes me suspect that he could get away almost entirely with Fuji films. But I know he still uses a lot of Kodachrome. Someday I'll ask him.

The astute reader will notice that so far, I have almost completely avoided the question of whether to use monochrome, colour print, or colour transparency film. This was because I wanted to make the other points first; but now, it is time for The Big Question.

BLACK-AND-WHITE

As I started this book, Kodak redefined the low-light ballgame by introducing a new T-max film with a speed range of ISO 800–3200: most ultra-high-speed films are quoted with a range of speeds, rather than a single speed, because a great deal depends on both subject matter and processing. Low-contrast subjects can effectively be given a stop or two less than high-contrast ones, and prolonging development also increases effective film speed. Others followed, as manufacturers woke up to the fact that monochrome is a big market, still growing in real terms.

The fastest conveniently available conventional monochrome films were around ISO 400, though by careful choice of developer (Microphen, for example) you could squeeze out another half stop or so without losing shadow detail. A large question mark had been hanging over the continued availability of Royal-X Pan for some time, but at the time of writing it was still catalogued and available in rollfilm and cut-film only, with a recommended rating of ISO 1250.

For some reason, chromogenic monochrome films have never enjoyed the success that they really deserve in low-light photography. They use colour-film technology to develop a dye-cloud image in much the same way as a colour-negative film, but of course they are much sharper than colour films because they do not have to have three emulsion layers. Their exposure latitude is enormous – Ilford's XP-1 is at its best between EI 400 and EI 1000, and if you are desperate you can rate it at anything from EI 64 to EI 1600 *on the same roll* – and they also permit very high silver-recovery rates. Even so, the speed and exposure latitude proved insufficient bait for photographers brought up on exposure-critical colour-transparency films, and the silver-recovery aspect was mostly of interest to professional laboratories; silver recovery was not economical for most amateurs, and the processing sequence was more expensive and more demanding than traditional processing. At least, it was perceived as such, which is what matters.

Although EI 1600+ may be the wave of the future, it is worth asking yourself how often you really need it. For most people EI 650 with full shadow detail is probably enough. If you own fast lenses (which is likely with most serious photographers who want to use monochrome), this is plenty: if you own a tripod as well, it is overkill for most applications. In fact, I habitually rate HP5 at EI 250 or 320, developed in Perceptol, because of the extraordinary tonal range and gradation which this gives. It is an unusual approach, but it works. For speed, Microphen gives EI 650 with the same film.

For *real* eccentrics, reversal processing of Tri-X and HP5 is possible with speed ratings up to EI 3200 without loss of shadow detail; because it is a reversal process, it also tends to be finer grained than neg/pos printing. This does however require highly specialised processing. Old Ilford manuals supply formulae if you want to try this.

Most people, though, prefer the ease of lab-processed colour films. Here we have a complete turnaround from the situation of

44 Restaurant window-shopping, Paris
As I say in the text, I have great difficulty in deciding whether I prefer tungsten-balance film or daylight-balance film for shooting at night. This is ISO 1000 tungsten film (*FES: Leica M: 35/1.4: 1/30 wide open*)

45 Faro, Portugal
In this picture, the colder effect of tungsten-balance film (640T again) is more effective than daylight-balance would have been. Stopping the f/1.4 Summilux down to f/2 and bracing the camera against a wall for the 1/30 exposure has greatly improved sharpness (*RWH: Leica M*)

53

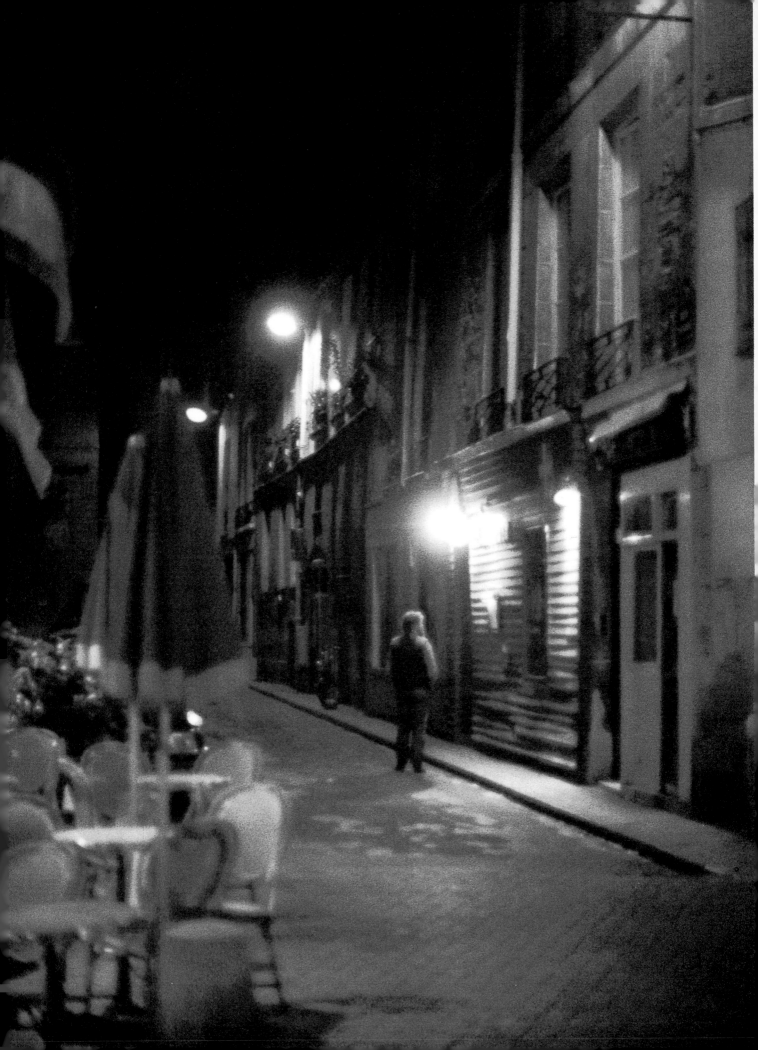

46, 47, 48 Souvenir shop
An inherent difficulty with colour-reversal films is that you have a choice between detail in the highligts or detail in the shadows, as shown here. Only with a print film, where you can hold back some areas and give others extra exposure, can you hope to represent a full tonal range – and when you do, the representation will not bear a 1:1 relationship with subject brightness (*RWH: Nikon F: 50/1.2 Nikkor: Kodak ISO 1000 colour film, printed on Panalure paper*)

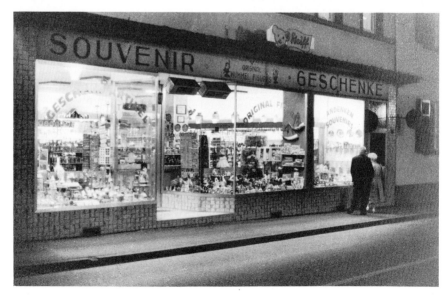

even 1980, when 'speed' meant 'monochrome', and colour was always slower.

COLOUR NEGATIVE

Often derided as a snapshotter's film, colour negative delivers the maximum available speed in currently available emulsions *and* arguably gives the most control.

The reason is simple. Because it is a negative material, it has an inherently greater recording range than a reversal film. If you expose your Fuji ISO 3200 at an EI of (say) 2000, you will have plenty of latitude and you can, if you wish, extract both shadow and highlight information from the film in a way which puts any transparency film to shame. You can even have a black-and-white print made, using panchromatic enlarging paper.

There are, however, three major drawbacks: money, time and lack of ultimate sharpness. There is also the minor one that it is impossible to 'push' a colour-negative film, because every iota of silver in the emulsion is already being developed: in effect, it is already being 'pushed' to the limit. This means that the manufacturer's speed is effectively the maximum, but with an ISO 3200 'bottom line', and the possibility of actually *improving* image quality by overexposing by one or even two stops, this is not really a serious problem.

To have a colour-negative film processed and proofed professionally is alarmingly expensive, typically five times the price of colour-slide processing. Most labs also take three days, instead of two to three hours. Then, you need to examine the

49, 50 Big wheel, Amsterdam
Although using colour-print film with Panalure offers plenty of speed, you have to process the films yourself – many colour-print photo-labs are utter slums – and printing in complete darkness is not convenient. What is more, exposure is *extremely* critical; the difference between these prints is that one was printed at eight seconds and the other at eleven. (*FES: Nikon F: 50/1.2 Nikkor: Kodak ISO 1000 color film, printed on Panalure paper*)

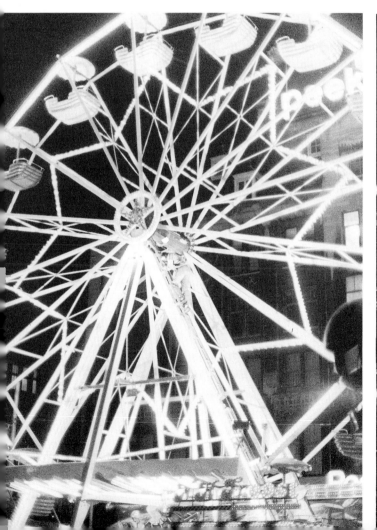
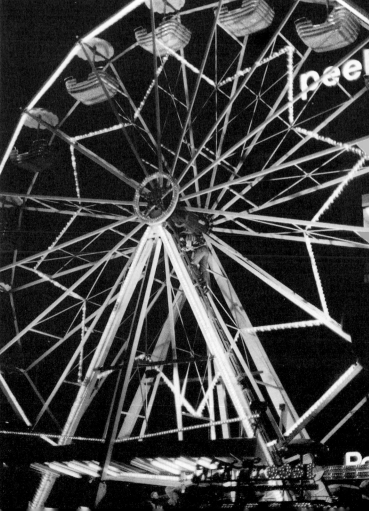

51 Sun and Tree
52 Flowers
Both of these shots were taken using a special-offer film which produces both transparencies and prints. As you can see, they are fairly grainy, but there is a warm, romantic 'colour signature' which is very attractive. Both shots are absolutely 'straight', without any filtration. The main difficulties with these films are first, finding a reliable lab, and second, avoiding scratches (*Both pictures WA Schultz, Canon FT camera; no other details available*)

prints and to specify what sort of hand-prints (or transparencies) you wish to have made: more shadow detail, or more highlight detail. The print or transparency cannot hold both, but you do get the option at this stage of specifying any colour casts that you want introduced or removed. Finally, you need an expensive hand-print (or transparency), and you have lost another three days or so.

These are the time/money objections, but as far as sharpness is concerned, you have two problems for the price of one. To begin with, colour-negative emulsions are typically thicker (and therefore less sharp) than colour-transparency emulsions, and in the second place, a transparency is a first-generation camera original. Even a contact-print from a negative introduces additional opportunities for unsharpness, to say nothing of dust, and if your transparency or print is made optically (as is almost certain to be the case), you have introduced a whole additional optical step which can lose quality.

In sum, then, colour prints are theoretically ideal but their usefulness in practice is severely limited. For ultimate versatility, you may wish to explore this avenue; otherwise, colour transparencies are probably more practical.

COLOUR TRANSPARENCY

The principal disadvantage of colour transparencies is the extremely limited exposure range which the film can handle, at least while maintaining believable colour rendition. In practice, colour-transparency films can record at least as many tonal steps as any negative film, but outside a lighting ratio of about three stops (8:1) or four stops (16:1) at most, the dark colours register as shades of grey and the light colours are so washed out as to be substantially useless.

This means that you have to get colour exposures *right*, which is to a large extent the subject of Chapter 6. On the other hand, you can also 'push' or 'pull' the speed, so if you combine your metering with intelligent bracketing (see below, and the next chapter), you have quite a choice. Most films using Ektachrome-compatible processes (E-6 at the time of writing) can be 'pushed' half a stop or even a stop without significant quality loss, and can go to two or even three stops with steadily deteriorating quality. They can also be 'pulled' or reduced in speed: an ISO 100 film accidentally exposed at EI 50 will still give acceptable quality if correctly processed.

This means that an ISO 100 film can be rated at EI 80 to EI 150 or even EI 200, while an ISO 800 film can be rated between EI 500 and EI 3200, retaining acceptable quality the whole while. If you are desperate, the limits become EI 50 to EI 400 and EI 400–6400 while still retaining a recognisable image. Pushing non-Ektachrome-compatible films is a whole lot more difficult, though the old Agfa process had its own rules and some non-Kodak labs will 'push' Kodachrome as requested. The Great Yellow Father does offer (at some cost, and in the United States only) a one-and-one-third stop push to save Kodachrome 25 which has been exposed as Kodachrome 64. Of course, this also translates into EI

160 for Kodachrome 64 and EI 500 for Kodachrome 200, to say nothing of EI 100 for ISO 40 tungsten-balance Kodachrome . . .

One drawback to film-speed adjustment, though, is that some labs charge handsomely for it. Others charge the same, but offer a 24-hour service instead of two hours, while still others do it in the same time for the same price. A lot depends here on your lab – the only thing to do is to get their price list.

As an aside, the question of colour balance should be one which is familiar to anyone who is interested in available-light photography, and it is *always* better to use a film of the correct colour balance (tungsten or daylight) with the appropriate lighting then to use a filter. Something which is not so well known, though, is that fast colour-transparency films are more tolerant of 'off-colour' lighting than slower ones, because the sensitivity peaks of the three emulsion layers are closer together than they are on slower films. For this reason, there are many occasions when a fast film (ISO 400 and above) will give better colour than a slow one, even if you could get by with a slower film. If you need filtration, and you haven't got the right filters, always err on the side of 'warmth' rather than blueness whenever possible; most people prefer it that way. Ideally, get a colour temperature meter; otherwise, use your head.

To return to EI modification, the inevitable problem is that if taken to excess it results in inferior image quality. With 'pulling', the usual result is a loss of contrast and a flattening of the colours; with 'pushing', the most obvious problem is a greatly diminished maximum density, so that shadows grow thin and greenish. Contrast often builds, too.

Fig 2 Colour temperature
Colour temperature can be expressed as the temperature to which a 'black body' would have to be raised to radiate light of a particular colour. Rather confusingly, lower temperatures are 'warmer' colours, and higher temperatures mean a light that is more blue (A/w by FES)

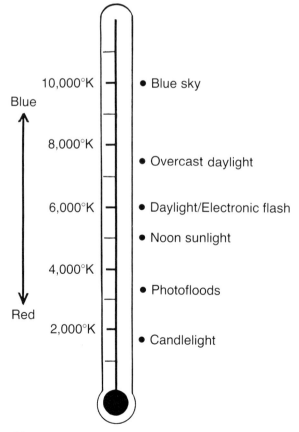

The two great advantages of transparency films, though, are equally inescapable. First, it is still the preferred medium for photomechanical reproduction, though this is as much a matter of tradition as of the real world. In more than one of my books, the printers have reproduced superbly from prints, instead of from transparencies – although, of course, the use of a 'camera original' (a transparency) means that they have saved a whole stage in the reproduction process. To some extent, also, it is easier to deal with a 6x9in (150x225mm) print on the scanner than it is to deal with a 24x36mm (about 1x1.5in) original. Second, the 'palette' of colour reversal films available means that you can select the colour rendition which suits you (or the colour renditions, if you prefer to try the Page approach), and bracketing means that you can obtain a range of subtly different pictures in the camera, merely by varying exposure.

Now, bracketing is something which many people look down upon with scorn. A truly skilled photographer, they argue, could get the exposure right first time: bracketing is merely a confession of incompetence. They have a point, but it is not a very good one.

This is because there is no such thing as a 'correct' exposure. There is only a 'most pleasing' exposure. Oh, there may be ISO standards governing the question, but we have all seen or taken pictures where a slightly lighter-than-usual transparency, produced by what might theoretically be called 'over-exposure', is better than a 'correct' exposure; and, of course, there are times when a darker-than-usual picture is again more appropriate than a 'correct' one. Also, it is a truism that the best transparencies for

53 Colour-temperature meter
The only easy way to judge colour temperatures is with a colour temperature meter. These are frighteningly expensive new, but you can sometimes find used ones at a reasonable price. The readout is in degrees Kelvin; corrections are effected with red and blue filters, as shown on the scale, and not with red and magenta as shown here! (*RWH*)

61

54 IRA

Most colour pictures can be
converted into monochrome. This is
the second such conversion in this
book (the other is on page 15). The
results are not always satisfacory,
though; colour-print film is a much
better bet if you want both
monochrome and colour. For British
readers, an 'IRA' is an Individual
Retirement Account! (*RWH: Leica M:
35/1.4: 3M 640T*)

reproduction are usually 1/3 stop darker than the best transpar-
encies for projection, which somewhat begs the question of
'correctness'.

In all fairness, a truly brilliant photographer would know his
film and his equipment so well that he or she could accurately
predict which transparency would look the best – but this
brilliance would, in this case, have to amount to genius. Even
Ansel Adams used to bracket his shots for insurance, and if it was
good enough for him, it is certainly good enough for me. Often,
you may be surprised at which transparencies look best: films do
not always record colour in the way you may imagine, so
bracketing is an excellent idea.

CONCLUSIONS

In both colour and monochrome, the single-film approach to
photography cannot be used if you do much low-light photo-
graphy: there are inevitably going to be occasions when you need
fast films. But unless you do need those fast films, you will usually
do better to stick with the slowest film you can get away with; that
is, the slowest film which will not lead to camera shake or subject
movement.

In colour, this may well be as slow as ISO 64, and anything
faster than ISO 200 should rarely be necessary. If you do have to
go much faster, consider going straight to ISO 1000 or faster, for
big grain and reportage-style immediacy. If you want to try Tim
Page's 'palette' approach, remember that processing and printing

variations in colour-negative films will far outweigh 'signature' variations, which are really only significant in slide films.

Whatever film you use, always get it processed at a professional lab for best results. Contrary to popular belief, 'pro' labs will *not* refuse to deal with amateurs: the only reason that some are wary is because they have had bad experiences with amateurs who complain that they are too expensive (in fact, they are often *cheaper* for colour slides) or who refuse to admit liability for their own mistakes in exposure, and so on. Look at it this way: professional labs exist to service demanding professional clients, and if they habitually got it wrong, they would not be in business for long. Processing colour slides or film yourself saves very little money and is unlikely to give you the quality which a pro lab takes for granted, though you may wish to do your own colour printing.

In monochrome, unquestionably the most versatile film is Ilford XP-1, rated at about EI 500. It is sharp and incredibly fine grained, and if you need more speed, you just open up. If you find processing a problem, though, you might care to try HP5 rated at EI 320, as described above: the loss of quality compared with a medium-speed film is very slight, exposure latitude is greater, and (like XP-1) it is far more versatile than a slower film. When you need *real* speed, you can still use XP-1 (up to 1600), or switch to one of the new generation of high-speed films for EI 1600 to 3200. I assume you will process your own black-and-white: the cost of custom monochrome work does not bear thinking about.

55 Near Monte Carlo
Finally, an argument for using a film you know. I knew that Kodachrome would record this heavy, thundery light in a really threatening way if I underexposed slightly. With other films, I would not have been able to predict the result with such confidence. (*RWH*)

56 Melissa
A frequent problem with available-light portraits is a high contrast range. Melissa's arm is illuminated by hazy sunlight coming through a window, but her face is more than three stops darker, which certainly qualifies as 'low light'. The extraordinary flexibility of Ilford's XP-1 allowed detail to be retained in both, though duringj printing the arm required *ten times* the exposure of the face. This is of course a close-up of the same scene as Plate 37 (*SRA*)

63

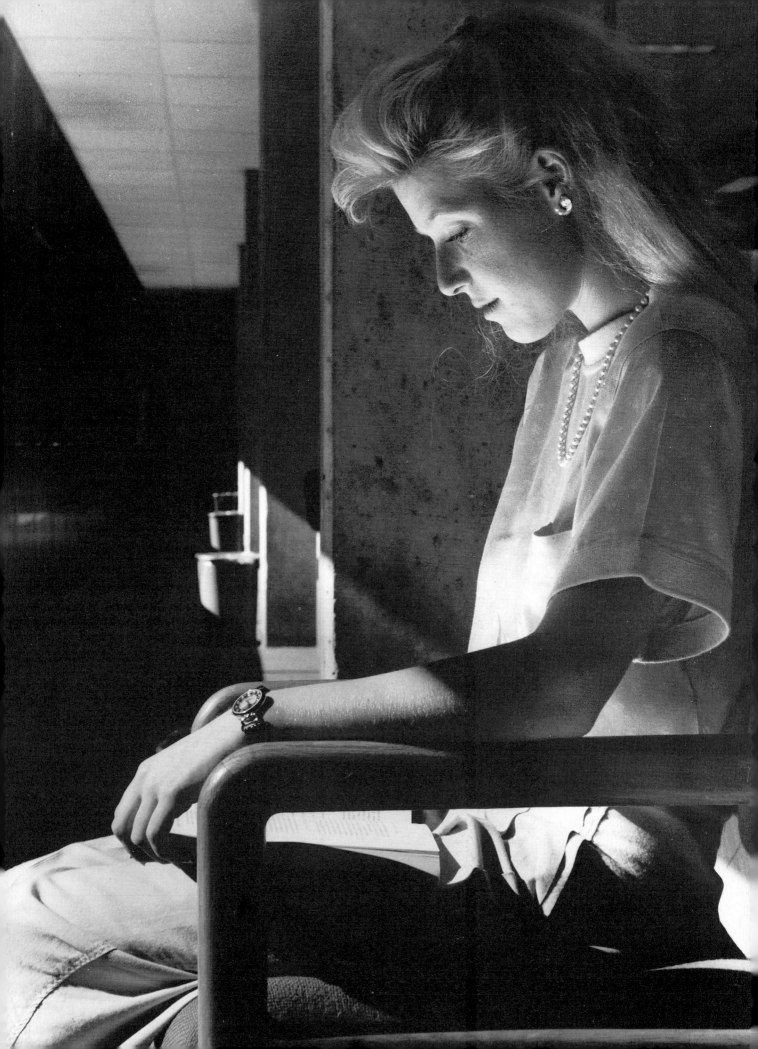

5
LONG SHUTTER SPEEDS – AND CAMERA SUPPORTS

It may seem strange to have left the cheapest weapon in the available-light photographer's armoury until last, after cameras, lenses and film. After all, any old camera with a 'B' setting can be used to get low-light pictures, simply by leaving the shutter open for long enough. Try it yourself, with an old Box Brownie: the lens is about f/14, but you will get an image in two or three minutes even with ISO 200 film.

There are, however, two good reasons for leaving long shutter speeds until so late in the book. One is blur: blur resulting from camera shake, or blur resulting from subject movement. You can get around the former by using a good camera support, but there is nothing you can do about the latter. The second is reciprocity failure. There is also the minor, but not insignificant, question of how you can reliably obtain *really* long shutter speeds.

CAMERA SHAKE

The rule of thumb which governs the longest hand-held shutter speed that you should use with a given lens is usually expressed

57 Girl at Great Western Beer Festival
Subject movement is always a problem with long shutter speeds, but if you can catch someone standing or sitting realy still in the midst of movement, it can be very effective. Here, the isolation is enhanced by shallow depth of field; the 50mm f/1.4 Nikkor on my Nikon F was wide open for the 1/30-second exposure (*RWH: HP5 rated at EI 320*)

as 'one over focal length'. This is not immediately clear, but it is easy to remember: with a 50mm lens, the longest speed you should hand-hold is one-over-50, or 1/50 second; with a 200mm lens, it is 1/200.

There are, however, major exceptions or qualifications to the general rule.

First, the general rule applies only to 35mm cameras. With larger formats, you can afford longer times, and if there are any devotees of half-frames or sub-miniature cameras among my readers, they will need to work to tighter standards.

Second, a very great deal depends on the design of the camera itself, as already pointed out in Chapter 2.

Third, there are considerable variations in individual photographers' abilities to hold a camera still. This will vary with the way they grasp it; with their own shakiness, or lack of it (which will be affected by exercise and mental state); and with their skill at pressing the shutter release.

To begin with the times for non-35mm formats. The reason that you can get away with longer hand-held exposure times on larger formats is that any camera shake on the negative is magnified less in the final print. Suppose, for the sake of argument, that during the exposure the image moves 1/250in (0.1mm) relative to the film. If you enlarge a 35mm image to 10x8in this means an 8x enlargement on the print and about 1/30in (0.8mm) blur on the final image – more than enough to look really fuzzy. If you enlarge a 5x4in image to 10x8in, on the other hand, the magnification is only 2x and blur on the final

58 Dawn, Atascadero
This is the only picture in this book shot on Kodachrome 200, which was fairly new as I was writing. With a tripod-mounted shot such as this, faster films are not normally necessary; but with fast-changing dawn light and a relatively slow lens (300mm f/4.5 Nikkor), the extra reserve of speed is useful. Furthermore, the faster Kodachrome delivers the same colour quality as other Kodachromes, but more subtly (*SRA*)

59 Sunset
With really long lenses – this was shot with a 300mm – some form of camera support is essential in all but the best light. Even a sunset requries surprisingly long exposures as the sun finally slips behind the hills: I used a tripod, stabilised as shown in Plate 62 (*RWH: Pentax SV: no exposure details*)

image is 1/125in or 0.2mm. This would be barely detectable on a fine print, and quite undetectable in newspaper reproduction, which is how the old press-men regularly used to get away with 1/15, 1/10 and even 1/5 second exposures with their 5x4in Speed Graphics.

Admittedly, this advantage in magnification is offset to a certain extent by the longer focal lengths found in larger cameras, but the net balance (based on experience alone) is that you can hand-hold exposures which are between three and five times as long as you would dare with 35mm.

With formats smaller than 35mm, the corresponding disadvantages in magnification are offset by corresponding advantages in focal length. Even so, it would be a rash man who reckoned that he could reliably hold a sub-miniature Minox at 1/15 second (it has a 15mm lens) in the same way that he could hold a Nikon with a 50mm lens at 1/60. For most people, 1/30 is the safe limit, even with a good grip and both elbows braced on a table.

Some people like to wind the strap of a 35mm camera around their wrists or elbows, as well as (or instead of) around their necks. Others find that tensioning the strap causes more camera shake than it saves. Experiment to see which is best for you.

Twin-lens reflexes are another matter; they are far more easily held with the aid of a neckstrap. Braced against either the upper stomach (especially suitable for the stouter male photographer, such as myself) or the bosom (for lady photographers, especially the more Junoesque ones) they can deliver sharp results reliably at 1/15 and with a fair degree of confidence at 1/5 second.

There are also various kinds of accessory grips. The Pentax 6x7cm has an add-on side-grip, and a number of cuboid cameras (such as the Mamiya 645 and the Rollei SL2000 and its derivatives) also benefit from such accessories. Linhofs make a beautiful side-handle, which costs as much as some whole cameras. The only real problem with all these grips, which normally stabilise the camera very well, is that it is often distinctly awkward to carry the camera with the grip attached.

The ultimate accessory grip, albeit one designed primarily

60 Inverness
In the winter, it is always a good idea to use fast film; in the north of Scotland, or in northern Canada or Alaska, you may be faced with 'low-light' conditions for sixteen hours a day, or more, and you cannot carry a tripod everywhere (*RHW: Leica M: no lens information: Kodak ISO 1000 colour-print film printed on Panalure paper*)

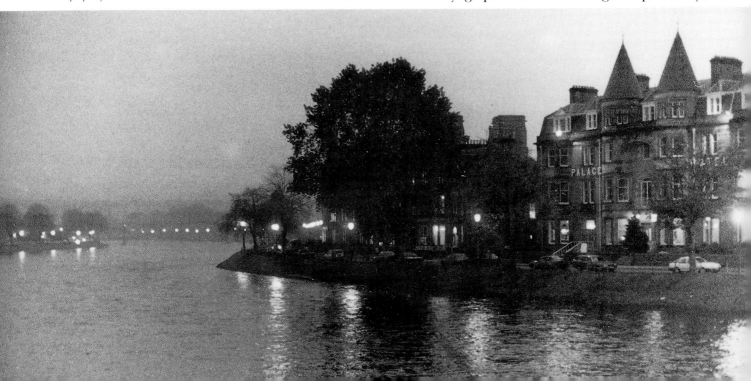

for long lenses, is probably the rifle-stock. It has been made in all kinds of shapes and sizes from the original pre-war polished-wood Leica variety to the more modern and sketchier 'sten-gun' types. Some of these are very much better than others – the Novoflex unit is pretty good, for example – but I have never met anyone who would seriously contradict my own experience that they are all somewhat overrated unless you can use them in the classic Bisley prone position.

Furthermore, you need to exercise caution in where you use them. As early as the 1930s, the SS were inclined to shoot first and check exactly what you were doing afterwards, and the Leitz catalogue warned that 'restrictions' applied to the use of these lenses: in fact, they were effectively banned in Germany. In our own terrorism-ridden days they are inviting trouble. At least one photographer has painted his long lenses fluorescent orange to make himself conspicuous, reasoning that no true terrorist would do so.

CAMERA SUPPORTS

Like many professional photographers, I am something of a tripod addict. My wife and I between us actually own six tripods: a massive Vinten cine tripod which will take an 11x14in camera, a Kodak Compact Stand which can handle 10x8in, a Benbo, a Gitzo and an M.P.P. which will all handle 5x4in, and a Leitz table-top tripod which could also handle 5x4in at a pinch. What is more, if I could afford it, I would buy a Sachtler for its super-light weight and extreme rigidity, but these cost the same as a

61 Monopod
The only way I have ever been able to get a monopod to work is by wedging it against a fence or wall, like this. I use either a ball-and-socket head, left slacked off as already described, or the even more compact Linhof levelling head illustrated here; this allows me about 20–30° of tilt and free rotation, or it can of course be locked. The flecks in the background are rain – I sometimes suffer for my readers!

62 Weighting the tripod
This Gitzo does not really need
weighting, but hanging your camera
bag from a shaky tripod will often
make it much more stable. The only
exception is in *very* windy weather,
where a swinging bag can make
matters worse even after the wind
has died down (*RWH*)

middle-range Nikon: lightness *and* stability cost serious money!

The Benbo is incredibly versatile and its 'reversed legs' can be used in water 18in (50cm) deep without worrying about leakage. Its only drawbacks are weight and bulk, which means that I normally go travelling with the Gitzo. Also, in the studio, the Kodak stand is more convenient than the 'drunken octopus' design of the Benbo. The Vinten is just for big cameras (10x8in and 11x14in, hardly available-light equipment), the Leitz table-top 'pod has its own special uses to which I shall return in a minute, and the M.P.P. was bought largely out of sentiment because I like Alan Dell's products. It is however sometimes useful when I have to walk any distance, because it is very light indeed, and it also comes into its own on the beach because the wooden legs are not prone to corrosion in the same way that alloy ones are.

What is noteworthy about all these tripods is that they are of 'professional' quality. Lightweight amateur tripods are simply not worth buying. The very best of them – makes like Cullman or Groschupp – are of professional standard, but most are not. Even if they are adequately rigid at first, they soon develop slop and wear, and the locking devices cease to lock. Sheer mass is the cheapest way to get strength, and a good, old, heavy second-hand tripod is almost invariably a much better buy than a new one for the same price.

To top your tripod, you also need a really good, solid head. Pan-and-tilt heads are all very well, but they are very bulky and (perhaps surprisingly) they are *less* rigid than a good ball-and-

63 Using a tripod against a window
No-one has ever taken exception to my Leitz table-top tripod, even where tripods are theoretically banned. One way of using it is to lean it against a (clean) window, like this – though it looks a bit odd, as if it is floating in mid-air, in this photograph!

socket (B+S) head. Small B+S heads are very flimsy, but Kennet's standard model with the 1.5in ball will hold any camera up to 4x5in. Buy the model with the platform top and the rotating base, for a bit of extra versatility. As it stands, my Leitz tripod is topped by a medium-size (1in ball) Cullman head, though when I find a Leitz large ball-and-socket head secondhand at the right price, I shall buy one.

Nothing less than a 1in (25mm) ball is usually worth having, and 1.5in (38mm) is the smallest I would normally consider, but the Leitz *kugelgelenk* is an exception. Small or cheap balls tend to wear out (or to become sticky and rough, which is the same thing) rather quickly. The Kennet head is an absolute bargain, at about the same price as four rolls of process-paid Kodachrome in its native England, but other excellent alternatives come from Linhof and Arca-Swiss.

You can usually afford to use flimsier tripods for heavy cameras than you can for small, light 35mm cameras. This is because the sheer mass of a big camera gives it the inertia to resist vibration, and the weight pressing down on the tripod tends to stabilise the whole shooting match. Also, there is an old professional trick for stabilising tripods which is still unknown to surprisingly many people. It is to hang your camera bag under the tripod head, to increase the weight. Some photographers even carry a string shopping-bag, and fill it with rocks when they get to their location, for just the same purpose.

Although tripods will almost invariably improve technical

71

image quality, there are three things which tell against them. One is that they are inconvenient; the second is that they are actually banned in some places; and the third is that there are occasions when you can actually get better quality – pictorially, if not technically – by not using a tripod.

You have to decide for yourself where to strike the balance. If there is not much in it – if the light is fair, and you do not think that camera shake will be a problem – you may decide to live without the tripod, even though you know it might result in a better picture. If you know in your heart that you really need a tripod, then use it.

Even where tripods are banned, you may be able to circumvent the rules. For example, tripods are not permitted in New York's World Trade Center, but you can get around this by using the Leitz table-top 'pod or something similar. This can be used in at least three ways: as a conventional tripod, as a shoulder support, or pressed against plate-glass (with the area in front carefully cleaned first). No-one has yet objected when I have used a table-top tripod in an area where full-size tripods are banned.

There are other places where they may or may not be formally banned, but where you would find yourself unpopular in pretty short order if you did try using a full-size tripod. An example of this is Disneyland. Once again, you can use a table-top tripod, or you can use a bean-bag (see below).

Yet again, there are places where a tripod would simply be too unwieldy and inconvenient to use, for example if you are shooting a rock band from the stage, or in many forms of reportage. In these cases, a steady hand is your only real hope.

Finally, there are occasions where you need to be able to move quickly and easily, and in this case, a tripod is simply an embarrassment. You may or may not be able to use a bean-bag, but if you *know* you are missing pictures because you are hauling a tripod around, ditch the tripod.

OTHER CAMERA SUPPORTS

I have already mentioned bolt-on accessory camera supports such as handles on page 68, and I believe that those bolt-on goodies, plus tripods, plus bean-bags should serve anyone well enough. A bean-bag can literally be a cloth bag filled with dried beans, though this may get you in trouble if you cross some national borders – or even state ones in the US – because of possible parasites in the beans. A heavy rolled-up scarf, a bag full of polystyrene noodles (the sort used in 'bean-bag' seats), or even a pair of gloves can act as a 'bean bag', the purpose of which is to provide a non-scratching, damped buffer between a wall, table, theatre balcony or other surface on which you can rest your camera.

I have owned a number of other camera supports, and quite honestly I would not give them house room (indeed, I no longer do). The only exception – possibly – is a monopod, and the only way I have ever found of making a monopod really steady was to jam it with my knee against a wall, fence, or other solid object. Otherwise, the side-to-side sway is just as destructive of sharpness as up-and-down shake. I use a ball-and-socket head or a Linhof

64 'Shoulder-pod'
Another way to use a table-top tripod is like this, as a miniature gun-stock. If you can, lean against a wall for support and shoot after *exhaling*: trying to hold your breath while your lungs are full is a short-cut to the shakes

65 Books
All sorts of other camera supports can be improvised, and with a waist-level finder a stack of books can often add useful height to an inconveniently low table (*Courtesy David Whyte/ Colin Glanfield*)

66 Child and fountain
Although a tripod might have secured a sharper shot – I had positioned myself by the fountain, and was waiting for passers-by – I suspect that a tripod would not have been in *precisely* the right place, and besides, the little girl might well have stayed away if she had seen anything so unfamiliar and formal (*RWH: Leica M: 35/1.4: 3m 640T: about 1/30 @ f/2*)

levelling head, with the screw fully slackened off to allow free movement, on top of my Kennet monopod. One advantage of monopods is that they make good alpenstocks when you are climbing and they are quite useful as quarter-staffs if you are attacked, but you need a big one like the Kennet if you intend to give it that sort of punishment.

Ground-spikes, designed to be pushed into the earth, never seem to give a very secure base. Tree-spikes, which are designed to be hammered or screwed into trees or other wood, are extremely anti-social and can be hard to extract.

G-clamps are arguably OK for fences and other out-of-doors applications, but they chew up furniture royally. Suction-cups rarely suck hard enough, and I don't want to risk my expensive camera being smashed when they jump off the glass or plastic. Magnetic clamps can magnetise steel parts in cameras, which doesn't sound like a very good idea, and they might possibly affect the operation of auto-diaphragms if you were unlucky. Besides, they scratch the paintwork on cars, which are usually the only metal surfaces large enough to hold them. Car-window clamps vibrate if the motor is running, rock if the people in the car move (or if anyone is leaning on the car), and provide an incredibly limited viewpoint: they are really only any use with long lenses and a Land-Rover on safari.

Finally, my own prize for eccentricity goes to a sort of belt which could be cinched tight around almost anything – trees, fence-posts, and so forth – and which bore a ball-and-socket head which was supposed to be pulled hard against the support and which would stop your camera falling about. Well, the camera didn't fall off, but it would not stay in one place either.

The question of camera supports automatically brings up the issue of cable releases, and there are two schools of thought on the use of these. One holds that you should always use a cable release when you use a tripod or similar support, as this ensures that no body tremors are transmitted to the camera. The other maintains that it is better to wrap your hands around the camera and to fire the release in the usual way, as the additional mass provides increased stability.

I use both methods, depending on the camera, the lens, and the length of the exposure. With cameras where I can wrap my hands around comfortably, especially 35mm cameras with lenses up to 90mm or so, and exposures up to one second, I use the wrap-around method. With longer lenses, longer exposures, or cameras which are not so easy to hold, I use a cable release. Years of experience have convinced me that this is the best compromise; I don't get camera shake from either approach.

If you do use a cable release, it is well worth getting a reasonably long, good-quality one with a lock. Cheap cable releases break and kink, but good ones last half-way to forever: I still have one which I bought twenty years ago, and the only maintenance it gets is a squirt of WD-40 or similar lubricant every half-decade or so. This only works with cloth-covered releases, and they smell a bit strong for a day or two afterwards, but it keeps them in working order! Screw locks are perfectly adequate, and a lot less tiring than holding the shutter open when you want

74

an exposure of more than ten or fifteen seconds, but I must confess to a weakness for the Nikon lock, which is much quicker to set and to release. As for length, anything between 10in and 20in (25cm and 50cm) is fine; anything shorter can pull the camera when you fire it, or especially when you tighten the locking screw, and anything much longer is inclined to be inconveniently long.

SUBJECT MOVEMENT AND PANNING

All good photography books before about 1960 used to publish wondrous lists of action-stopping shutter speeds for different moving objects, according to whether they were moving at right angles to your line of vision, diagonally, or coming straight towards you. Some authors used to publish, apparently seriously, the correct action-stopping shutter speed for a steam locomotive coming straight towards you at 60mph. For my part, I would be more concerned with getting out of the way.

In any case, subject movement is not always undesirable. Properly used, it can convey speed, or simply movement, or it can add a surreal dimension as some parts of the image are sharp while others are blurred. Admittedly, there are many other occasions when a totally frozen image has a certain fascination, so for the sake of auld lang syne, there is an action-stopping list in the panel. Generally, though, 'overkill' is easier: use the shortest possible shutter speeds when you want to freeze motion (whether pedestrian or locomotive), and bracket a series of fairly long exposures when you want to convey movement.

If you try photographing a runner, you will begin to appreciate just how complex movement can be. While a speed of 1/60–1/125 will 'freeze' the body at a distance of ten or fifteen feet, the hands and legs will still show some blur; so may the head. You may need to go as high as 1/250 or 1/500 to freeze all movement if the camera is mounted on a tripod.

If you pan the camera, on the other hand, you can show movement against the background at speeds as high as 1/30 or 1/60, or you can become more and more impressionistic as the speeds get longer: the runner's face should still be recognisable at 1/15–1/8, while the figure can still be read as a runner at 1/8 or even 1/4. Plenty of experiment, preferably with cheap film, is the only way to learn here: one of my favourite panned shots was taken at Le Mans, with a car travelling at about 100–120mph and a shutter speed of something like an eighth or a quarter of a second!

ACTION-STOPPING SHUTTER SPEEDS

All speeds are for movement at right angles to the line of sight. For diagonal movement, you can afford one stop longer; for movement straight towards or away from the camera, you can go two stops longer. Thus (for example) a car which would require 1/1000 when traversing your field of view can be given 1/250 if it is coming straight towards you.

Also, all these speeds hold good at about 10m (30ft). For closer subjects (say 3m/10ft) go one step *faster*, and for more distant subjects (say 20m/60ft) you can afford one step slower.

Animals grazing and walking	1/60
running	1/125
racing (horses, dogs)	1/100
People standing still or walking slowly	1/60–1/125
walking quickly	1/125–1/250
working	1/250
Flowers in slight wind	1/125
in strong wind	1/250
Vehicles at 20mph/30kph	1/250
30mph/50kph	1/500
60mph/100kph	1/1000
120mph/190kph	1/2000
Sports & Athletics	1/500–1/2000
Waterfalls	1/250
Waves	1/500

As an aside on panning, if you don't know already, you follow through by swivelling around the hips; this gives the smoothest swing, as any golfer will tell you. Don't try to swivel your shoulders only, as this only allows a very restricted movement, and don't move your legs because this is likely to cause unsteadiness and camera shake. Also, continue the pan *after* you have passed the shutter; for some extraordinary reason, some people 'freeze' when they press the shutter release, which completely negates the point of panning. Alternatively, use the pan head on a tripod.

If you use a tripod and *don't* pan, matters are rather different. Even a walker can show some movement at 1/30, and a runner will record simply as a streak. This is when you need those 'action-stopping' shutter speeds. On the other hand, long exposures (1/4 second and more – up to about 4 seconds) can result in the most intriguing surrealist blurs, as shown in Plate 154.

RECIPROCITY FAILURE

67 Rinchen Khando-la
If you want a careful, considered sort of picture you really have to use a tripod. This is especially true if you are using an ultra-wide-angle lens (this is a 35mm f/3.5 on a Mamiya 645), because it gives you a chance to make sure that the camera is level, thus avoiding crazily tilted verticals. Rinchen Khando-la is the Dalai Lama's sister-in-law; this is the drawing-room of one of the three suites she and her husband rent at Kashmir Cottage in Dharamsala (*RWH: ER: exposure details forgotten, but probably 1/15 @ f/5.6 or so*)

As a matter of course, we assume a linear relationship between aperture and exposure time: 1/30 at f/2 is the same as 1/60 at f/1.4 or 1/15 at f/2.8.

The problem is that this linear relationship only holds good across a certain range of exposure times, and that variations from linearity are different for almost every film.

Most films are optimised for exposure in the 1/10 second–1/1000 second range, and the linear relationship will hold good anywhere in this range. At very long or very short exposures, however, the film will normally require extra exposure.

In available-light photography, we are unlikely to be concerned with what happens at exposures of less than 1/1000 second, unless of course we use flash (see the next chapter). It is however worth mentioning in passing that if you have fast film in your camera, and if you use the ultra-high maximum speeds available on some models because you are using that film in bright sunlight, shutter speeds of 1/2000 may well require 1/3 stop extra exposure and 1/4000 may require an extra half stop.

It is at the other end of the scale that you are likely to run into problems. With some films, shutter speeds of one full second may require no extra exposure; with others, a third to half a stop may be desirable. At 10 seconds, most films will lose one or two stops of sensitivity, and at 100 seconds they may be as much as three or four stops down. This really gets interesting if you are already working at maximum aperture, as might be the case (for example) with a telephoto shot at night. Eight seconds at f/4 might call for an extra stop of exposure, and increasing the exposure to 16 seconds would merely compound the reciprocity problems. What you would *not* do is to correct again for 16 seconds, because that might call for two more stops, giving you 64 seconds, and so forth in an infinite series. In practice, intelligent guesswork would be enough, coupled with bracketing: you might try something like 10 seconds, 20 seconds and 40 seconds.

To make life still more interesting, colour films are subject to colour shifts at very long and very short exposures. Once again, these vary considerably according to the make of film and the exposure time, but they are normally expressed by the film manufacturers in terms of CC (colour correction) filter values. At 1 second, a CC05R (very weak red) might be recommended for one film; at 100 seconds, another film might call for CC30G (quite a strong green).

Film technology is changing so fast that in any case any set of figures for a range of films would almost certainly be out of date before the book is published. *Typically*, the following advice holds good:

1 second 0–1/2 stop extra exposure; little or no colour correction – typically CC05 or at most CC10 filter. Filter colour will vary according to film, but is generally not worth bothering with anyway. I give one extra bracket, so an indicated 1 second exposure would get 1/2 sec, 1 sec, 2 sec, 4 sec.

10 seconds 1 stop extra exposure; colour correction starts to

become significant at CC10–CC20. I still don't bother with filtration, but I bracket on the side of extra exposure. If the meter reads (say) 8 seconds, I might give 6–12–25 seconds and one minute.

100 seconds Time to consult the manufacturers. As much as 3–4 stops extra exposure, plus colour shifts of at least CC20. In fact, I *still* ignore the reciprocity colour shifts in most cases, but an indicated 120-second exposure might lead me to give 90 seconds, 3 minutes, 6 minutes and 10 minutes.

1,000 seconds This is getting on for a quarter of an hour, so there is no time to bracket. Get the manufacturer's specification sheets and follow their advice. I have seen a successful *two-hour* exposure made by starlight.

One point worth making about very long exposures out of doors is that at anything more than about 8 seconds (with a standard lens) stars start to record as streaks rather than as points, and that with (say) a 30-second exposure using a 200mm lens, the moon will look like a sausage. Astronomers use equatorial mounts to compensate for this, but this means that the background is blurred instead. In practice, I almost never go beyond about 20 seconds for precisely these reasons.

TIMING LONG EXPOSURES

Although more and more cameras offer 'settable' shutter speeds longer than one second, these reliable long exposures are still the exception rather than the rule. Also, using automation to achieve long exposures may work with some subjects (notably landscapes) but it will be hopeless if the subject consists of small bright areas against a large dark background, for reasons discussed in the next chapter.

There are two ways of getting longer speeds than your camera gives, both involving the use of the 'B' setting on the shutter. If you have one of those few cameras offering a 'T' setting, you may find this useful for *really* long exposures (more than a few minutes), but a locking cable release is usually easier to use.

The cheap way, which is still remarkably accurate, is to press the cable release and count the time: a-thousand-and-one, a-thousand-and-two, a-thousand-and-three . . ., or as one of my more loyal Kodak friends counts, ONE Kodak, TWO Kodak, THREE Kodak . . . With a little practice, this can become astonishingly accurate – certainly within 10 per cent, which is as good as most shutters – and there is little point in using a stopwatch.

The slightly more expensive way is to use an auxiliary shutter release with a built-in timer: these typically run from 2 seconds to 32 seconds, on a straight doubling sequence. You wind the dial to the appropriate time, and then just press the release. It is useful for the very short exposures, up to three or four seconds, which are most difficult to count accurately, and for the long ones (30 seconds) where the cumulative errors add up. The interesting thing, though, is that my timer (which is admittedly fairly elderly)

is actually *less* accurate than the counting method: a marked 30 seconds is actually 25 seconds by my stopwatch, and the others are in proportion. The advantage, on the other hand, is that the speeds are more accurately repeatable than the counted ones.

CONCLUSIONS

Using longer and longer shutter speeds is essentially a luck-pushing exercise, unless you actually want blur. In most cases, camera shake is the main risk; subject movement rarely becomes serious until 1/8 or longer. Bean-bags and various other forms of camera bracing are quite adequate up to this sort of speed, at least with lenses up to 'standard' (50mm for 35mm cameras).

For longer exposures, provided subject movement is not a risk, you need a tripod – and you need the best tripod you can afford. Not all solid tripods are heavy, but most heavy tripods are solid.

Having said all this, there are times when it is a question of risking a longer-than-sensible exposure, or missing the picture. When in doubt, shoot. You may well miss it, but if you don't play, you can't win.

68 Firefighters, San Luis Obispo
This is a part of the same series as Plate 31. Normally a tripod would be desirable for a picture like this, but Steve came upon the scene unexpectedly and did not have a tripod with him. There is probably some slight camera shake (this was shot with a 80–210mm f/3.8 lens at 80mm) but it is masked by the subject movement – movement which contributes to the dynamism of the pictures (*SRA: Nikon F3: Ektachrome 400: exposure not recorded*)

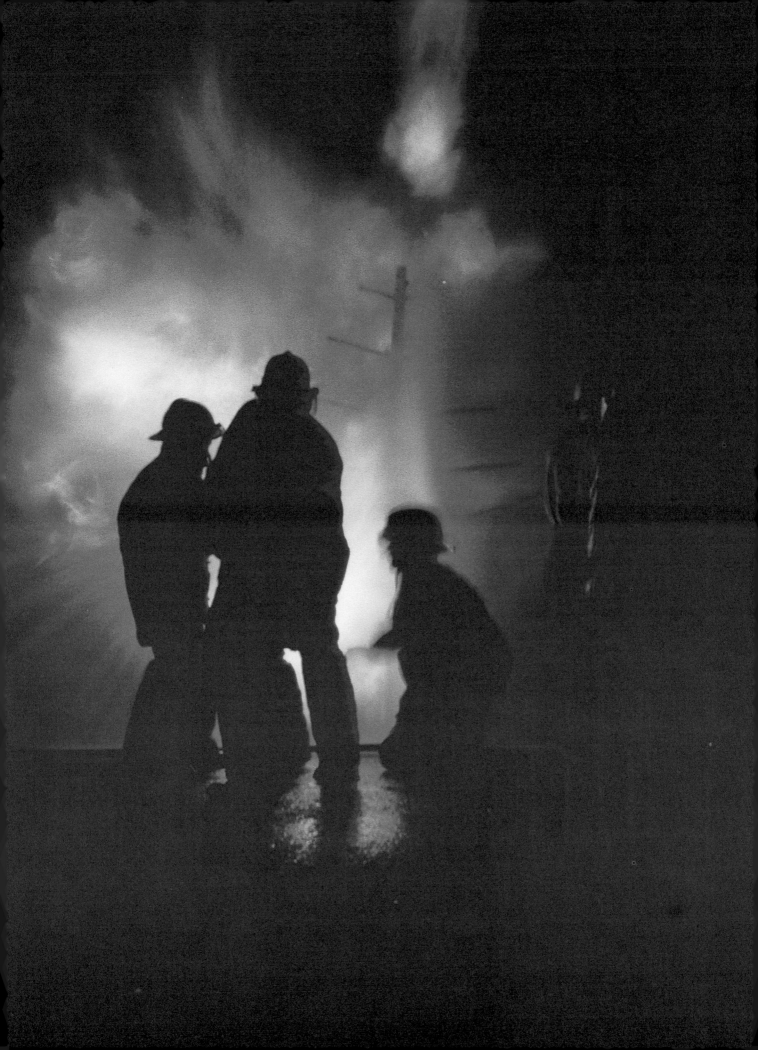

6
METERING

In the days of the all-singing, all-dancing auto-everything multi-mode camera, it may seem quite anachronistic to have a separate chapter on metering. Metering is, however, a surprisingly complex subject, and while there are certainly occasions when you can trust an in-camera meter – even an automatic in-camera meter – you will be much better placed if you know when you *cannot* trust it. The main considerations are fivefold:

1 Contrast range
2 Acceptance angle
3 Sensitivity
4 Speed of response
5 Reciprocity failure
 Reciprocity failure has already been covered, so the remaining four headings are the subject of this chapter.

CONTRAST RANGE

Purely empirically, meter designers have found that on average, the world reflects 18 per cent of the light that falls on it. If we take that 18 per cent as our 'mid-point', black-and-white films (and colour-negative films, for that matter) can record approxi-

69 Battery Park, New York
Metering at dawn, as at dusk, is extremely difficult. The light is highly directional, and changes fast. A reading off the palm of your hand or (better still) with an incident-light meter will give you a good starting point for bracketing. A reading into the light, in snow, would be next to useless *(RWH: Leica M2: 35/1.4: PKR: no exposure details – I followed my Weston Master)*

mately three stops either side. Anything which is four stops or more darker will disappear into featureless shadow, and anything which is four stops or more lighter will 'burn out' into featureless highlights. This corresponds to a contrast range of 128:1. With colour-transparency films, or colour prints, matters are further complicated by the fact that colours will not be meaningfully represented if their brightness is more than two stops either side of our mid-point. This corresponds to a contrast range of 16:1. Outside this range, the *tones* may register but the colours will not.

The real world, though, has a contrast range infinitely greater than 128:1, let alone 16:1. For example, consider an outdoor shopping mall at night. The brightly lit shop windows might require an exposure of 1/60 at f/5.6 to record their contents, while an unlit corner might require 1 second at f/2. This is a contrast range of nine stops or 512:1. Of course, if you include the lights themselves, you can add another three or four stops: to record detail in a street-lamp might call for 1/500 at f/8.

Even within the modest nine-stop range, you will have to select an exposure which will show what you want to show – but fortunately, the human eye can accept a remarkable range of exposures as more-or-less 'correct'. At one extreme, a 'correct' exposure shows us what is in the windows, with shoppers silhouetted and the road itself (apart from the street-lights, and perhaps the occasional passing car) in inky blackness. At the other extreme, a 'correct' exposure renders the roadway as bright as day, with plenty of detail visible, but the highlights (the shop windows) are hopelessly 'burned out'.

An in-camera meter, assuming it reads a representative areas, will give us a middle-of-the-road exposure which loses both the shop windows and the road detail. Of course, the question of 'representative area' is a vexed one, and we shall look at it in greater detail in the next section. But because most of the interest in the picture is likely to be *either* in the shop windows *or* in the general scene, without much in the mid-tones, an averaged reading based on a representative area is likely to give the worst possible exposure. What is really needed is either two stops more, or two stops less. With a non-automatic camera, this can be done. With an automatic, there may be override options, or there may not.

It is the contrast range, together with your own assessment of the need for colour-matching, which determines the extent to which you will need to bracket.

In a carefully lit studio shot, where the contrast range was low and colour and density have to be matched precisely, the normal professional procedure is to take a reading with an incident-light meter (see below) and then to bracket half a stop either side.

In normal daylight shooting, you need not be so precise. If you use an incident-light meter, a full stop either side of the indicated reading will normally be fine, though for a particularly important (or hard-to-meter) shot you might expose across a wider exposure range (two stops over to two stops under), and if there are subtle tones you might use half-stop intervals instead of whole stops. A wide bracket might also be advisable in the case of

something like the shopping mall, though there would be no need for half-stop rests: one stop would be plenty.

In extreme cases, bracketing verges upon obsession. A professional might even bracket at half-stop rests from three stops over to three stops under, a staggering total of thirteen pictures, but this would normally only be for something critical and unrepeatable, such as a news picture or an available-light advertising shot. Carrying this to the ultimate limit, some people will even double up on every single exposure, in order to cover against the possibilities of drying marks, fingerprints, scratches, etc. This means using the better part of a roll of 36-exposure 35mm film for a single image or (more likely) three rolls of 120 film. This may seem a lot to spend on film, but when you consider the other expenses of an advertising campaign (or the amount an unrepeatable news shot can earn), it pales into insignficance.

ACCEPTANCE ANGLE

A true 'spot' meter typically reads an angle of 1/2° or 1°. This means that you can target a representative area – something which corresponds to an 18 per cent mid-point – and take your reading from there. An alternative to a spot meter is a limited-angle accessory for a conventional 'system' meter: the one for the Lunasix/Lunapro allows you to read a 7.5° circle or a 15° circle. With this, you can generally get close enough to any subject to meter a representative area; if you use Zone metering, as described below, you can be almost certain of an accurate reading.

Most hand-held selenium-cell meters have an acceptance angle of about 60°, which is similar to the coverage of a 35mm lens. Most cadmium-sulphide (CdS) or silicon-cell meters have an acceptance angle of about 30°, which is comparable with an 85mm lens; this is the easiest way to visualise the area that is being metered.

You might think that through-lens metering would give you a better idea, but this is not so. The big problem with most in-camera meters is that you do not really have the faintest idea what you are actually metering. Most are 'centre-weighed', so that *most* of the metering is done off a central area (which may or may not be defined in the viewfinder), while the rest of the picture contributes an uncertain amount to the meter reading.

While this works well enough with 'average' subjects, available-light photography is often far from 'average'. Suppose, for example, that you are photographing a busker beneath a street light, and that the light is inside the picture area, just near one corner. How much influence will that light have? You might be able to work it out, given full technical information on the camera's metering pattern, but it would be day again before you had finished your calculations.

What you need, therefore, is either a spot or limited-angle meter built into the camera (and several firms do make them), or a separate hand-held meter with a known acceptance angle. Some form of viewfinder on the meter is ideal, but conversely, a meter with the widest possible acceptance angle – 180° or even more – is also very useful.

The way in which you can use a limited-angle meter is

70 Carpet cutter
This is not exactly low-light, but it is not exactly good light either. Brilliant dawn sunlight was coming in through a door where this Tibetan refugee was finishing a carpet, and few if any through-lens meters could have given a reliable exposure. An incident-light meter (Weston Master with Invercone) held pointing towards the door gave a very reliable indication for the brightly lit side, though, and I decided simply to let the rest go dark (*RWH: Leica M: 35/1.4: Kodachrome*)

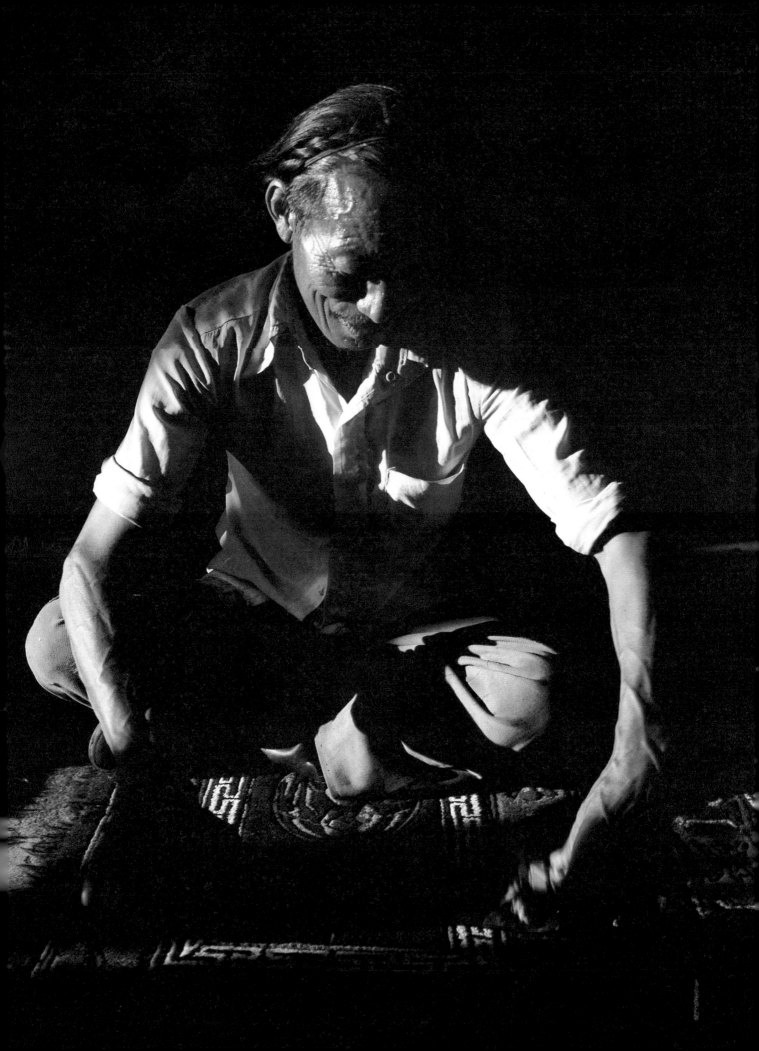

71　Dawn on the Ganges

Another dawn shot, and another argument against in-camera meters. Because I was shooting from a boat, I had to use the highest possible shutter speed to avoid blur due to the motion of the boat. A 'program' automatic would almost certainly have given me the wrong exposure (*RWH: Nikon F: 135/2.3 Vivitar Series One: PKR: 1/125 wide open*)

72　'Zoned' Weston Master meter

Weston meters are particularly easy to customise for 'Zone' use, simply by using little stick-on labels. This is an old Weston III, which uses the Weston scale rather than ASA or ISO; all you have to do, though, is to set the next *lowest* Weston speed: Weston 50 for ISO 64, and so forth (*RWH*)

73 Incident-light readings
When taking an incident-light reading, you measure the light falling on the subject, ie the light coming from *behind* the camera. You must be careful, though, that you are standing in the equivalent lighting to your subject; if your under a street-light, and your subject is in the shade, your reading will be worthless (*RWH*)

obvious (though there is an idea in the next section, SENSI-TIVITY, which may not have occurred to you), but a 180° acceptance angle is another matter entirely. It is useful principally for incident-light measurement.

Incident-light Metering

Incident-light metering is so simple and reliable that it is amazing how rarely it is used, except by professionals. All that you do is to measure the light falling on the subject, so that your reading is not influenced by subject reflectivity.

To take an extreme example, imagine a black cat walking past a snowdrift. The cat will reflect perhaps 5 per cent of the light falling on it; the snowdrift will reflect better than 90 per cent. Reflected-light readings would be severely influenced by where you pointed your meter, but an incident-light reading is completely unaffected. All you have to do then is to work out whether you want detail in the cat (give an extra stop) or texture in the snow (knock off a stop), and you are home and dry. If the contrast range is inside seven stops/128:1 (for monochrome) or four stops/16:1 (for transparencies), you do not even need to make any additional adjustments.

Most meters provide some sort of incident-light adapter. The bulky, easy-to-lose Weston Invercone is probably the best, while the slide-in hemisphere of the Lunasix is pretty good. Flat-surface incident-light adapters require more careful use; curved designs work well pointed in the general direction of the light source.

Ideally, you should take your reading from the subject position: returning to our shopping-mall example, this would enable you to determine your exposure for the roadway, or the shop window, or even the unlit corner. Fortunately, though, the human eye is very good at comparing light intensities, even if it cannot measure them in absolute terms, and you can usually take a reading from an area of equivalent brightness. At worst, you are likely to be a stop out, and a one-stop bracket either side of your reading will almost certainly give you at least one exposure which creates the impression you want. In practice, two or even three of these bracketed exposures may be perfectly acceptable.

SENSITIVITY

Modern in-camera meters are vastly more sensitive than they used to be, so this is no longer much of a problem until you get down to *really* low light levels. When that happens, you will be faced with two possibilities: guesswork, or using a separate meter.

Guesswork is less hazardous than it might seem, not least because of the wide range of exposures which we can accept as 'correct'. Also, bracketing at one-stop rests across a range of (say) five or even seven exposures is almost certain to put you in the right ball-park. There really is no substitute for experience here, but if you look at the exposure information beside the pictures in this book, you will begin to get a feel for the right exposure.

A hand-held meter such as the Lunasix/Luna-Pro will allow you to make readings down to very low light levels, and there is a useful trick if you find that you simply cannot get a reading any other way. It is an adaptation of the incident-light method outlined above.

Point the bare cell of the meter at the light source (in other words, without any incident-light attachment in place), and give *five times* the indicated exposure. This will work even with a relatively limited-sensitivity meter such as a Weston Master or other selenium-cell instrument, and indeed a Weston may give you a *more* accurate reading because of its wider acceptance angle.

If there is slightly more light about, and you are shooting black-and-white or colour negative, you can use the Zone System to get an accurate reading; indeed, you can often do this with an in-camera meter, if you can find a large enough area of even tone – another problem with acceptance angles.

The Zone System has been greatly elaborated upon by a number of writers, but I use the relatively simple and original nine-stop version: if it was good enough for Ansel Adams, it is good enough for me. The nine steps are symmetrical about Zone V, as follows:

Zone I	The darkest black of which the print is capable
Zone II	The first tone distinguishable from maximum black
Zone III	The darkest tones in which texture and shadow detail are distinguishable
Zone IV	Dark mid-tones
Zone V	The mid-tone which meters are set to read: 18 per cent grey reflectance, by definition

74 Disneyland
With interior shots like this, where lighting is a predominant feature, inspired guesswork is the only possible approach. My reckoning was that the lights were a bit darker than daylight (1/125 at f/8 that day), so I opened up a couple of stops and gave 1/250 at f/2.8: the high shutter speed was to negate the effect of movement in the ride (*RWH: Leica M2: 35/1.4: KR*)

Zone VI	Light mid-stones
Zone VII	The lightest tones in which texture and highlight detail are visible
Zone VIII	The lightest tone distinguishable from pure paper-base white
Zone IX	Pure paper-base white.

Zones I and IX are limiting cases; they cover anything with less exposure than Zone II, or more exposure than Zone VIII, respectively. The other Zones are separated by precisely one stop, so that Zone VI is one stop lighter than Zone V, which is in turn one stop lighter than Zone IV, and so forth.

Usually, we make our meter-readings at Zone V, for the reasons given above. But if you select Zone VII, the lightest-textured tones, and base your readings on them, you can get an accurate reading with a meter that is two stops less sensitive than would be required to take a reading at Zone V. You can either re-set the film speed to four times its normal value, which is the only option with an in-camera meter, or you can put additional arrows or index marks on your meter (as shown) and use the Zone VII index instead of the main arrow.

With colour-transparency film, Zone VII readings would probably be washed-out, but Zone VI readings (light mid-tones) are still a possibility and represent a way of wringing an extra stop of sensitivity out of the meter.

One other point is that the sensitivity of a cell can vary according to the wavelength of light falling on it: in other words, it might possibly read high under red light, and low under blue light. Selenium cells are apparently less affected by light colour than CdS cells, while silicon cells are reputed to lie somewhere between the two. This effect is only likely to matter with strongly coloured light, and I have never had it cause a problem, but it is worth knowing about in case you get apparently anomalous exposures from a 'correct' reading.

SPEED OF RESPONSE

There are two separate questions here: the speed of response of the meter cell, and the speed of response of the meter/camera combination. Neither is a matter of great consequence, once you understand them, but if you do *not* understand them you may find yourself in occasional difficulties.

Cadmium-sulphide cells are very sensitive, but unfortunately have a 'memory': it can take them several seconds of creeping close and closer to the correct reading before they are spot-on. Even a high-quality meter such as the Lunasix can take ten or fifteen seconds to come to rest in poor light: in good light, it seems to respond much faster, though in good light I normally use a Weston Master anyway. Westons, with their selenium cells, respond much faster, but are less sensitive. More modern photosensitive cells, including the so-called 'silicon blue' and phosphide cells, are as fast as selenium and as sensitive as cadmium sulphide, but are only found in the most expensive new

75 Zurich
This is my favourite time of day for photographs, but the long tonal range of the picture means that it is all too easy to get a wrong exposure and lose the colour in the sky. An incident-light reading is vastly easier, and bracketing one stop each way will cover you handsomely. You will however need a Lunasix or similar photoresistive meter, as Weston Masters and other selenium meters run out of sensitivity at these light levels (*RWH: Leica M3: 35/1.4 Summilux*)

hand-held meters. They are used as a matter of course in almost all modern in-camera meters.

The speed of response of the meter/camera combination is another matter entirely. The very fastest system is to have your camera pre-set to the correct exposure, so that you can just press the button: with a non-reflex, the shutter will open some 10–15 milliseconds (ms) afterwards. With a reflex, the time taken to get the mirror out of the way increases the delay to 15–20ms (10 milliseconds is 1/100 second; 20 milliseconds is 1/50 second).

Without pre-setting, the fastest approach is to use a modern fully automatic camera with off-the-film metering; the response time here is about the same as the response time for a non-metered reflex. Older automatic reflexes were quite a lot slower to respond, with delays of up to 30ms. The catch, of course, is that the exposure you get may not be the exposure you want, for the reasons already given above.

What is more, you need to be careful what sort of exposure automation you use. With aperture-priority exposure automation, there is the major danger of the 'perfectly exposed blur', where the camera selects a shutter speed which is so long that either camera shake or subject movement puts paid to sharpness. Shutter-priority automation is more useful, but the danger then is that you will run out of lens speed. The least useful form of automation, for all except the most carefree amateur or the newspaper reporter, is 'fully programmed', where the camera makes *all* the decisions on aperture and shutter speed, without the chance of an override.

76 Mission de la Purisma Concepcion, California
A correctly exposed film can capture a greater tonal range than any paper is capable of showing. When this happens, careful burning and dodging are necessary in the final print: here, the door has been 'held' (dodged) to show the grain while the left door-jamb has been burned to show extra texture (*RWH: printed FES: leica M2, tripod-mounted: 21mm f/2.8: FP4 @ EI 100 in Perceptol 1+3: 15 seconds @ f/8–f/11: Grade 2 paper*)

Fig 3 Angles of view of exposure meters
Incident-light meters have an acceptance angle of up to 220°; most reflected-light meters are about 60° (selenium) or 30° (Cds and other photoresistance cells); the Lunasix attachment illustrated is typical of 'semi-spot' systems, and offers a choice of 15° or 7½°; and true spot meters measure 1° or even ½°. The differences are spectacular, as illustrated by this diagram! (*A/w by FES*)

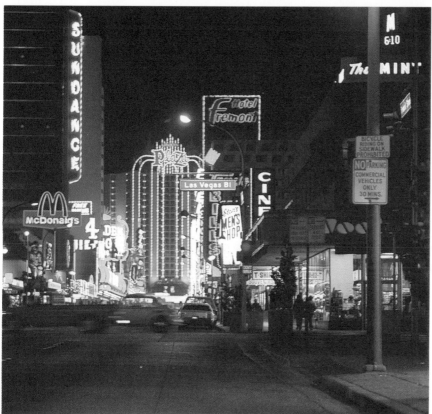

77, 78, 79 Lighting Effects
The influence of time and weather on pictures is well illustrated by these three shots by W. A. Schultz. The subject is not inspiring, but the differences in the light are incredible. All these shots are 'straight', with no filtration (*W. A. Schultz: Canon TL: no other technical information available*)

80 Las Vegas, Nevada
Neon lights are surprisingly bright, and a major danger is over-exposure. Stopping down helps to reduce flare, so this was shot with the Nikon on a tripod and an exposure of about 1/8 @ f/5.6 (*RWH: 50/1.2 Nikkor*)

Although it is nothing to do with exposure, it is worth mentioning that autofocus can *really* slow you down. The time required by the focusing movement in some cameras can result in as much as 100ms (1/10 second) delay between pressing the button and getting the picture.

If you have a non-automatic camera, the easiest approach is to take readings periodically so that you know the maximum and minimum exposures which are likely to be required, and set your camera accordingly. For example, one night in Amsterdam, the range was 1/60 second at f/1.2 to f/2.8 using ISO 1000 print film rated at EI 650. I left the shutter-speed dial on 1/60, and adjusted my exposure by 'guesstimation' on the aperture ring.

CONCLUSIONS

Automation and in-camera meters are all very well, but they have to be used *very* carefully in tricky lighting situations; the only utterly reliable in-camera meters, even allowing for the new 'trick' meters which perform all sorts of calculations on the exposure, are spot or semi-spot meters which tell you exactly what area you are metering.

For most purposes, incident-light metering will give the most reliable exposures, and this means using a separate meter. If you run out of sensitivity, resort to the tricks described on pages 89 and 90. Alternatively, try limited-area metering, either with a spot meter or with a conventional reflected-light meter used close up.

81 Mission de la Purisima Concepcion, California
Metering large expanses of whitewashed adobe is easy – if you have an incident-light meter. Here, a stop *less* exposure than the meter indicated gave more texture in the wall. This is the maximum correction you normally have to give: for a very dark subject, you would give a stop *more* if you wanted to show texture (*RWH: printed FES: Leica M2, tripod mounted: 21mm f/2.8: FP4 @ EI 100 in Perceptol 1+3: 1 second @ f/5.6: Grade 2 paper*)

82 Hôtel de France, Paris
Many of the buildings of Paris are lit with sodium-vapour floodlights which look rather bilious in real life but reproduce as a magical gold on film. Notice however the secondary reflections of the lights above the bridge, always a risk if you use ultra-fast lenses with filters at night when there are light-sources in the picture (*RWH: no other details available*)

83 Snowy roofs
Although I normally have no time for 'effects' filters, I find that they are occasionally useful at night. If you use a through-lens meter, however, you can confuse it royally: the weighting which it will accord to starbursts like this cannot be predicted, and you will normally find that your pictures are underexposed (*RWH: tripod-mounted Nikon F: 50/1.2: KR: 1/15 @ f/4*)

84 Times Square
Wet streets and neon signs almost always combine to make memorable night pictures, and they are quite a change from the usual daytime shots which are on all the souvenir postcards. This is one of the oldest tricks in the low-light photographer's book, but it nearly always works (*RWH: Leica M: 35/1.4: PKR: 1/30 wide open*)

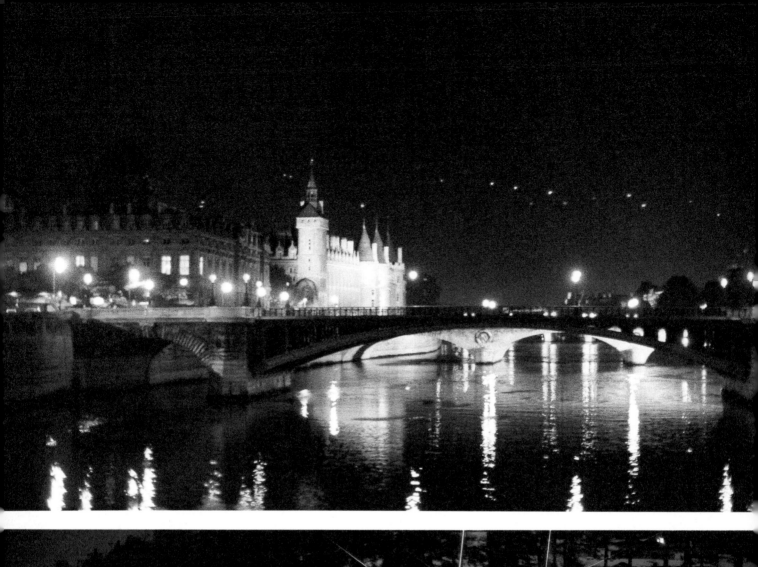

7
FLASH AND ARTIFICIAL LIGHT

If you have the choice, available light is almost invariably more natural-looking than flash or any other form of supplementary lighting. On the other hand, there are many occasions when extra light is either desirable or essential, and this is the subject of this chapter. There are thirteen sections here, of widely varying lengths; although the headings may appear cryptic at first, the sections themselves make sense.

ON-CAMERA FLASH

This is the lowest common denominator of additional lighting. The cheapest on-camera flashguns cost about the same as a roll of film, processed; many cameras, of course, have flashguns built in. If you insist on using this form of lighting, you should keep the flash head as far from the lens as possible, and 'bounce' the flash whenever possible. Also, try to keep the subject away from walls, in order to avoid those tell-tale hard-edge shadows which show that you took the easy way out.

85 Bulb flash
If you want sheer, blinding, raw *power*, a big old bulb flash is hard to beat. The big bulbs, the size of domestic lamps, are hard to find and can be expensive, but the light output can be ten or twenty times that of even a fairly powerful portable electronic flash. Also, 'bare bulb' flash (with the reflector removed) gives surprisingly even lighting

Keeping the flash head well away from the lens serves two purposes. One is to avoid 'red-eye', which is caused by the light from the flash being reflected back through the blood vessels of the eye itself: the result is glowing red eyes which turn the subject into a passable impression of Count Dracula. The other is to avoid (as far as possible) 'atmospheric revenge', where smoke and dust in the air throw the light straight back into the lens, resulting in flat, degraded pictures. I call it 'atmospheric revenge' because using flash almost invariably destroys that intangible sense of place and occasion which we call 'atmosphere', while the fault is literally caused by the atmosphere.

How far you can get the flash head from the lens is a matter of compromise between sheer bulk and image quality. Using my big Metz 45-CT1 with a Leica, I can have a reasonably handy package with the two about 10in (25cm) apart or I can slide the camera to the end of the bracket for a 12in (30cm) separation. With a typical small flash, the separation is down to about 4in (10cm) if I use the accessory shoe, or about 6in (15cm) if I use the rather inconvenient Leitz flash bracket.

'Bouncing' the flash off the ceiling, or off a nearby wall, is usually much more effective. Because the light is more diffuse, and is not obviously coming from the camera, the effect of the photograph is much more natural. Obviously, you need a lot more power with 'bounce' flash than you do with straightforward on-camera flash, which is why I own the big Metz: the guide number (see below) is about three to four times as high as for a typical small on-camera gun. As far as I am concerned, bounce flash is my normal last resort; on-axis flash is the ultimate last resort, when I have not the power to use bounced light.

Whether you use on-axis flash or bounce flash, you have three ways of determining exposure: guide numbers, flash meters, or automation.

Guide Numbers

Guide numbers are simply distance times aperture. With a guide number of 20 (feet) you need f/4 at 5ft (5x4=20), f/2 at 10ft (2x10=20) and so forth. The guide number varies with film speed, for obvious reasons, and it is usual to add (metres) or (feet) after the guide number, again for obvious reasons. The standard film speed for comparison is ISO 100, so the Metz 45-CT1 has a guide number of 45 (metres, ISO 100) or 160 (feet, ISO 100). The little Hanimex XS-14, by comparison, has a guide number of 14 (metres, ISO 100).

Guide numbers for other film speeds are given in the flashgun's instruction book, and often on the flashgun as well. There is frequently a little table or slide-rule giving the appropriate aperture for different film speeds and distances. If you only have the GN for a single speed, remember that *quadrupling* the film speed will only *double* the guide number, while *quartering* the film speed will only *halve* the guide number. Thus, for the 45-CT1, going to ISO 400 film gives you a guide number of 90, while ISO 25 film gives you a guide number of 22.5.

The main drawbacks of guide numbers are that they are not very convenient to use, and that they are really only suitable for

86 Tormas
For once, I broke my own rules and used direct flash to photograph these *tormas*, Tibetan ritual cakes made of coloured butter. The direct flash brought out the brilliant colours, and although I also had some pictures without a worshipper present, I thought he added to the picture even if he did throw a tell-tale shadow (*RWH: Nikon F, 50mm f/1.2 lens, Metz 45-CT1 on auto*)

87 Abbot
'Bounce' flash is a lot more comfortable-looking than direct flash, but it still lacks the appeal of natural lighting. Unfortunately, I met this venerable abbot before dawn, so there was no chance for natural lighting, and as my 35mm kit had been stolen in Delhi, I was forced to use the Hasselblad with the only lens I possessed, the 80mm f/2.8. You can also see that the plane of best focus is behind the subject; I don't think too clearly before dawn (*RWH*)

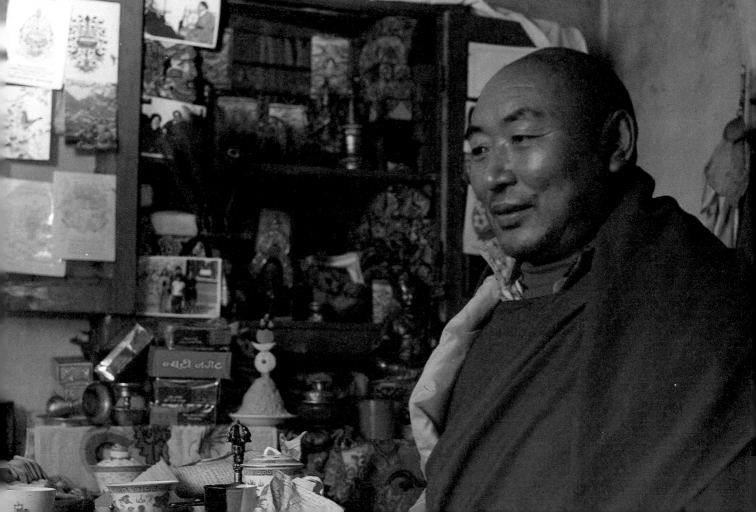

on-camera, non-bounce flash. Also, if you want to use more than one flashgun, especially dissimilar ones, you can get involved in quite hellish calculations. Two identical guns are easy enough – they double the output and give you one extra stop – but it is easy to forget that for two extra stops, you need four guns and for three extra stops you need eight.

Flash Meters

A flash meter is simply an incident-light meter (see page 88) designed to read flash lighting, but there are a couple of differences between flash meters and regular meters. One is that most flash meters can be used cumulatively, 'adding up' a series of flashes to arrive at a particular exposure recommendation; this means that they *must* be reset between readings. The other is that most can be used on 'open flash' (firing the flashguns elsewhere) or 'corded' (firing the flash from the meter). Flash meters are not particularly expensive, and I have always considered mine a good investment, even though I use it rarely. They are all but essential if you want to use multiple flash (see below).

Automation

Automation is something which I do not normally favour – as I have said before, 'what ain't there, can't go wrong' – but since coming to terms with the uncanny accuracy of the Metz 45 CT-1, I am converted. After all, a flashgun is a pretty complex piece of electronics anyway, and adding in a thyristor circuit for

88 American Football
Flash used out-of-doors at night can be very dramatic, but you need quite a lot of power: this was shot with *three* guns together, two Vivitar 283s and a Vivitar 2500, and even then the ISO 400 film had to be pushed one stop to EI 800 (*SRA: Nikon FM: 200mm f/4, wide open*)

automation seems hardly to make much difference. If I use on-camera flash, I almost invariably use the CT-1 in automatic mode. The way it works is quite interesting: a sensor on the flashgun measures the light reflected back from the subject, and automatically terminates the flash. Older (or cheaper) designs simply 'dump' the spare power, while better designs re-use it to give you more flashes and a faster recycling time. The Metz is by no means the only good gun, but it is one of the best.

Open Flash and Self-test

Like other good guns, the Metz has both an 'open flash' button and a self-test, 'Open flash' means that you can fire the gun without using the camera; this is useful if you are using a separate flash meter, or if you want to try the 'painting' technique described on page 109. The self-test is a little red light on the back of the unit. If this lights up when the flash fires, it means that enough light has reached the sensor for correct exposure at the aperture selected on the auto-dial on the top. This works even with bounce flash, so you can know in advance (or check when you make the exposure) whether or not you have enough light to try 'bouncing' instead of on-axis flash.

Although automatic flash is in theory subject to the same objections as any other form of automation, if it is used intelligently (again like any other form of automation) it works very well. The rules are simple: it works best indoors, and if you have subjects at widely differing distances you may find (with direct flash especially) that the nearest ones are 'burned out' and the more distant ones are murky.

'Dedicated' flash is a rather cleverer version of automatic flash. It usually sets the camera's shutter speed automatically, so that you cannot accidentally use too fast a speed to synchronise, and the flash reading is through the camera's lens instead of via a sensor on the flashgun itself. It is good stuff, but it is a lot more expensive (and complex) than an equally powerful non-dedicated flash, and it is not significantly more effective than an intelligently used 45 CT-1 or something similar.

The only advantage in most cases is that it is easier to use, though there is one specialised application where it is actually superior: when you are shooting close-ups, it saves you having to make any allowance for extra camera extension. On the other hand, for close-ups you should normally be using twin flash on a bracket anyway, as described in the next section.

The only trouble with any automatic flash (or with variable-power flash, if you turn the power too low) is that you may find yourself into *short*-exposure reciprocity failure; flash durations of 1/10,000 second are not unusual, and some go as low as 1/30,000. This can mean that an extra stop of exposure is required, possibly plus filtration, as described on page 78.

Close-up Flash

Most natural-history photographers use either complex off-camera equipment or a simple two-flash arrangement using a twin-boom bracket. A few use ringflash.

Ringflash is familiar to most people from advertisements: far

fewer actually own one, because it is expensive, highly specialised, and useful chiefly when you want a record shot rather than a shot with any pictorial merit. For example, medical photographers use ringflash because it gives absolutely flat, even lighting with no awkward shadows.

There are many kinds of twin-boom set-up, but they are all similar in principle. They attach to the camera, usually via the tripod bush, and they have two arms which can be moved independently. Some use flexible 'goosenecks', like old-fashioned lamps, while others consist of jointed rods which can be extended and swivelled at the joints. One of the best is made by Kennett: it is rather heavy, but it is also very versatile and almost indestructible.

The booms are set to give pleasing lighting at a given subject distance: one main light (closer or more powerful, or both) and one 'fill' (more distant or weaker, or both). Small, low-powered units are all you need, because you will be working at very close distances. Even a GN of 20 (feet) is plenty: at two feet or so, you will be shooting in the f/8–f/16 range, even after allowing for the extra exposure needed in close-ups.

Exposure determination is really only possible with a flash meter. At first sight, dedicated guns or remote sensors might seem to provide an answer (remember, the flash and the camera may be at different distances from the subject), but by the time you have bought a switchable-power remote-sensor or dedicated gun, you are looking at an awful lot of money: you will need the switchable power because most guns will be too powerful at the ranges required. A much better bet is two cheap guns and a modestly priced flash meter. If you need to reduce the power of the guns still further, you can tape tracing-paper, ordinary paper or even a handkerchief over the reflector: this will have the additional advantage of diffusing the light further.

With the flash booms set, the exposure pre-checked, and the camera pre-focused, all you have to do is to frame the subject and press the release. This is particularly useful if you are photographing small animals or insects, where you have to shoot quickly if you are to get a picture at all. Check composition, lighting, etc with a dead specimen or an object of similar size – a scrap of paper, or even a piece of modelling clay.

Fill-in Flash

Fill-in flash is essentially a method of contrast control: for example, if you want to photograph someone against a sunset, using only available light, you have a choice of exposing the person correctly and getting a 'washed-out' sunset, or exposing the sunset correctly and reducing the person to a silhouette. By using fill-in flash, you can get detail in the person's face *and* colour in the sunset.

The reason that fill-in flash works is that flash exposure depends on aperture and distance, while ambient-light exposure depends on aperture and shutter speed. As long as the shutter speed is long enough to permit synchronisation of the flash (no problem on leaf shutters, but a consideration with focal-plane designs), everything is fairly easy.

89 Bonfire
Although this was taken at a public bonfire, the agitated pose of the man in the foreground and the sheer size of the conflagration suggest something much more serious – a war, perhaps, or a burning building (*RWH: Nikon F: 50mm f/1.4: tungsten-balance Ektachrome: 1/30 wide open*)

90 Nun in cave
This is a *really* interesting flash shot, which taxed even the Metz 45 CT-1. This nun lives in a tiny hermitage about eight or ten feet along under an overhanging rock, with mud for the remaining wall. The ceiling is black with smoke from the butter-lamp which (apart from the door) is the only source of light. I did my best with bounced flash, but the black ceiling swallowed it up (*RWH: Hasselblad: 80/2.8: ER*)

91 Melissa on a swing
This shows very well how a fill-in flash can be used both to lighten a *contre-jour* picture and to freeze motion; it is the speed of the flash itself (less than 1/1000 second), not the flash-synch speed, which determines 'stopping power' (*SRA: Nikon FM: 135/3.5 Nikkor: Fujichrome 100: no other details available*)

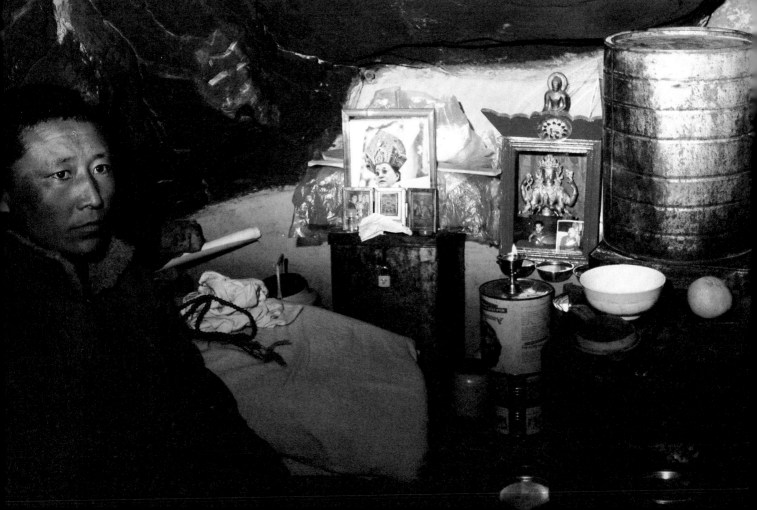

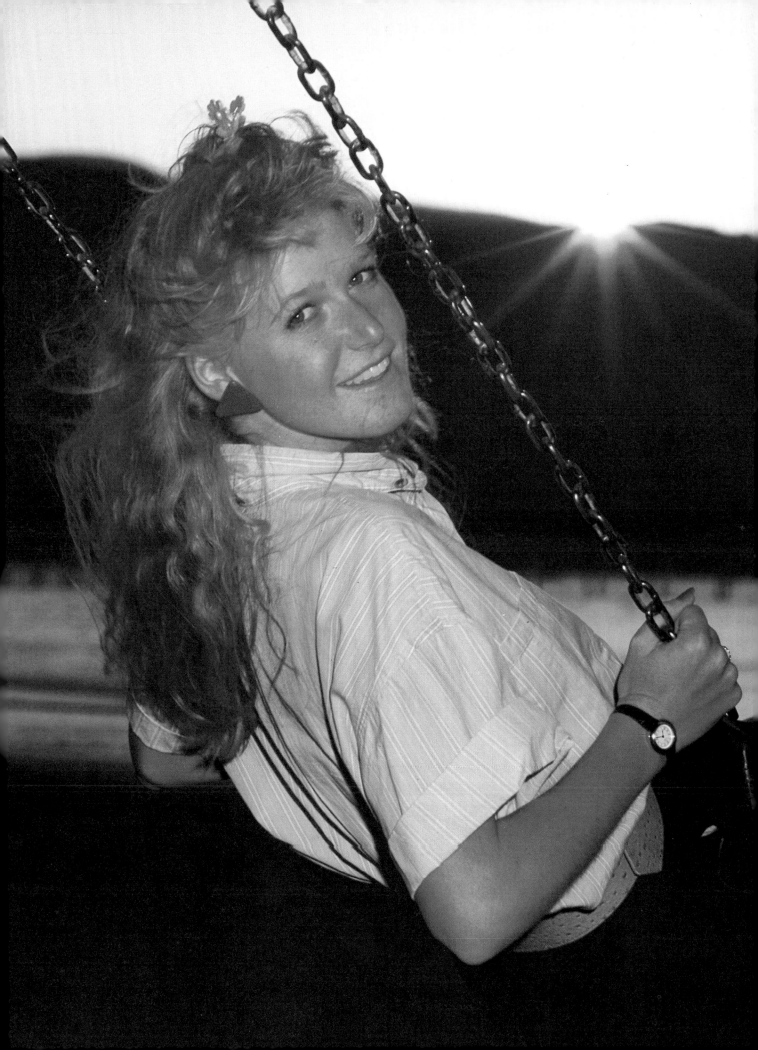

Rather than getting involved in complex calculations, I have a small on-camera flash (an XS-14 again) which I use for fill-in flash, marked up with the apertures for ISO 50/64 film (the difference is not significant) at various distances. All I do is to pretend that I am using ISO 100 film, which means that the fill-in flash is one stop weaker than it would normally be for 'correct' exposure. Try the same approach yourself: if the fill-in is too strong for your taste, go to ISO 200, and if it is too weak, try ISO 50.

One thing which rarely works is fill-in flash using an automatic flashgun, mostly because fill-in flash is usually used outdoors, and the auto-sensor does not have enough light reflected back at it. Some people swear by it, though; begin by setting *twice* the actual speed of your film on the flashgun, and modify it from there.

OFF-CAMERA AND MULTIPLE FLASH

Off-camera flash is normally only used in studio set-ups, though it is possible to use it (with a lightweight 'wobble-pod' tripod as a lighting stand) on location, where the gun can be positioned near a window and used to enhance feeble light. This is a form of reverse fill-in flash, so you will need to figure in the available-light exposure when calculating (or measuring) the flash exposure.

Multiple flash outside the studio is even less usual, and is certainly a long way from 'available light', but the reason I use Hanimex XS-14s is that they have built-in slave cells, so that they can be fired by the main gun, mounted either on camera or on a wobble-pod. I have lit (for example) dark library interiors using multiple flash, but a flash meter is essential if you want to try this level of sophistication. Also, Polaroid tests are invaluable, as it is extremely difficult to visualise where the light will go without benefit of modelling lamps. Studio packs such as Monolites are equipped with modelling lamps, but at this point we really are wandering a long way from low-light and available-light photography.

One serious consideration, though, is the use of old-fashioned bulb guns or even flash powder if you want to light large areas out of doors. Expendable-bulb guns kick out a tremendous amount of power, and you can often find them quite cheaply. The bulbs themselves are quite expensive, as well as getting harder to find all the time, but I have seen photographs of whole buildings and indeed of an aircraft carrier lit in this way. Old-fashioned flash powder is dangerous stuff, which is why the formula is not published here, but it can also produce a lot of light. Watch out for the billowing white smoke, though, and do not attempt to use the stuff indoors: the fire risk is simply too great.

Bear in mind that uncoated (clear) flash bulbs are balanced to a different colour temperature from either electronic flash or continuous tungsten lighting, typically 3300K for the 'paste' variety and 3800K for the wire- and foil-filled variety. 'Paste' bulbs (usually the smaller ones) can therefore be used with tungsten-balance films (usually 3200K or 3400K), while wire- or foil-filled bulbs will require a weak red filter on camera if used with

tungsten-balance film, or a fairly strong blue filter if used with daylight-balance film. The colour temperature of flash powder will vary with the composition and the conditions of combustion: if you want to try this dangerous substance, you will need to experiment for yourself.

'PAINTING' WITH FLASH

If you leave the shutter of the camera open, you can achieve multiple-flash effects by roaming around with a single flash and 'painting' large areas – even buildings. Ideally, you need an assistant: you stand by the camera, open the shutter, and call out the first order to fire. Then, you hold a piece of black velvet in front of the lens while your assistant moves to the next station, and so forth. The black velvet is useful because it prevents passing cars, etc, registering on the film while you are working.

This is merely a high-tech adaptation of a much older technique, that of 'painting' with torches (flashlights). The drawback of flashlights, however, is that the light is feeble, requiring long exposures, and the colour temperature of the light is low which means that even tungsten-balance colour films require heavy filtration, which extends the exposure still further. The advantage of flashlights, on the other hand, is that the light is continuous and can be swung around from a single standpoint.

There are three important things to remember if you want to try this sort of 'painting', whether with a flashgun or a torch. One is that you will need to plan your lighting sequence carefully,

92, 93 Portraits
Although the purist may decry it, flash does have its uses. In the available-light shot, the contrast range on the face is altogether too high and the direction of the light is all wrong. A well-executed flash shot can still look surprisingly natural; the almost inevitable shadows on the background actually improve this picture, by increasing the differentiation between the head and the background. With closer cropping, you would have to look hard to realise that it was a flash shot at all (*SRA: Nikon FM: Tamron SP 35–80 f/2.8: Tri-X*)

and to conduct some experiments to try and work out what on earth the exposure will be. The second is that you will need a *very* rigid tripod, well seated on the ground. The third is that your assistant should be careful not to silhouette himself or herself against the illuminated area. This can be accomplished by using natural cover such as bushes, by lying flat on the ground, or simply by firing the flash (or pointing the torch) at an angle, so that the assistant is in the dark. A short cone of black paper or aluminium foil around the torch will reduce the risk of its appearing in the shot.

You can also try this technique with flash powder or magnesium ribbon, but remember to shield the conflagration from the camera.

INFRA-RED FLASH

It used to be possible to buy flashbulbs which were coated with a deep-red, almost black varnish which only permitted infra-red light to pass; pictures could be taken by this means in 'darkened' areas such as cinemas. All that could be seen when the flash was fired was a weak, reddish glow for a moment.

I have never tried this, and I cannot say that I really want to: the lighting effects are horrible, with dead-white flesh and extremely high contrast. Old books on photography will however furnish recipes for making up your own varnishes. You will really have to use big bulb flashguns for this, as nothing else produces enough light. There is little point in adding to your difficulties by putting an infra-red filter on the lens of the camera as well.

ENHANCED AVAILABLE LIGHT

There are a number of ways of enhancing available light, and one of the easiest is simply opening curtains and doors; a kindly *tulku* (incarnate Lama) once did this for me in a Tibetan temple and gave me another four stops of light in the process!

A trick which I have tried but *cannot* recommend in any way is to substitute 275w and even 500w photoflood bulbs for domestic lighting. The increase in general light levels is spectacular, but it tends to destroy the lighting balance of the room and the *fire risk is considerable*; most domestic lamps are designed for 100w or even 60w maximum wattages, and things begin to cook, char and even ignite if you leave these high-powered bulbs running for more than a few seconds at a time. Thirty seconds would be an absolute limit for most domestic light fittings.

Off-camera and bounce flash are of course ways of enhancing available light, but they have to be used with discretion or they become too obvious; I mention them only in passing.

If it is simply a question of getting *more* light from existing sources out of doors, and atmosphere is not a problem, you may also wish to consider a very old-fashioned solution: magnesium ribbon. This burns with a fierce white light (I don't know the colour temperature), and if you support it with a damp twig or something similar you can literally buy your light by the yard. I haven't used this stuff for many years, but I can warn you that it is painfully bright to look at and that it gives off a thick, choking white smoke as it burns. It also burns very hot indeed: this is the

94 Man with grinder
The lighting range here was tremendous: the workshop was huge and gloomy, with shafts of bright sunlight streaming through skylights. Then, when this man started using the grinder, I knew that I had to have a picture. This was shot with a Nikon F2 and a 50mm f/2 lens on ER at about 1/60 @ f/4 (*RWH*)

95 Larry Meier
Larry Meier is a dentist. Here, he is checking X-rays. Quite apart from its qualities as a portrait, the interesting thing is that the light is from a dental lamp; the colour quality, on daylight-type Kodachrome 64, is very similar to that of warm daylight (*SRA: Voigtländer Bessamatic: 50mm f/2.8 Color-Skopar: no exposure details*)

96 Computer-controlled robot arm
The light trail here was made by a robot arm under the control of the computer. The picture could have been improved by switching the computer off part-way through, so that the screen did not burn out so badly, but the double exposure of the face seems to me to be very effective. What do you think? (*SRA: Nikon FM: 50mm f/1.8 Nikkor: Tri-X: available light plus flash: total exposure about half a minute*)

97 Welder
This picture is included more for discussion than for anything else. First, would it have been improved by using fill-in flash? I don't think so. Second, would it be better if I had come in closer, or if I had burned the windows back to black in the print? I don't know. More blackness makes the picture more powerful, but it also loses the feeling of working in a dark, empty shed (*RWH: Leica M: 35/1.4: FP4 rated EI 80 and developed in Perceptol: about 1/60 @ f/2*)

material that was used to make the casings of incendiary bombs! You can ignite the ribbon with a match or cigarette lighter, and it can be used beside (or instead of) floodlights to give as much light as you want.

ADDITIONAL LIGHT AS PART OF THE PICTURE

The classic example of this, and one which has appeared in countless books, magazines and photographic competitions over the years, is the pipe-smoker's face illuminated by the light from the match with which he lights his pipe.

If you have ever tried this, you will be deeply suspicious of the lighting: I don't believe that it is possible to get a *good* picture using *only* the match-light. It is a small, dramatic, and welcome addition but I would want to use some other form of light as well.

There are other occasions, though, where fire can be a useful part of the available lighting. Fireworks, whether on Guy Fawkes night or the Fourth of July, are one example – though once again, additional light (preferably from a bonfire) is useful to fill in the shadows; those pictures you see of a child rapt with a sparkler are more carefully lit than they look. A sneaky little trick is to tape a red filter (or even a piece of red Cellophane or something similar) over a small flashgun and to use that as a fill-in flash.

Bonfires themselves are useful light sources, and so are barbecues, though you need a time when the fat is flaring to get much light out of them. Many religious services use fire – Christians use candles, Tibetan Buddhists use butter-lamps, and Hindus at Divali use oil-lamps, for example – and if you pick the right part of the ceremony, you should be able to get a good picture. Because most fire ceremonies are fairly joyous occasions, no-one is likely to object too much if you take pictures, provided of course you don't use flash, which would remove the point anyway.

Use ultra-fast tungsten-balance film (you'll need the speed), and consider using a blue filter to get slightly less reddish colours. Do not try to correct too fully, because redness is part of the appeal, but remember that the colour temperature of a candle is about 1750°K, while tungsten-balance films are designed for use with 3200°K or 3400°K light-sources. An automatic camera with off-the-film metering is probably the easiest way to get good close-up exposures, especially with flickering flames, though there is always the danger that the 'middle-of-the-road' exposure will leave you with a burned-out flame and a too-dark face; try resetting the film speed to one-half its normal value. Alternatively, take a few close-up readings with an incident-light meter or a spot or semi-spot meter, and base your exposures on that. This approach, combined with experience, will probably result in more out-and-out failures than intelligently applied automation, but many more really spectacular successes too.

NUIT AMÉRICAINE

Nuit Américaine, literally 'American night' but more normally translated as 'day for night', is the cinematographers' way of

98 Zurich
One way of obtaining *nuit Américaine* in colour is to use tungsten-balance film at dusk, underexposing slightly. Between them, the blueness and the darkness create the effect that is wanted (*RWH*)

faking night pictures during the day. It is accomplished in two ways, depending on whether you are shooting monochrome or colour. In monochrome, the best effects are normally obtained by using an orange or red filter, and then printing the result very dark. This is especially true if you have a clear blue sky, as the filter will darken it to night-like blackness while maintaining the tonal differentiation of the buildings.

In colour, *nuit Américaine* is normally accomplished with some blue filtration plus severe underexposure – anything up to three stops – though in the right lighting conditions you can achieve it by underexposure alone. Overcast skies, especially late in the afternoon of a dull day, can provide exactly the right sort of lighting for this. In the final analysis, *nuit Américaine* is not true low-light or night photography at all, but I felt that I would be remiss if I did not mention it.

CONCLUSIONS

On-camera flash, especially *direct* (non-bounced or axial) on-camera flash, is something of a last resort, but it has its uses. If you find that you must use additional light, however, do consider the alternatives to on-camera electronic flash. Also, if you see a 'night' shot which looks too good to be true, look at it closely to work out whether it is a true night (or at least evening) shot, *nuit Américaine*, or 'fudged' with the help of additional light.

8
CITIES

The only way to photograph a city is on the hoof. Driving will not do. In London, use the Underground to travel, not a car; in Paris, use the Métro. In smaller cities, or in New York where the subway is not too savoury (or savory), just walk. Even in Manhattan, you can cover everything you need to on foot, from the tip of the island to about Thirtieth or Fortieth.

Don't worry about getting mugged. Don't dress in too rich a fashion, and don't carry a lot of money, but don't worry either. I have never been troubled, even in New York City, where I feel less comfortable than in any other city in the world.

Almost all the best 'night' shots in a city are actually taken when there is still some colour in the sky – that is, normally at twilight. Otherwise, the sky blocks up to a solid black, and the edges of the buildings are lost against it unless they are particularly well floodlit. This is not necessarily true for details, but now we are entering our next section, 'Subjects'.

SUBJECTS

Vistas are one obvious subject, but (as already mentioned) these do look better while there is still light in the sky. You may also find it easier to look for a slightly elevated position, so that the endless cars which infest modern cities do not block your view. In this context, 'vistas' include what the movie business calls 'establishing shots': the Tour Eiffel and Arc de Triomphe in Paris, the Statue of Liberty in New York, and so on.

Another possibility for pictures which really tell you a lot about a city are the details: the characters, the unique architectural features such as the Métro signs in Paris, the shop-windows with their displays and (often) their names and advertisements in unfamiliar languages. In the United States, the great roofed-in shopping malls offer all kinds of opportunities for picture-taking; in Europe, these are as yet less well developed. Look out too for buildings which are reasonably well known, but not actually establishing shots, such as the Opéra in Paris, or for distinctive buildings in provincial towns, such as Birmingham's neo-classical Town Hall.

Yet a third possibility is the people: fellow-tourists, or locals out promenading or sitting at a sidewalk cafe. A difficulty here lies in making crowds look dense enough: it is often better to concentrate on one or two people, or a small knot of friends, than to try to get everyone in.

One subject which is perennially appealing, but devilishly difficult to carry off well, is the individual person sitting on a wall, or a park bench, lost in his or her own thoughts. When these pictures work, they work beautifully; but all too often, they are either empty or saccharine. I know; I still keep finding them among the transparencies I pick up from the lab!

99 Chandni Chowk
In the narrow, crowded streets of Old Delhi it can be surprisingly dark even if the sun is blazing overhead. Chandni Chowk is the area for camera stores; this was shot with a 35mm f/1.4 Summilux on a Leica, with HP5 rated at ISO 320 and developed in Perceptol (*RWH: about 1/30 @ f/2*)

100 New York
The Statue of Liberty from the World Trade Center is a classic 'establishing shot', though if you look closely you will see that a lot of the information comes from context; Liberty herself is not terribly clear (*FES: Nikkormat on table-top tripod, pressed against the glass: 200mm f/3 Vivitar Series 1: KR: exposure not noted*)

101 Two Girls
Even in a crowd, there are always some people taking it easy. Heaven knows what these two girls were talking about, but it certainly kept them rooted to the spot. I was able to use a monopod to steady the camera enough for a 1/8-second exposure at f/1.4 on Kodachrome 64, and although they looked up for a moment, they soon went back to their conversation (*RWH: Leica M: 35/1.4 Summilux with dirty filter – look at the top right-hand corner*)

102 Dancing Chairs, Paris
Even the Boulevard St Michel closes eventually, at about one in the morning. My wife spotted these chairs, heaped and chained together for security, and said 'They look as if they're dancing!' I shot them using a 35/1.4 Summilux on a Leica M-series, using 3M 640T, at about 1/30 wide open (*RWH*)

117

EQUIPMENT

The mose useful lens in the city is almost certainly a fast wide-angle: the 35mm f/1.4 is a dream, as it covers a conveniently wide field of view and gives fair depth-of-field even wide open, at least when used at reasonable distances. If you cannot afford an f/1.4, get an f/2, and if you cannot afford that, an f/2.8 and fast film will have to do.

The second choice for most people will be between a still wider lens – 24mm or 20/21mm – and a standard lens. The ultrawide can be very dramatic, and is my personal choice, though I know others who prefer the 50mm. If you do go for an ultrawide, you may be embarrassed by lack of speed: it was speed, rather than improved quality or the availability of rangefinder coupling, which led me to trade in my specially adapted 21mm f/4.5 Biogon for a 21mm f/2.8 Elmarit.

A standard lens is surprisingly useful, and if you are really worried about the territory into which you are venturing, you may do better to use a 'disposable' camera with a standard lens rather than your system SLR. I put 'disposable' in quotation marks because I am still talking about pretty good cameras: an old Kodak Retina, perhaps, or one of the big old Yashica fixed-lens rangefinder cameras. You can find these cameras for very modest prices, complete with f/2 or faster lenses, and they take superb pictures; but if you lose them, you have not lost too much.

If you are not worried – and I must stress again that if you keep an eye on your equipment and look as if you know what you are doing, you are unlikely to be troubled – you will find ultra-fast standard lenses such as the f/1.4 and the f/1.2 very useful.

Anything longer than a standard lens normally requires a tripod, though you can sometimes hand-hold f/2 lenses up to 135mm, or f/2.8 up to 90mm, at least with the aid of a bean-bag.

Although a tripod can be extremely useful when you are photographing cities, it is also exceptionally inconvenient. It is heavy, awkward to carry around, and would make you a sitting target for muggers in a place like New York City. If you possibly can, the best thing is to explore a place without a tripod, and then to go back if there is a shot where you *know* you will need a tripod and where it is safe to use it.

A table-top tripod can be surprisingly useful, in that you can set it on parapets, on top of traffic bollards, and lean it against walls in order to give you some extra stability, but it is still no substitute for a full-sized tripod.

If you are walking any distance, as I suggest you should, you would be well advised to cut your equipment to a minimum: one or two bodies and two or three lenses. A lot depends on how secure you feel – in Paris or Las Vegas you could carry more cameras, more confidently – but keeping the load down does more than just save your back: it also reduces the chance of theft. Carrying a camera bag is a very bad idea: if you can possibly avoid it, don't. You have only to put it down once to lose it.

FILM

A surprising number of photographers who love cities use Kodachrome 64. It is slow, but those super-saturated colours seem to convey the mood of the city better than 'gentler' films. Kodachrome 200 still offers surprisingly good saturation, but much less contrast: whether you prefer this, or the old style, is a matter of personal taste. If you use the slower films, you will frequently run into under-exposure, but this simply intensifies the colours still further.

For a completely different effect, try 3M's ISO 1000D and ISO 650T films. At first, they seem impossibly subdued, flat and grainy. But if you combine them with a flary lens, they give a uniquely romantic and soft image. I habitually shoot these ultra-fast films using a very old (about 1962) Canon 50mm f/1.2 rangefinder lens, which delivers truly awful image quality in conventional terms until you stop down to f/2. I love to shoot Paris this way, because that is the way I see it, romantically and none too clearly. The same approach would work in parts of San Francisco. You may well be able to find old, high-speed lenses of dubious quality for your camera; or, of course, you could try using a zoom, because the limited aperture will not be particularly problematical. Leave the lens-hood (lens-shade) off for this type of photography.

Choosing between daylight-type film and the tungsten variety is a matter of personal choice, and I honestly cannot decide which I prefer. For some applications, such as inside shopping malls, tungsten-balance film is unquestionably better. For others, day-light-balance film seems better able to hold the wide range of light-sources which exist in a modern city – not just tungsten lighting in buildings and car headlamps, but also sodium-vapour and mercury-vapour street lamps, and neon signs.

EXPOSURE

City streets are the archetypal location in which a wide range of exposures is acceptable – see page 84 – but with Kodachrome 64, you will frequently find yourself up against the wall. This is just as well, as walls are very useful for steadying cameras, and exposures of 1/4 and 1/2 second at f/1.4 are by no means unknown.

With fast films, such as 3M's ISO 1000, you may find that you have plenty of light: 1/30 at f/2 is often possible, and you may even reach the heady heights of 1/60. The best way to take your readings is as described on page 97, taking two 'limit' readings and guesstimating the actual exposure in any given case. A spot meter (whether built into the camera or separate) is one possibility, but a highly sensitive incident-light meter such as the Lunasix/Lunapro is arguably even easier.

103 Trocadéro, Paris
The plaza and gardens of the Trocadéro are usually full of people. These two were perhaps holding a philisophical discussion, perhaps discussing their love-lives, in the shadow of the Musée de L'Homme when I photographed them with a 90mm f/2 on my Leica (*RWH: 3M 640T: about 1/60 wide open*)

104 Streets of New York
One of the many things which fascinates me about New York is the clouds of steam which issue eerily from gratings and manhole covers. They look even stranger at night, and a long exposure seemed the best way time to capture them (*RWH: Leica M: 35/1.4: 3M film*)

105 Arc de Triomphe
The Place Charles de Gaulle which surrounds the Arc de Triomphe is the scene of one of the world's wildest traffic jams. This was shot with a 90mm f/2 on ISO 1000 daylight-type film; what I would really like to do is to use a still longer lens, shooting from much nearer the Place de la Concorde, to compress the perspective yet more. I would however need to use the fastest film available, probably ISO 3200, because my 200mm lens is only an f/3 (*RWH*)

121

9
CONCERTS AND PLAYS

106 Dancers
A major problem with dance in general, and ballet in particular, is that white clothes under theatre lighting are much inclined to 'burn out'. Ilford XP-1 is ideal for handling this (see Plate 56), but even the old standby of Tri-X can handle it adequately *if* you expose generously and print carefully (*SRA*)

In many ways, the photographic requirements for concerts and plays, or for various kinds of concerts for that matter, are very different. There are however enough family resemblances to make it worth considering them all together.

To begin with, unless you are shooting at a rehearsal or photo-call, you must be careful not to spoil the enjoyment of other patrons. At the very least, this is rude and inconsiderate; at worst, it can result in rapid physical ejection and (at some rock concerts) in damage to your cameras and your person.

Even if you are at a rehearsal or photo-call, it is very rarely advisable to use flash. Often, there is no need anyway – stage lighting is plenty bright enough, and a lot more interesting than flat on-camera flash – and even if the light is poor, flash will destroy the atmosphere. Again to preserve the sense of occasion, a quiet camera is highly desirable: often, an SLR without motor drive will be too noisy, and an SLR *with* motor drive is totally inappropriate.

The best locations for shooting plays and classical concerts are from the stalls of a steeply raked auditorium, but if the stalls are too flat, it is better to shoot from the mezzanine or lower balcony (circle). The only occasion when you might want to go really high, into the upper circle, is if you are shooting a musical and want to show the patterns on the stage, in the fashion of Busby Berkeley. Otherwise, shooting from the pit can be very restricting, but shooting from too high can result in pictures which the actors do not particularly like: no-one is keen on being looked down upon. Shoot from the centre, or you may reveal the edges of the scenery – something which is easily ignored during the play itself, but which can be very obtrusive in a photograph. If you have the option, also check out lighting-technicians' boxes, projection boxes, and even (for some sorts of experimental productions, including modern dance) the fly-loft. An old-fashioned prompt-box, plus a wide-angle lens, might also be interesting for some sorts of show.

If you are shooting rock concerts, you may be able to move much more freely, even up onto the stage. Or, of course, you may be firmly fixed in one place. *Always* get permission to photograph rock concerts, preferably in writing. The only exception to this is if it is a small venue and you are personally introduced by the musicians to the management. At big events make yourself known to all the hired gorillas before the concert starts, unless you want to risk grievous bodily harm and smashed cameras with the film ripped out of them.

SUBJECTS

At a play, go for cameos of individual actors; small groups; and, where appropriate, 'set pieces'. If you are shooting at a photo-call,

107 Iroko Quartet

In smaller, more intimate theatres you can work perfectly well with a standard lens: this was shot with the old 58/1.4 on my Nikon F, using ASA 160 tungsten-balance Ektachrome, and the exposure was about 1/125 at f/2.8. I needed a fairly fast shutter speed to 'freeze' the musicians' hands, and I also had to stop down for depth of field. I was able to use a reflex because I was shooting at a rehearsal, at the request of the producer, Senggye Tombs Curtis. The picture would have been improved with the use of a light blue filter, but the golden light is still quite acceptable (*RWH*)

108 Essential Bop

If you can get up on the stage, you can often get some very interesting pictures. This is Steve Bush, an extremely talented songwriter, singing with his first band, Essential Bop. The effects would be quite unacceptable in most cases, but here the contrast and yellow lighting echo the raw edge of some of his work (*RWH: Nikon F: 50mm f/1.4: film and exposure details not recorded*)

it is a better idea to ask the actors to repeat a sequence two or three times, rather than asking them to freeze in particular poses, which usually looks awkward.

At musicals and other spectaculars, go for the big set pieces, often with a 50mm lens to cover the whole stage.

At concerts, the most interesting pictures usually come from concentrating on one musician at a time. This is true whether you are shooting the second violin in a symphony orchestra or the singer in a rock band. With rock bands and small classical ensembles, such as string quartets, it is also a good idea to get a picture which shows the whole band, particularly if you are shooting with publicity in mind.

When shooting dancers, do not neglect the possibilities of using extra-long exposures (up to one second) to create colourful and dramatic blurs. You may also care to try the same techniques at rock concerts and conventional plays.

EQUIPMENT

Equipment can be divided into two groups: rock concerts, and all other events. At rock concerts, subject to the above reservations, you may be able to use lenses as wide as 21mm, plus motor drives – during the noisy passages, at least, the sound of the camera should be drowned by the roar of the amps. Alternatively, if you are stuck in a fixed position, it will usually be some way from the musicians. In this case, long, fast lenses are what you need.

For the rest, the importance of a quiet camera has already been stressed, but unfortunately it is usually impracticable to use a leaf-shutter camera because you are also likely to need a longer-than-average, reasonably fast lens. A Leica with a 75mm f/1.4 is probably the ideal, but if that is beyond your means consider other lenses such as the 85mm f/2 Jupiter for the Russian Kiev and Zorkii cameras. You can often pick up camera, lens and viewfinder for less than the price of a fast (second-hand) 85mm lens alone from another manufacturer. The lens is slightly flary wide open, so cut exposure by half a stop to a stop, and you may be amazed at the romantic quality of your images. If you must use an SLR, an 85mm f/2 or something similar will be fine.

Folk concerts are often held at more intimate venues, so you may be able to get much closer to the singer. In this case, a 50mm lens (on a very quiet camera) may well be ideal: alternatively, consider a leaf-shutter camera, either 35mm or rollfilm. With a 50mm, though, you may have to stand up in order to get your picture; unless you can work from the aisles, you may still prefer to shoot from a distance with a longer lens.

Tripods are rarely practicable, but a bean-bag (page 72) can be extremely useful if you are shooting from a theatre balcony. Secure it to your camera bag or something similar with a piece of string so that it does not fall on anyone below!

FILM

For colour, fast tungsten-balance film is essential, not so much because of the light *levels* as because of the light *colours*; as already explained, fast films are much more tolerant of off-colour lighting. Even so, remember that dimmers are normally used to

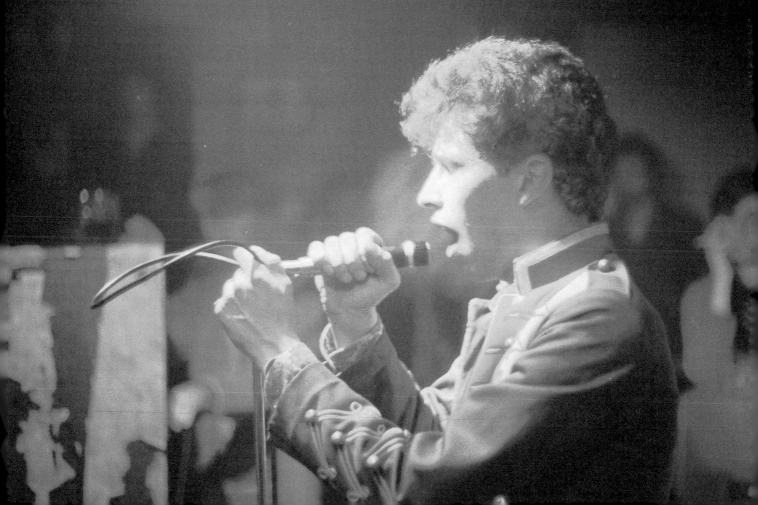

109　Singer
The rich textures of operatic
costumes are well worth capturing,
even if the expression in this case is
less than flattering. A longer-than-
standard lens (here, the old
Voigtländer Zoomar used at
maximum focal length) allows you to
pick out details; with prints, you can
further crop the picture while
enlarging (*SRA*)

110　Simon Tyler
Ultimate sharpness is not easy at a
rock concert – even if you have a fast
lens, because you then run into
depth-of-field problems – but a little
blur can add to the sense of
occasion. This is Simon Tyler, at the
time playing with Essential Bop,
photographed on HP5 rated at EI 800
and developed in Microphen (*RWH:
Nikon F: 28mm f/2.8 Nikkor*)

111 Dakini
The magic of this picture lies not in the king, who is suffering somewhat from camera shake, but in the demon beside him. The extremely long exposure (1 second at f/2.8) has produced an effect which is truly demonic. Would a tripod have been better? It is hard to say. It would certainly have made the king sharper, but it would also have inhibited rapid focusing and composition (*RWH: Linhof Technika 70: 100/2.8 Planar: ER*)

112 Antigone
Using Ektachrome 200 in a 4×5in camera (a Speed Graphic, in this case) may not be everyone's idea of theatre photography, but the results are undeniably superb. The lighting was straightforward theatre lighting, and the lens was slightly wide-angle for the format (a 135mm f/4.7 Xenar). You have to get in close if you want to shoot like that (*SRA*)

control light intensity, so colour temperatures even without coloured gels ('jells' – filters, formerly gelatine but now usually acetate) can vary from about 3200K downwards. A very weak blue filter (say 1.5x) may not be a bad idea.

Remember also that many black-and-white films lose half a stop to a stop in speed when they are used in tungsten light, though the faster the film, the less likely this is to be a problem.

EXPOSURE

The biggest single problem, as already intimated, is likely to be the variations in colour temperature. If you can, use a colour-temperature meter and an incident-light meter, and make all the compensations you can. At rehearsals and photo-calls, if you are the official photographer, you may well be able to arrange for less contrasty lighting to be used. Ask the lighting tech to bring up the cycs ('sikes' or cycloramas, used to light the background) or dips (footlights) or both, and possibly for spots to be widened or barn-doors opened. Aim for a maximum lighting ratio (measured with an incident-light meter) of 16:1; anything less than about 8:1 is unlikely to look sufficiently theatrical, while anything more than 16:1 is likely to record as pools of light amid general blackness.

Otherwise, use a spot or semi-spot meter and bracket a stop either way. It is very difficult to give meaningful recommendations, but there have been many shows where I have been able to use 1/60 or 1/125 at f/2 even with the old ASA 160 tungsten-balance Ektachrome; if your subject is strongly spotlighted, you may well be able to use 1/250 at f/2.8 or even 1/250 at f/4 with something like 3M 650T or Fuji 1600 with an 80-series blue filter (effective rating about EI 500).

At rock concerts, where the light can vary wildly in both colour and intensity, some off-the-film automation systems *may* be able to cope with things. Otherwise, take repeated readings, rely on experience, and bracket like film is going out of fashion. If you possibly can, get your readings (incident, of course) while the lights are being set up.

10
INTERIORS

Although many of the other topics covered in this book are shot indoors, and are therefore 'interiors' almost by definition, the difference is that in this chapter we are concerned with the interior itself: its architecture, its décor, or whatever.

There are, however, two very different kinds of interiors. There are those that do not show people, and those that do. They call for different techniques, different exposures, and different films. And among the interiors where you do not show people, you have a choice of general shots or detail shots.

With most interiors, too, the key to getting the best pictures lies in one word: *permission*. If you ask the correct authorities, you will often be permitted to set up your tripod and do the job properly, rather than trying to grab a shot and possibly making yourself unpopular in the process.

You will find it easier to get permission if you promise to give the owner (or whoever) a print: this is especially true if you point out to them the archival value of a record. This was how I got permission to shoot the interior of the Methodist Central Hall in Bristol, a magnificent panelled room which looked more like a parliament-hall than a chapel. Unfortunately, as we shall see, I did not actually get to take the picture.

If you can, have your camera and tripod in the car, so that you can shoot as soon as you have permission: it looks a bit presumptuous if you actually have it with you, as if you were only asking their permission as a formality. If it is not convenient to shoot then and there, fix a firm time and date. Otherwise, time may simply slip by and you will not get around to it. This is what actually happened to me over the Central Hall picture, and I still regret missing it: the building was sold for redevelopment.

If you go to the trouble of getting permission, use it! If you don't, you will create three problems. One is that you will make it more difficult for yourself to get permission in the future; the second is that you will make it more difficult for others to get permission (imagine how you would feel if you were denied permission because of another photographer's casualness); and the third is that you may well regret missing the picture, especially if the building is subsequently torn down for redevelopment, as already described.

SUBJECTS

If you want to see some truly superb church interiors, go to the library and look through old *British Journal of Photography* Almanacs, pre-World War II. They show a superb control of perspective, and they were shot using impossibly slow films, f/32 apertures, and exposures of one or two *hours* or more. The photographers used to take lunch in a nearby pub during the exposure!

133

For my part, I have photographed more Tibetan temples than churches, but there are other interiors which have fascinated me. One day I am determined to go and photograph the mighty interior of Grand Central Station in New York, using a tripod-mounted camera; in fact, the interiors of stations could be quite a fruitful field to explore.

Another possibility, which has been well explored by David Whyte among others, is the world of 'designer' interiors, or the highly personal ways in which some people decorate their rooms. You can get ideas for these from reading magazines, especially features like 'A Room of My Own' in general-interest magazines.

EQUIPMENT

If you want to show as much of an interior as possible, you are going to need a wide-angle lens. Speed is not particularly important, as you are likely to want to stop down considerably for maximum depth of field, but this in its turn implies long shutter speeds, which means using a tripod. If you are using a 35mm camera, the least you are likely to want in the way of a wide-angle is 24mm; 21mm or 20mm is often useful; and anything wider, while occasionally useful, is likely to be ruinously expensive, and best hired for particular pictures.

For 'classical' interiors, like the churches mentioned above, you will need a rising front on a view camera, or its modern equivalent, the shift lens. You can sometimes buy a 4x5in camera, and a rollfilm back, for the price of a shift lens: consider this option, instead of remaining wedded to 35mm. Larger formats hold detail better, and present a 'richer' image. Also, you can use faster film if the occasion demands it: ISO 400 on 6x7cm gives much less grainy results than ISO 400 on 35mm! I actually use a 'baby Linhof', a miniature technical camera which accepts 6x7cm and 6x9cm rollfilm backs as well as cut film, with a 65mm Angulon – the old f/6.8 model, not the modern Super Angulon. If I could afford it, I would buy a 53mm f/4.5 Biogon, but these are rare and very costly nowadays.

As a compromise between 35mm and the Linhof, consider a conventional rollfilm SLR such as the Mamiya RB67, which offers a wonderfully wide and relatively fast lens in the shape of the 50mm f/4.5. This lens can actually be used at full aperture, and is equivalent to about 24mm (arguably even 21mm) on 35mm.

If you want to shoot details, you may be surprised at how long you will need your lenses to be: some church paintings, for example, really need a 200mm lens. Also, as most details are flat or at least relatively shallow, you can use wider apertures if you have them.

If there are people in your picture, you will normally need to use action-stopping shutter speeds (see below), and you may also choose to use wider apertures with consequent differential focus. In this case, 35mm is normally your only practical bet: I often use the 21mm on my Leica at full bore, because even at f/2.8 everything from 10ft (3m) to infinity is in focus. At closer ranges, a focused 10ft (3m) gives about 6ft to 30ft (2m to 10m) in focus, which is normally adequate.

Whether or not you should use flash is a moot point, and will

113, 114 Bar
I shot this picture twice, once with people and once without. The Linhof Technika 70 was mounted on a Benbo tripod, with the 100mm f/5.6 Symmar lens used wide open. For me, the image with the blurred patrons is much more interesting (*RWH: White Hart, Exeter: ER: about 1/2 or 1 second*)

depend on the circumstances of the shot as well as on personal taste. If you decide not to do so, remember that few flashes will cover the field of view of anything wider than 28mm lens, even if they are fitted with some sort of wide-angle diffuser. In this case, a home-made flash bracket with two or more guns positioned for maximum coverage may be useful. Because most guns throw a rectangular or oval pitch of light, it is usually best to mount them the 'wrong' way; then, two regular guns can be made to cover about 60–65° vertically, 90° horizontally. This is just about enough for a 20mm lens on 35mm, or 47mm on 6x7cm. Two guns of the same power allow you to close down by one stop, when compared with a single gun.

Alternatively, you can use bounce flash. This is really only useful in confined spaces, as even the most powerful guns are simply not up to lighting an entire full-size church. The advantage of bounce flash, on the other hand, is that you can use it with people in shot; non-bounce flash is likely to give tell-tale shadows, 'cardboard cut-out' effects, and overexposure of fore-ground material.

For details, you may sometimes find that direct flash is desirable. On the other hand, direct flash will usually flatten any modelling on carvings or mouldings, and may even lead to 'flashback' (direct reflections) from some kinds of paintings. The latter is not usually worth worrying about, though, if you are working at forty or fifty feet or more, as may often be the case with church ceilings. For close-up details, consider using a twin-boom flash bracket, as described on page 105; for distant details, you may find it useful to use a 'telephoto' attachment on your flash.

A number of the better guns accept these: they are clip-on tubes which fit over the flash head and focus the light with a plastic fresnel lens, so that the angle of coverage is reduced considerably. Some are fixed, and correspond to something like a 105mm lens; others offer a 'zoom' facility, for matching the output to different lenses. The only way to determine exposure with these is usually the guide-number approach, and of course the guide number varies according to the setting.

The best tripod to use is probably the Benbo, as it can be set up in the most extraordinary positions. On those occasions where you cannot use a tripod *or* flash, fast film is your only salvation.

FILM

With a tripod, it seems pointless to accept the loss of image quality, to say nothing of the expense, inherent in using fast films: ISO 50 or 64 is plenty, unless there are people in shot.

Tripods are, however, forbidden in many places and inap-propriate in others. In this case, you should be able to get away with a modestly fast film if you are using extreme wide-angles, even in quite poor light: I have found that I don't often need anything longer than 1/30 at f/2.8 with ISO 200 film.

Only very rarely do you require anything much faster, but there are interiors so gloomy that your only real hope is seriously fast film. Before you make your decision, think hard. Interiors often have a strong 'personality', and you might find that one was

best served by the mushy, romantic grain of Scotch/3M film while another looked best on a Kodak or Fuji product. Remember too the impact of a really subtle picture in black and white, with a very long tonal range.

EXPOSURE

Tonal ranges are often very long in interiors, and the most useful meter is undoubtedly a spot or limited-area meter, whether hand-held or built into the camera. Meter as many areas as possible, and choose your exposure carefully. With black and white, expose for the shadows; with colour, expose for the highlights.

In many cases, the best way to determine the shutter speed is to use the optimum aperture of your lens, and to let that determine the length of the exposure. With the Linhof/Angulon combination already mentioned, this means working at f/16–f/22, which often means exposures of several seconds. If you have to, stop down for still more depth of field or open up to allow a shorter exposure.

With 35mm cameras, you will normally be using larger apertures. For a top-flight lens, resolution should not improve beyond f/5.6 or so, and will deteriorate significantly beyond f/11. With cheaper lenses, f/11 may be the best bet. This normally means exposures in the 1/30–1 second range, or more if you have to stop down further for more depth of field.

If you cannot use a tripod, the best bet is often to use the lens wide open, and (once again) to let your maximum aperture determine the shutter speed. If the shutter speed is unrealistic, go to a faster film. You lose the 'deep field' effect, but this seems preferable to using fast film as a matter of course. With a bean-bag (page 72), you can in any case go to 1/15 or 1/8 with a fair degree of confidence. In most cases, 1/8 is all right for people seated; if they are moving, they tend to require at least 1/30, though 1/15 is often acceptable if they are standing still.

115 Grand Central Station, New York
Grand Central Station is one of those places that I would like to document for a whole day. This dates from my first visit, and was shot with a 21mm f/2.8 lens on a Leica. If I get back, I shall seriously consider hiring a 15mm lens for the Nikon, and even if I use faster film (this is Kodachrome again) I shall still use a long exposure because I love the swirling crowds (*RWH*)

116 Longwood gardens, Delaware
Tripods were not permitted here, but unfortunately I did not know this when I went, or I would have packed some faster film. As it was, I was still able to get some surprisingly good pictures on Kodachrome 64 (*RWH: Leica M: no lens or exposure details*)

117 Ice-cream parlour, Champs-Elysées
In the Champs-Elysées, there are a number of what Americans would call 'malls', large shopping complexes. In this shot, there seems to me to be just the right balance of people and open space. I can't remember which lens I used, but it looks like 35mm (*RWH: Leica M: 3M 640T*)

118 Tibetan temple
In Western churches, black and white normally emphasises the austerity of the geometry. In many other religions, colour plays an important part, as can be seen from the interior of this Tibetan temple (*RWH: Linhof Technika: 65mm Super Angulon: no other information recorded*)

11
LANDSCAPES

As with cityscapes, most of the best 'night' landscapes are not shot when it is fully dark. At the very least, they are shot when there is some light in the sky, usually at dusk rather than at dawn, and it is not unusual for them to be shot during the day, using *nuit Américaine* or 'day for night' (page 112).

I have already talked about the advantages of having some light in the sky in Chapter 8. In the city, the principal concern is normally to 'hold' the edges of buildings, so that they do not simply merge into the general blackness. With landscape photography, the motives (and effects) are often somewhat different.

To begin with, the sky often *is* the main attraction in twilight shots. The range of colours that the sky can assume is astonishing: literally every colour in the spectrum, red, orange, yellow, green, blue, indigo, violet. The only catch is that the extraordinary grandeur of a sunset (or more rarely, of dawn) can be so overwhelming that we shoot it without stopping to consider the composition of the picture. As a result, anyone who shoots sunsets is likely to have many, many photographs which record these colours but have nothing else to commend them. Sunsets are not difficult to capture, provided you do your metering properly (see below), but in many cases, the sunset is all that there is to see. There is no focal point to the picture, nothing to hold the attention; once you have finished the 'ooh, aah' responses that the colours evoke, there is really nothing there.

Also, a landscape is likely to have a far shorter tonal range than a cityscape. In the city, the glaring lights make for a range of contrast which is far too great to be captured on film; in the country, there is at least a chance that you will be able to record a natural-seeming scene without too many areas of inky blackness or burnt-out highlights.

This means that you can shoot successful landscapes when there is far *less* light in the sky than you would need in the city; in fact, you may still be able to get some detail in the sky for several hours after the sun has set, though eventually you will run into the kind of deep, velvety blackness which will require an enormously long exposure if it is to register at all. The problem here, as already mentioned on page 80, is that the stars will elongate into streaks and the moon will assume the appearance of a sausage. 'Streaked' stars can be seen in Plate 11, which was about a ten- or fifteen-second exposure.

Unless you live well out in the country, you may however find that the sky is never really 'clean'. I live about 200 miles north of Los Angeles, and the air on the Pacific Coast Highway is staggeringly clean and clear; sometimes, I will just sit and stare at the night sky. If I go south to Los Angeles, I know that the night shots will usually have a brownish or orange sky, which is caused by light from street-lamps, homes and advertising signs reflected from the well-known Los Angeles smog.

119 Sunset, Club Med
Effective black-and-white sunsets are rare, but Cath Milne managed it here. The foreground is reduced to a silhouette, but that is the penalty you pay for shooting sunsets unless you can use fill-in flash (page 105) (*Cath Milne: no technical information available*)

120 Early morning, Arizona
The overall veil of white light in this picture belies the actual light level. It was dawn, and it was surprisingly cold; I had to use a tripod to avoid the risk of camera shake. The exposure was about 1/30 at f/4.5, using a Mamiya RB67 with a 90mm lens and ISO 64 Ektachrome (*RWH*)

121 Sunset, Bombay Hook
Some sunsets last well after the sun has actually slipped below the horizon. Frances Schultz shot this in Delaware, several minutes after sunset, and was rewarded with a spectacular range of colours (*FES: Nikon F: 50/1.2: KR: no technical information available*)

122 After sunset in the Himalayas
Another post-sunset phenomenon, albeit a rare one, is rays of light shining up into the sky. This was shot from the balcony of Kashmir Cottage (see Plate 00) (*RWH: tripod-mounted Nikon: 200/3 Vivitar Series One: KR: about 1/60 @ f/4*)

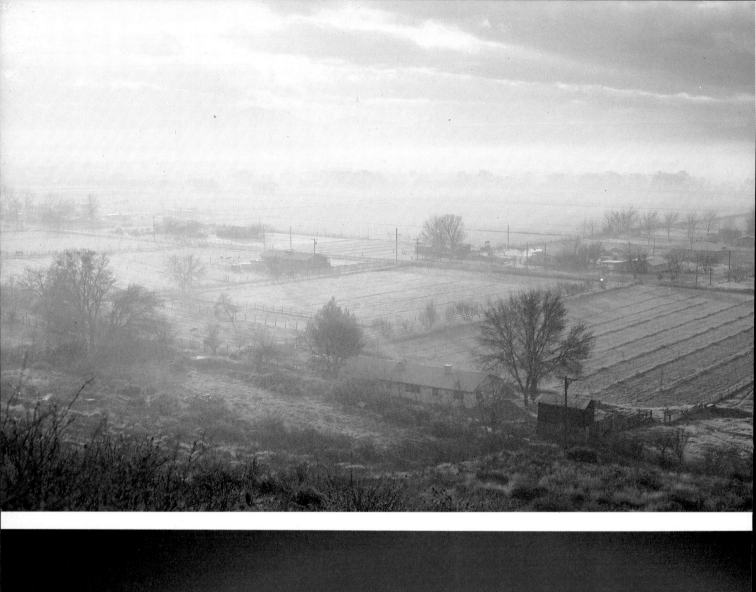

Of course, if you are shooting villages, you will usually be faced with a compromise between countryside techniques and the techniques already described for the city. Village lighting is likely to be a lot weaker than city lighting, but it will still overpower sky-light eventually, so you will have to stop shooting earlier than you would in the countryside.

SUBJECTS

Virtually any landscape that you could shoot during the day, you can also shoot at night (or at least, in twilight). In some cases, the colours in the sky will allow you to silhouette the foreground; in others, where the sky is duller, you may decide to go for a more conventional rendition.

Effects at dawn and at dusk are often quite different. Not only is the light coming from the opposite direction but at dusk there is usually far more water-vapour and dust in the air, so that the contrast of distant subjects is lower while the richness of the colours in the sky is greater. Dawn is the time for breathtakingly clean lemon-coloured skies, sometimes shading into green; dusk is the time for the reds, the blues and the purples.

Whether you shoot at dusk or dawn, there is one problem you are going to have to face. Either before or after you take the picture, you are going to have to get to or from the shooting position in darkness or partial darkness. Even if you are willing to impersonate a mountain goat while searching out the right position for shooting a landscape, you should be aware of the dangers of walking in the dark. Wear *very* stout boots, tightly laced to protect your ankles; carry a torch (see below); and use your tripod both as an alpenstock and to probe the ground ahead of you.

EQUIPMENT

One of the most important things for shooting around dawn or dusk is sheer speed of operation: because ideal lighting conditions are unlikely to last long, you really need to have the right lens on your camera and to be ready for action. This really means that you have to pre-plan your shots, and to keep your kit to a minimum so that you waste no time changing lenses. If you have more than one camera body, have them *all* loaded and ready for use; I have even been known to set up two tripods, one with a 280mm lens and one with a 400mm lens, ready to shoot a particular mountain scene as the sun set.

You can use virtually any camera and virtually any lens for low-light landscapes; I have used everything from the shortest lenses I own to the longest, and all have had their place. One word of warning, though, concerns the use of long-focus lenses. Mirror-induced vibration with reflexes can be a real problem in the 1/15–1/60 second range, so I always use 1/8 or longer, even if it means stopping down to do so. Often, I use the mirror lock too.

For lenses over 200mm, consider using *two* tripods. The bigger, heavier one is fitted to the lens in the conventional way (I assume that your big lenses have their own tripod sockets) while the smaller one is either attached to the camera's own tripod socket or used to support a home-made cradle in which you rest

123 Waterfall
Steve Alley, in his own inelegant but telling phrase, 'froze his butt off' taking this picture with a Rollei TLR at dusk; the moral is that you sometimes have to suffer for your art. The film is Ilford's remarkable XP-1 rated at EI 1250; the exposure was 4 seconds at f/8 (*SRA, printed by Frances Schultz*)

the front end of the lens. You can make the cradle out of a piece of bent metal, covered with a bit of fabric to stop it scratching your lens and to improve damping. Because the function of the second tripod is to kill vibration, rather than actually supporting the camera, it can be an old, cheap, lightweight 'wobble-pod'.

One piece of non-photograpic equipment which every would-be night-time landscape photographer should carry is a reliable, well-made torch. City-dwellers often forget that it gets *dark* away from city lights, and a torch will not only help you to see the way; it will also enable you to set shutter speeds and apertures on your camera, though you should of course be able to do this largely by touch (page 28). Rechargeable batteries are a good idea, and so are the modern high-intensity bulbs, available for most popular flashlight fittings.

FILM

When it comes to landscapes, there really is very little point in using fast films. A tripod allows long exposures, and slow film (such as Kodachrome 64) is often the ideal medium. Kodachrome is also very tolerant of long exposures; check the reciprocity characteristics of any film that you plan to use for very long exposures. The main reason for using faster films, such as Kodachrome 200, is to tame contrast somewhat – and even then, high contrast is often what adds drama to a landscape.

Admittedly, there may be occasions when another film suits your purpose better – as so often, the ultra-grainy material from Scotch/3M comes to mind – but this is an artistic rather than a practical decision.

EXPOSURE

The most critical thing about shooting at dawn and dusk is the way in which the light is changing so rapidly. At the moment of sunrise, the colour of the light suddenly changes from blue to red, and you find yourself with an extra stop or two of light in a matter of seconds. At sunset, the reverse can happen, though the light loss is usually slower and less dramatic.

You might suspect that an automatic camera was the easiest solution to your problems, but the problem of the 'average' exposure (page 84) raises its head again. Also, many cameras are unable to give accurate readings of more than eight or ten seconds. Much the easiest option is either a spot-meter (in-camera or hand held) or a separate incident-light meter. Either way, you are going to have to make frequent readings, and unless you are using an in-camera meter you may well have to guess at increases or decreases in exposure since the last reading. It is also a good idea to bracket generously.

Perhaps surprisingly, an in-camera meter often handles sunsets just as well as a hand-held meter. Point either straight at the sunset (without the incident-light cone, in the case of the hand-held meter) and use the reading as a starting point: expose at the indicated exposure, and at one, two and three stops less. Alternatively, turn your back on the sunset and take an incident-light reading facing east: this will give an astonishingly accurate exposure, though it is still as well to bracket one stop either side.

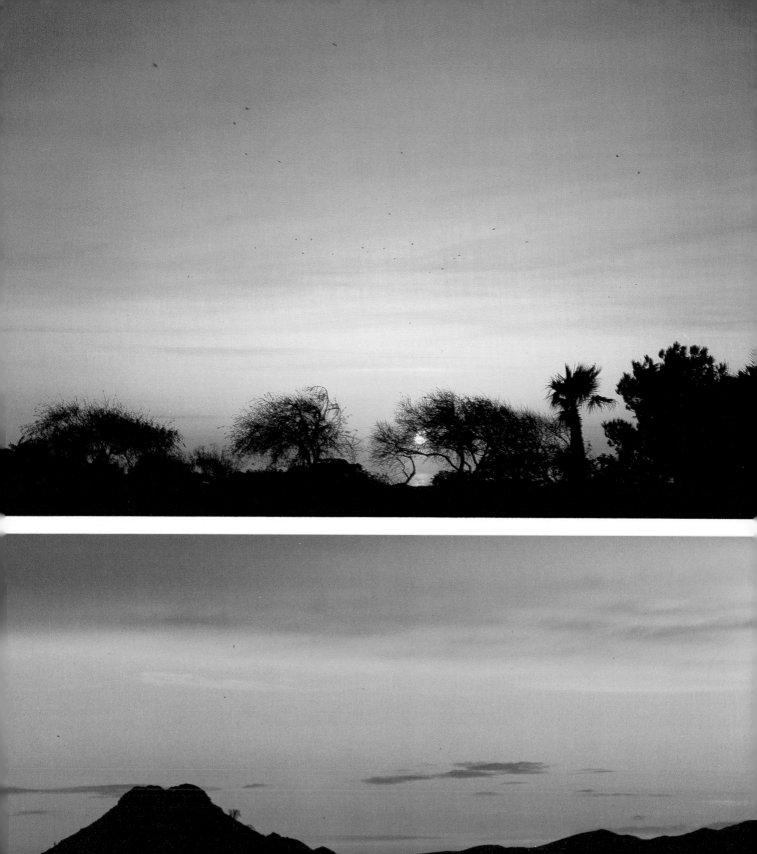

12
NIGHT LIFE AND PARTIES

'Night life' is a form of reportage (Chapter 14), but it is played on more familiar turf. 'Night life' is going to a disco, or a restaurant, or a pub, or just going for a walk. It is essentially about people, but it is not portraiture; the emphasis is on what people are doing, rather than on how they look. Plays and concerts (Chapter 9) are excluded; people in night life are participants, actors in their own right, rather than spectators.

SUBJECTS

Your choice of subjects will depend on your own preferences when it comes to night life. It will also depend, to a certain extent, on your own *chutzpah* or even bravery: I would love to take more pictures around the red-light Dam area of Amsterdam, but I would want to make sure that my cameras were fully insured first.

I have however taken a lot of photographs in pubs; the English pub is one of the most agreeable public places in the world, and people are very rarely self-conscious.

Your interests may well be different: for example, you may like dances and discotheques, or formal balls and dinners. I have, therefore, departed from the usual format in this chapter and

126 Girl in beret
I don't know who this girl was, but she semed to me to personify the vivacity of student-age night-life, when no issue is too large to be discussed far into the night (*RWH: Nikon F: 58/1.4: HP5*)

127 Gent's toilet, Great Western Beer Festival
I debated long and hard about putting this in — some people might find it in questionable taste — but eventually I decided that it was a classic example of night life, and it shows that you can take a camera almost anywhere without seriously offending anyone (*RWH: Nikon F: 50/1.4: HP5 @ EI 650: 1/30 wide open*)

128 Friterie, Paris
An important part of night-life is food, from *grand luxe* restaurants to fast-food stalls. The Place Pigalle abounds in places like this, and despite the somewhat unsavoury reputation of the area I have never had any trouble there except for the time I was propositioned by an extremely beautiful whore – so beautiful that I almost regretted turning her down. In Franch slang, 'Je suis Anglais' means both 'I am English' and 'I am broke' (*RHW: Leica M: 35/1.4: KR: about 1/30 wide open*)

129 Chess in the rain, New York
New York is an extraordinary city. I don't like it, but I can see why some people do. Where else would you find people playing chess under umbrellas in the rain, just outside a topless bar? (*RWH: Leica M: 35/1.4: KR: 1/30 wide open*)

given at the end a list of different subjects, with suggested combinations of cameras, film and techniques.

EQUIPMENT

Because you are dealing mainly in 'grab' shots, you need to keep your equipment simple and fast-handling. A fast wide-angle is probably the most useful single lens; one camera body should be enough, though if you have room, you might care to carry another body (and possibly another lens, if you have a particular shot in mind). If you are intent on serious night-life photography, or if you are deliberately trying to 'cover' an event, you might want more equipment, and the best way to carry it is in a photographers' jerkin – the sort with lots of pockets – but if you are just out wandering or going to the pub or a party, you will usually be better served by a single camera and one lens.

Very occasionally, there is a need for a long lens. The image which comes to mind is one I have not yet taken: a long shot of a pair of lovers walking beside the Seine, to give a more natural perspective when shooting from a bridge. With 90mm or shorter lenses, you get an unpleasant foreshortening if you shoot downwards, but if you shoot from the path itself you do not get the background. If I still owned it, my soft, old 135mm f/2 would probably be ideal; as it is, I suspect that I shall use either the 135mm f/2.8 for the Leica or the 200mm f/3 on a Nikon.

There is one other case when special equipment is highly desirable: parties. In this case, it is usually much more interesting to forget about fine technical quality, and concentrate on enjoying yourself. The only exception is when you are being paid to cover a celebrity 'bash'.

The party camera must therefore meet three requirements. First, it should be simple: you don't want to spend the whole evening fussing with interchangeable lenses, flash, exposure meters and so forth. Second, it should be reasonably party-proof: ideally, it shouldn't matter if someone spills a drink on it. And third, it should not be too valuable, so if anything does happen to it, you won't mind too much. Ideally it should also have a wide-angle lens, and be reasonably compact.

While you could buy a modestly priced new camera which meets these specifications – some people buy disk cameras for just this sort of purpose – you can also have fun looking for a second-hand camera which meets these specifications. My own choice is an old Olympus Pen-W half frame with a 25mm wide-angle lens (about equivalent to 35mm on full frame), which is amazingly small and delivers surprisingly good quality: at the party, it lives either in a pocket or on a wrist-strap. Other possibilities might include the kind of 'disposable' cameras described in Chapter 8.

FILM

An altogether astonishing amount of night-life photography can be done with slow films: just look at the number of Kodachrome 64 images reproduced in this book. This is, however, somewhat masochistic nowadays: Kodachrome 200 is a lot easier, and still delives surprisingly good quality. On the other hand, Koda-chrome 64 is a good deal cheaper than Kodachrome 200, it

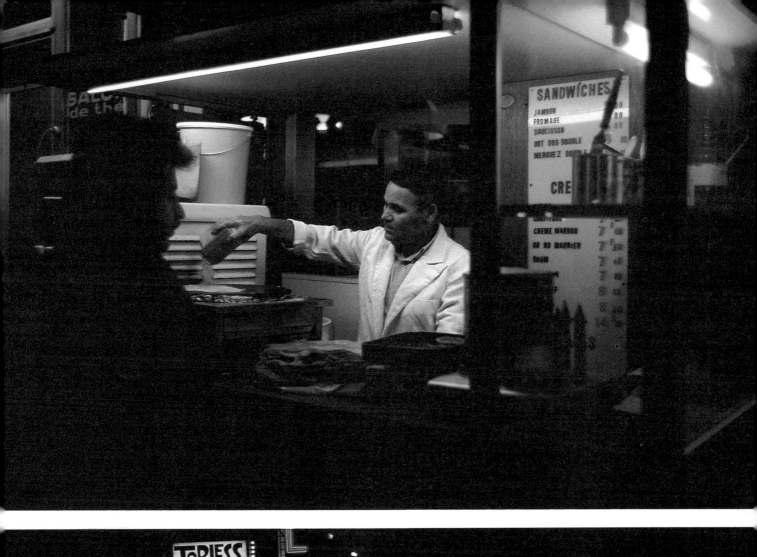

130 Senggye

Some people are in their element at night; this is one of the best pictures I have ever got of Senggye, taken on a floating pub in Bristol. In the original print, you can *just* distinguish his black shirt from the night beyond, but it will be lost in reproduction. It doesn't matter; the eye links the head and the hands together (*RWH: Nikon F: 58/1.4 Nikkor: HP5 rated at EI 1600, with no regard for shadow detail, and developed in Microphen: about 1/30 @ f/1.8*)

131 Arnolfini Gallery, Bristol

A rather more decorous example of night life than the Beer Festival, this is also a much more considered shot. I liked the arrangement of the sculpture, but it seemed a bit 'empty', so I waited until someone came into shot. She most obligingly stopped to look at a picture, so I was able to bracket the shot to my heart's content (*RWH: Nikon F: 50/1.4: HP5 @ EI 650: 1/60 @ f/2*)

delivers more saturated colours, and besides, Kodachrome 200 was so new when this book was written that I had not had time to expose much of it!

In monochrome, Ilford XP–1 is ideal (use a base rating of ISO 650 or so) or you can rate something like HP5 at EI 320 for fine grain or EI 650 for speed while retaining full shadow detail: see page 53.

For party photography, using a snapshot-type camera, you usually need colour-print film. Use either ISO 100 film with flash, or fast film and no flash. I use Fuji ISO 1600 in 24-exposure loadings, which gives me a maximum of 48 exposures, but even if I don't finish the film, it still goes into the one-hour lab next day. Not all these labs can handle half-frame, and some charge extra if they do, so it is worth checking around before you go for this little economy. The grain is like popcorn, and the colour balance isn't too good, but everyone likes to see the pictures.

Other film recommendations are given below, under the various subject headings.

EXPOSURE

Exposure determination is usually a matter of guesswork plus the occasional incident-light or spot-meter reading; if you read (for example) a shop interior, a sidewalk cafe, and the area beside a street-lamp, you will have a pretty good idea of what exposure to use in order to favour a particular area of your picture.

As a general guide, a good starting point for non-flash exposure indoors is 1/30 at f/2 using ISO 650 film; this will give

132 Helen Garside
Helen was getting dressed up for a
'tarts and vicars' party, where all the
girls look as depraved as possible
and the men pose as models of
rectitude. I arrived just as she was
getting ready to go: the picture may
not be brilliant (there was very little
light) but it certainly brings back
memories! This was in the days
before ultra-fast films, and I manged
to shoot this on ISO 50 stock at f/3.5;
by the look of it, at about one second
(*RWH: Leica IIIa, 50/3.5*)

good shadow detail. For places that are more brightly lit, you can afford to go to 1/60 at f/2.8 or f/4 with the same film. With really slow (ISO 64) film, 1/30 at f/1.2 or f/1.4 will normally give good detail in the faces, but with very little shadow detail.

For ISO 1600 'party' photography, you can guess accurately enough. A brightly lit room calls for 1/60 at f/2.8; a typical domestic room is 1/30 at f/2; and when the lights go down, you start guessing. Err on the side of over-exposure if anything, as with any colour-neg film: this is what the above recommendations are based on. Because no-one worries about a little camera shake, you can get away with long shutter speeds if no-one bumps against you or tickles you; I frequently use 1/15 and sometimes go to 1/8.

TECHNIQUES FOR DIFFERENT SUBJECTS

Balls: there are two approaches here. You can treat the ball like a party, and take snapshots (see above, and **Parties** below), or you can treat it as an exercise in photojournalism (Chapter 14). Either way, you are going to be fairly obtrusive. Most people seem better able to handle the 'snapshot' approach and you may care to use a very small camera which can be put out of sight when you are not using it.

Banquets: as with balls, you are going to be obtrusive no matter what camera you use. If you are well known to your colleagues as a manic photographer, this is no problem; otherwise, you might do better to forget taking pictures. You can get good candid shots with anything from 24mm to 50mm and fast film: if you are not seated near the head of the table, you may care to use a fast (f/2 or so) lens in the 85mm–105mm range during the speeches. Flash is never welcome: fast black-and-white film often reflects the slightly old-fashioned nature of a formal dinner more effectively than colour.

If you want to try something really original, use a large-format camera (4x5in or above) at the end of the dinner and shoot an old-fashioned 'banquet group'. Don't worry about subject movement: drunks usually sit surprisingly still. Once upon a time, special 12x20in 'banquet cameras' were manufactured especially for this kind of picture.

Barbecues: as for **Parties,** below. You will get more dramatic pictures at the barbecue itself if you wait for the fat to flare up. Warn the cook before using flash: being momentarily blinded while you are manipulating a hot hibachi is no joke. Watch out for sputtering fat on the camera lens!

Beach Parties: the only ideal camera here is a 'hardened' model. The Nikonos is of professional standard, but it is expensive and requires a weird Nikonos-unique underwater flash fitting. Otherwise, there have been a number of submersible cameras which will withstand a brief dunking in shallow water. The better models will float.

If you want to use your regular camera, cover all the joints with gaffer tape (duct tape) before you go on the beach, and don't put the camera down on the sand, which can still get into the focusing helical of the lens. Protect the glass with a UV filter. Alternatively, buy a 'hot-water bottle' cover such as the one made

154

133, 134 Student Parties
If you can keep your head when all about you are losing theirs, you probably know Kipling's poem. Both of these are typical 'party' shots (though Steve prefers flash, and I prefer very fast film), but the girl in the middle of one picture 'ties it all together' and makes a much more satisfying picture. If people are posing for the hell of it, try to get them to pose properly! (*SRA*)

by Ewa Marine: these are inexpensive and will protect most cameras against most things, short of prolonged immersion at three feet or more.

Flash is normally the only option for beach parties, unless you have a fire, though these are illegal on more and more beaches. If you are going to use flash, you might as well use slow film – ISO 100 for snapshots, ISO 50 or 64 for transparencies.

Card games: DO NOT try to shoot these in casinos, or the management will either ask you to leave, or set their hired gorillas on you. For pub games, use a standard lens and fast film: black-and-white often looks better than colour. For private games, try to catch the light so that it emphasises the cigarette-smoke which seems always to accompany card games. Never us flash unless you want to make enemies: these people are trying to concentrate.

Carnivals: these probably call for a wider range of lenses and techniques than any other form of night-life photography. You may need lenses from 35mm (crowd shots, intimate reportage-type pictures) to 200mm (floats and individuals in parades), and the minimum film speed which you are likely to find useful is ISO 200: this or ISO 400, depending on your personal preferences, are probably the best bet in colour, while the usual fast films will be fine in black-and-white. If you are using long lenses, you may need even faster colour films. See also Chapter 14.

Discotheques: apply similar techniques to those described for rock concerts (page 125), but use faster film since the lights are usually less intense. Use any focal length from fish-eye to 50mm:

156

longer lenses will not cover enough area and will also create too much risk of camera shake. If you want to capture strobe effects, choose areas where the other lights will not 'burn out' the strobes, which are normally very low-powered, and use reasonably long shutter speeds – at least 1/15 second, and possibly as much as a full second. Strobe-lit subjects will show up better against a dark background. For laser light shows, short exposures (1/60 or less at f/2.8 or so) will capture the light show but not the floor; if you want that, you will need to use flash as well. Get permission first!

Even if you get permission to use flash, remember that it can be dangerous if it blinds or disorients dancers, even momentarily. This is particularly true in roller-discos.

Night clubs: as with banquets, consider other people's feelings. There are some night clubs where cameras flash all the time, and others where merely taking our your camera may lead to your being thrown out. Use your judgement, preferably in conjunction with a 35mm f/1.4 lens, ISO 800 or faster film, and no flash. If you use a Leica, people may even think you are one of the *paparazzi*.

Parties: this has really been covered in the 'equipment' and 'film' sections above. Order a double set of prints, if need be, and remember that it is always easier to shoot extra pictures at the time than to get reprints later: if you have five friends in a single picture, shoot five exposures if you think they will all want a copy.

Pubs: the simpler your equipment, and the more resistant it is to getting beer on it, the better. A single camera body loaded

with fast film (I prefer monochrome; you may prefer colour), and a fast wide-angle lens, is ideal. A standard lens is also useful if you want to photograph others without their being aware of it. I have had a good deal of fun shooting pubs 'all in' with a 21mm lens.

Restaurants: always remain considerate of other people. How many times have your meals been ruined by a large, giggling party who seem to want pictures taken of everyone, every thirty seconds, using flash? Shoot a few good pictures rather than a lot of bad ones; for a table-full of friends, use reasonably fast (ISO 200) colour-print film and bounce-flash (off the ceiling) to get even lighting. Direct flash can all too easily burn out the foreground and leave the people at the other end of the table in murky darkness.

Sidewalk cafes: you can live without shadow detail; besides, if you try to get detail out of doors, the indoor part of the cafe will 'burn out'. Even quite slow films (ISO 64) can be used, but Kodachrome 200 exposed at 1/60 at f/1.4–f/2 will help tame the contrast. Use 50mm or even 90mm lenses. Be careful when photographing lovers: some will be flattered, but others (especially if they are married to someone else) may offer you a punch in the throat.

Some people like to use a low-powered flash for this sort of photography, but I don't: it seems to me to be rude and intrusive, and to remove the point of this sort of photography anyway.

Street scenes: recommendations are difficult here. With Kodachrome 200, look for 1/30–1/60 at f/1.4–f/2.8. Slower films

135 Sophomore dinner party
Sometimes, if you carry a camera with a flashgun, you find yourself appointed 'official' photographer, and people will 'mug it' for you to give you some excellent shots (*SRA: Nikon FM: Tamron SP 35–80mm f/2.8: Vivitar 285 on bracket: Kodachrome 64*)

136 Poetry Circle Party
I am on the far right in this picture; I followed my own advice, and took a camera that anyone could use. I cannot even remember what it was, but I do remember the party

can be used, but you will lose too much shadow detail. Any lenses in the classical reportage trilogy – 35mm, 50mm and 90mm – will be fine, and there is a place for ultrawides (20/21mm and 24mm).

Street vendors and markets: the main problem here is extreme contrast. Most vendors use bare, bright lights which will burn out hopelessly if they are in shot. Close to the lamp, which is where most people will be, you can use 1/30 at f/2 or so, even with ISO 64 film. Tungsten-balance film is generally preferable; Kodak's ISO 160 material is probably a good balance of grain and speed, and allows slightly greater depth of field.

Window shopping: this one is really difficult, because you have to choose between detail in the windows, and detail in the windows, and detail in the street (including the shoppers). You also need shutter speeds of at least 1/30 second and preferably 1/60, in order to avoid subject movement. Very fast films are not only useful for freezing movement: their inherently low contrast also helps to overcome the problems of balancing detail. Nothing slower than ISO 200 should normally be used, and ISO 1600 is not out of the way. With the faster films, you may find yourself using surprisingly short exposures, even as little as 1/125 at f/4. You will also need to bracket a stop either way of the indicated exposure, though through-lens meters work fine.

13
PORTRAITS

Available-light portraits are often the most intimate portraits we ever have. I can think of my grandmother, knitting; of Annette, reading a book; of my wife, in the bath; of friends at the bar of the old Arts Centre in Bristol, before it went all trendy and became the Watershed; and even of total strangers in venues as disparate as the Great Western Beer Festival and the Arnolfini Gallery.

Most available-light portraits are candid, and if you don't use

137 Headmaster/Bartender
In order to support Bristol Arts Centre, this worthy gentleman (who was the headmaster of a school by day) used to work for one evening a week behind the bar at the Arts Centre, for nothing. Cath Milne took this picture with a Nikon F, a 58mm f/1.4 lens, and Ilford HP5 rated at EI 650 – about 1/60 wide open (*Cath Milne*)

138 Annette
This is one of my oldest available-light portraits, taken in the late 1960s. It was probably shot with my first decent camera, a Pentax SV with a 50mm f/1.8 lens, on 3M ISO 50 stock which I processed myself. Portraits of old friends often look contrived; this one is dated, but very warm and affectionate (*RWH*)

139 Trudie
Another oldie, from the 1970s. This was shot with the Pentax again, using FP4 film rated at ISO 200 and the 50mm f/1.8 lens (*RWH*)

140 Arnolfini bar
The bar of the Arnolfini Gallery in Bristol is a happy hunting ground for the photographer; this magnificently casual young gentleman was ordering a drink when I took this picture (*RWH: Nikon F: 58/1.4: HP5*)

flash, many people will never even believe that the picture will 'come out', as they always put it. This is definitely a quiet, gentle, friends-and-family oriented activity which can result in some of the most memorable snapshots you ever take.

SUBJECTS

There are really three kinds of portraits that you can shoot by available light. One is candid pictures of friends; one is more formally posed pictures of friends; and one is pictures of strangers, which is effectively reportage and more appropriately belongs in the next chapter.

You do not necessarily have to shoot at home: often, pubs and bars are just as intimate. There are however three words of warning if you choose the latter course. Look after your camera, so that it doesn't get stolen; watch out for pugnacious drunks; and watch out for excessively friendly drunks, too, who can be almost as much of an embarrassment. I have never had any problems with either of the first two, but I have frequently encountered the third. You simply cannot make them shut up until you have taken their picture and promised to send it to them, and sometimes you cannot get rid of them even then.

When it comes to formally posed pictures of friends, you normally have to arrange the people to suit the light – which is perilously close to arranging the light to suit the people, and really takes things out of the realm of 'available' light. Devotees of portraiture are referred to my *Advanced Portrait Photography*,

162

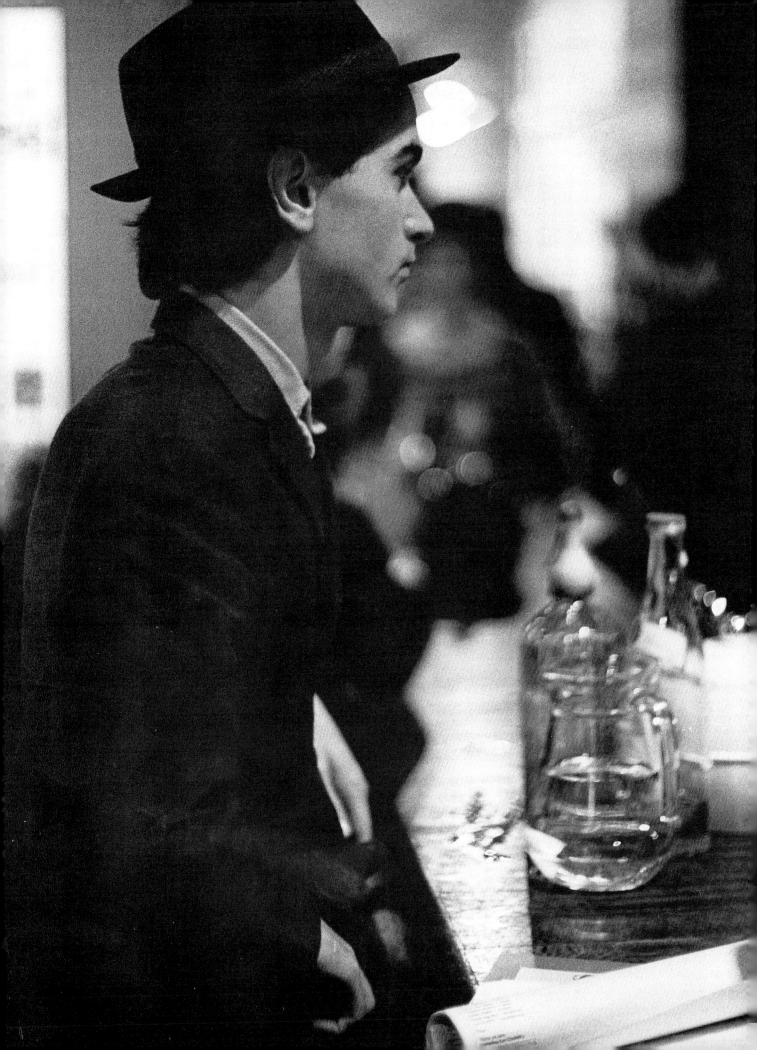

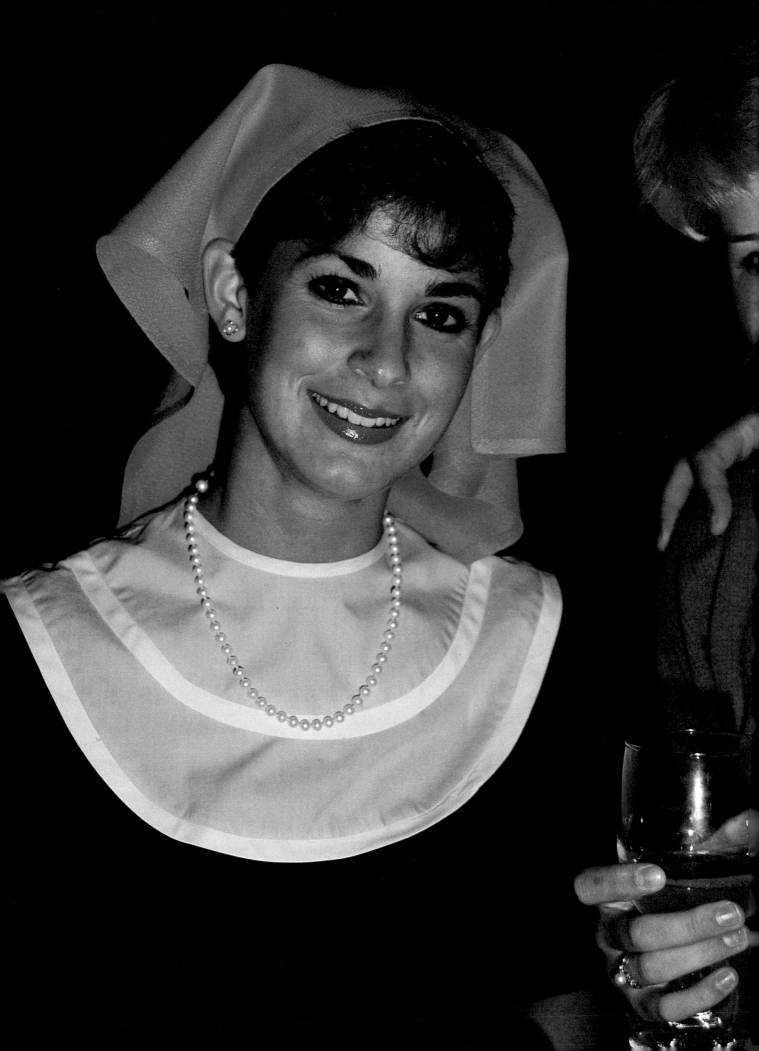

published by Blandford Press in 1987 and distributed in the United States by Sterling Publishing.

EQUIPMENT

This really is one area in which you can use a plain, vanilla-flavour ordinary camera with a standard (50mm) lens; anything wider tends to give unpleasantly steep perspective, while anything longer is rarely convenient. Auto-exposure will be fine, too, especially if you use reasonably fast film and an f/2 or faster lens wide open. For years, I used only one lens for available-light portraits: the only fast one I had, which meant the standard lens on whatever camera I owned at the time. I particularly liked the very slightly longer-than-average lenses, especially the 58mm f/1.4 Nikkor, because they gave very pleasing perspective renditions.

After the standard lens, something like an 85mm f/2 is useful for 'large head' shots, but it is by no means essential. You may be able to find one of the cheap f/2 Russian lenses which were made in Pentax thread (and which can therefore be adapted to a number of other cameras) as well as in Leica and Kiev/Contax fitting. They are not all that brilliant at full aperture, and it is advisable to underexpose by half a stop (and to use a deep lenshood) to keep the contrast adequate, but they are surprisingly good portrait lenses and they can often be picked up for no more than the price of two or three rolls of process-paid Kodachrome.

The longest lenses I have ever found suitable for any kind of portraiture were the 105mm f/2.5 Nikkor which I briefly owned,

141, 142 Girl with guitar
Notice the difference that it makes to have the two subjects looking towards one another, instead of towards the photographer; it unifies the picture much more effectively. Also, if you are faced with depth-of-field problems, do what Steve has done here; focus on the better-lit subject, which the eye will inevitably perceive as a primary subject (*SRA: Voigtländer Bessamatic: 36–82mm Zoomar f/2.8: Tri-X*)

143 'Nun'
The 'nun's coif' in this picture is actually a dinner napkin; if you were making a Cibacrome, it would be easy to 'dodge down' the figure on the right, or even to crop her out completely (*SRA: Nikon FRM: Tamron SP 35–80mm f/2.8: Vivitar 285 on bracket: Kodachrome 64*)

144 Ngakpa
A *Ngakpa* is a sorcerer or (literally) 'spell-adept', a powerful practitioner of Tibetan Tantric Yoga. I photographed him with my Hasselblad and standard 80mm lens, holding the camera in my lap to steady it (*RWH: ER: 1/30 @ f/2.8*)

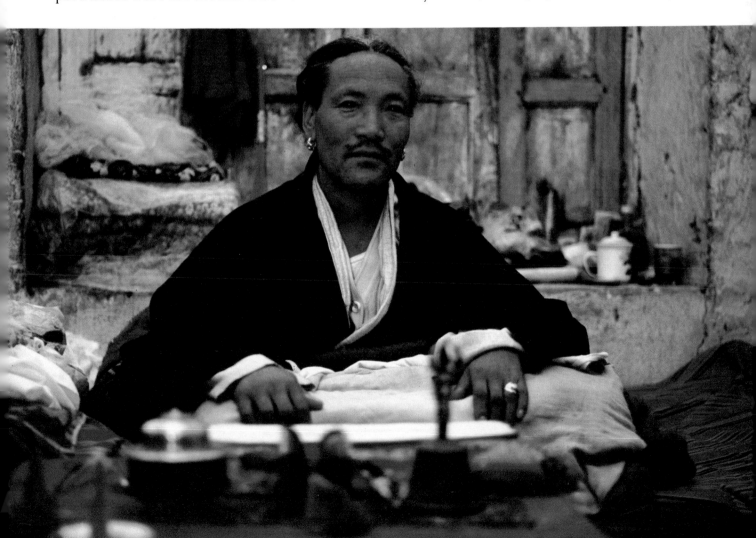

145 Joe Lawson, Magician
The slight loss of sharpness in the fans of cards echoes the way in which a magician deceives us by sleight-of-hand; conjuring relies on a slight failure of vision or attention *(SRA: Nikon FM: 50mm f/1.8 Nikkor: Kodak T-Max ISO 100: 1/60 at f/2)*

and the 135mm f/2 Soligor. In fact, the Soligor was so good for this sort of thing that I half regret getting rid of it; it was very soft, it is true, but that has never worried me much in portraits.

For street portraits, I cheerfully use the 35mm f/1.4 or (occasionally) the Nikkor 50mm f/1.2 that my wife couldn't bring herself to give up when we unloaded most of the Nikon lenses and switched to Leicas as our main system. As for the camera, the main thing is to accustom your friends and relatives to seeing you carrying it all the time. This is the secret of successful available-light candid portraits, getting people used to the camera. Once, I even shot pictures of a group of college friends (one now a respected professional man in his small-town community) cheerfully smoking dope. Perhaps it is as well that I lost the negatives!

A tripod is rarely necessary: most available-light portraits are quiet, spur-of-the-moment things and getting out the tripod can destroy precisely the atmosphere you are trying to capture. If you are sitting still, you may find (like me) that you can generally rely on a safe 1/15 second without camera shake, or you can always rest the camera on something. I have even taken hand-held shots, unsupported, at one full second. Sometimes they are shaky, but they are always fun.

FILM

Again speaking from experience, you can get away with ridiculously slow films: I used to shoot 3M's ASA 50 material in my Leica with the f/3.5 lens, though I did have to resort to 1/4 and 1/2 second exposures sometimes. For most purposes in black-and-white, ISO 400 is plenty fast enough; in colour, rating ISO 1000 colour-print film at ISO 500 (or ISO 250 with an 80A filter) gives you a large margin for accidental underexposure. Out of doors, you normally need more speed; HP5 rated at EI 650, XP-1, or even the new super-speed transparency films rated at EI 1600. As described in the next chapter, though, you can often get away with something slower.

EXPOSURE

As already described on page 152 average room-lighting at night will allow you to expose most negative films (colour or monochrome) of ISO 250 and above at about 1/30 second at f/2, though you may notice some loss of shadow detail with the slower films. You don't even need to use a meter, though if you have a through-lens meter in the camera you would be foolish not to use it, and of course if you are shooting colour transparencies you cannot afford to be so cavalier. You will also need to worry about filtration, using a strong-blue filter with daylight-type film and a weak-blue filter even with tungsten film. Tungsten film is balanced for 3200° or 3400°K, and domestic lamps typically run around 2700°K.

If you don't have a built-in meter, fussing with an external meter is much more disruptive than simply bracketing. Even so, nine times out of ten, your subject will forget about it all in a few minutes, even if they noticed the first exposure. In public places, exposures rarely fall below 1/30 at f/1.4, and they can go as high as 1/60 at f/2.8 or more, again with ISO 400 film.

14
PHOTOJOURNALISM AND SPECIAL EVENTS

Photojournalism is perhaps the most glamorous aspect of photography today. The photojournalist, with his battle-scarred Leicas and Nikons, is one of the most familiar images of photographers in the media. What is more, the techniques of photojournalism are probably the most useful that the average photographer can learn – not least because many of them are not what are normally called 'photographic'.

These techniques can be applied to an enormous range of picture-taking situations, whether you are shooting for publication, planning a slide show, or even making up a few pages of the family album. Teachers who want to use photographs in their work will find them useful, too. This is also an appropriate place to talk about the special techniques involved in shooting fireworks. This is why this chapter, the last in the book, is considerably longer than the other six 'subject' chapters.

To be sure, there are particular combinations of equipment, materials and techniques which are associated with photojournalism, and we shall come to those later; but for now, it is worth

146 H.H. Dalai Lama
His Holiness the Dalai Lama is the spiritual and temporal leader of Tibet; he lives in exile in Dharamsala in northern India. This was taken during a religious ceremony; the image behind him, which might have been of solid gold in Tibet, is gilded clay (*RWH: Nikon F: 135/2 Soligor: Kodachrome: 1/125 wide open*)

147 Ama-La
Ama-la lives in *real* poverty: the walls of her house are papered with magazine pages as insulation against the cruel Himalayan winter, and she shares a single water stand-pipe with six or eight other families. She is one of the 100,000 or more Tibetans who have risked death to escape from the Chinese who occupied Tibet in 1950 (*RWH: Leica M: 35/1.4: Kodachrome*)

148, 149 Basketball

In newspaper reporting, the most important thing is simply to get an image; artistry comes second. Often, flash is the only reliable way to get a picture, though the extent to which it is intrusive will depend partly on background, and partly on luck. For my taste, the tell-tale shadow in one of these is not a problem, while on the other it is (*SRA*)

looking at the *other* skills which a photojournalist must cultivate. These skills are as relevant to the amateur taking his daughter to Disneyland for the first time as they are to the seasoned photojournalist covering a war.

It is also worth distinguishing between single-shot reportage and photojournalism. The former uses many of the same techniques as photojournalism, but it is less demanding and often less technically skilled – although, of course, the great reportage photographers can stand comparison with any photojournalist. This is covered at greater length in 'The Final Image', below.

PLANNING AND ORGANISATION

First, you need to do your research. In other words, you need to have a good idea of what you are going to photograph. Not just the subject, but also the terrain, the weather, the architecture, the culture and everything else you can learn about your subject. Remember, for example, that many religious festivals are based on a lunar or modified lunar calendar: when this year is Ramadan, or the Festival of Tabernacles, or the Tibetan New Year? Somewhere, the information you need is available: there is nothing in the world so remote nowadays that it has not been touched upon in print, both in the written word and in pictures.

This immediately raises another question. If everything has been done, why do it again? The answer is that you need an 'angle'. If it is your daughter in Disneyland, then the 'angle' is obviously purely personal. In *Hidden Tibet* (see panel), the 'angle' was to present a well-rounded view of Tibetan culture from a

150 Fire Engine and Firefighers
You can mix 'found' reportage and 'posed' reportage sometimes. This picture was made after Steve had completed the series of 'found' shots down (in part) in Plates 31 and 68. At a real fire, the crew might not be so amenable, but at many other events you can shoot a picture like this which can be used either as an opener or as a closing picture. (SRA: Nikon F3: Tamron SP 35–80mm f/2.8: Ektachrome 400: no exposure details)

Tibetan viewpoint, instead of the usual choice between Chinese propaganda on the one hand, and tedious devotional writing or neo-hippie 'wow-man' stuff on the other. Your 'angle' may present new information, or it may present old information in a new and more attractive way, but either way, you want to keep people interested.

HIDDEN TIBET

Many photojournalists tend to specialise. Tim Page, for example, made his name in Vietnam; to this day, he still seems to be more at home in Asia than elsewhere, and he has returned to Vietnam a number of times. *All* photojournalists agree that they do their best work in places they know, and are interested in. Obviously, the more you visit a place, the more you can get 'under its skin': this is as true of Vietnam or Dharamsala as it is of Brighton or Disneyland.

Several examples in this chapter are taken from my experiences when working on *Hidden Tibet*, a book about the continuity of Tibetan culture both in its native land and in exile. If you want to see how I practise what I preach, *Hidden Tibet* was published by Element Books in 1988.

If you possibly can, you should reconnoitre the area first. For subjects which involve long-distance travel, this may not be feasible, but if for local events it is often very easy. For example, a church which will be crowded for a special festival may well be empty a day or two before. Choose the best possible locations for shooting, making whatever allowance you can for other people, for decorations, and possibly for TV or film crews if the event is an important one. You do not even need to carry your camera: I use detachable viewfinders to check angles, a 21mm and a 35–200mm 'zoom' finder.

Next, find out whether you can shoot from the location or locations you have chosen. This may involve getting permission from the appropriate authorities, or it may simply involve arriving early: many firework displays, for example, operate on a 'first come, first served' basis. If there is more than one location that you fancy, consider the likelihood of your being able to get from one place to another, and of your places being 'stolen' while you are in transit. If none of your first-choice locations is available, have a list of second- and third-choice options, at least in your mind. While you are at it, scout out refreshments and toilets if it is going to be a long event.

If permission is required, get it in writing. Often, there are special passes issued by the organiser of the event: these are vastly more useful, in most cases, than any sort of generalised 'press pass', including an NUJ (National Union of Journalists) ticket. You may also want to check with the police, *after* getting accreditation from the organisers: sometimes, they issue their own passes too.

Next, check (or plan) the timetable. For public events, this will normally be published in the local newspapers; for a visit to Disneyland, you will know when it is likely to get dark, and you

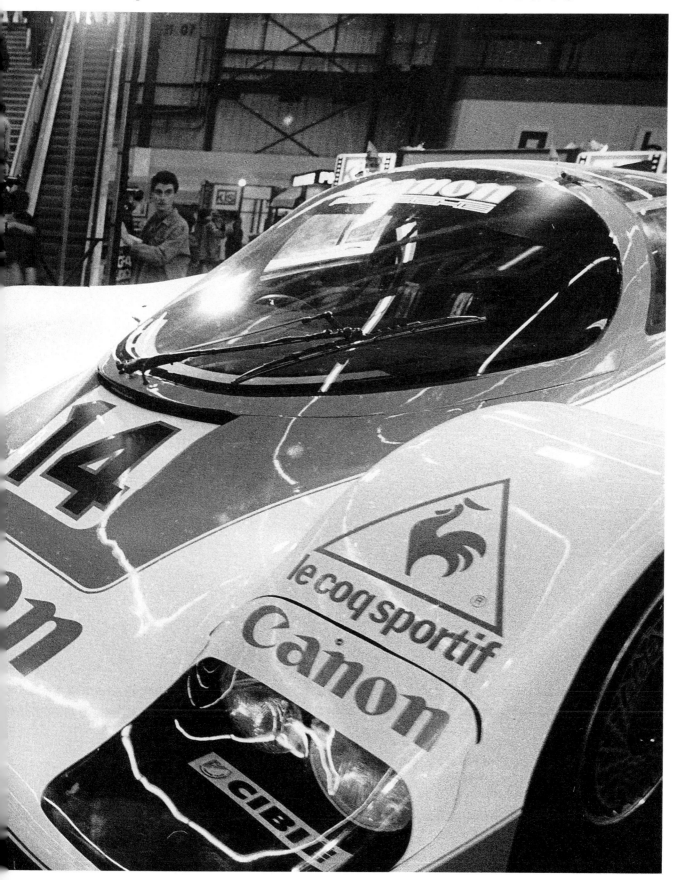

151 Paris Photo-Expo
For hard reportage or newspaper photography, you may need to concentrate on personalities or (at a photo show like this one) the new products. For soft reportage or a picture essay, you may however get a more effective picture if you concentrate on the 'feel' of the place (*RWH: Leica M: specially adapted 21mm f/4.5 Zeiss Biogon: HP5*)

152, 153, 154 Le Mans
Panning and deliberate blur seemed to me to capture the spirit of the greatest sports-car race in the world, the 24 Heures du Mans. The most recognisable shot is plate 152; plate 153 is still more impressionistic, and plate 154 is effectively meaningless except as a part of this set (*RWH and FES: Nikon F: 50/1.2: about 1/2 to 1/15 sec @ f/1.2*)

can plan your twilight shots appropriately.

When planning how to get there, allow for crowds and traffic control; if you can, leave your car well away from the epicentre of the attraction, and walk in. Newspapers often use motorcycle couriers, and sometimes they even use motorcycles as 'taxis'.

SHOT LISTS

Part of the process of planning is to draw up several generations of 'shot lists', or lists of pictures you want to take. The first tentative shot list can be made as soon as you have the idea for the shoot. The second-generation shot list will evolve as you are doing your research, and the third will come out of your reconnaissance.

When you start shooting, you may well find that you cannot get some of the shots on your list, while opportunities for other pictures which you had not even considered will present themselves. This is fine, but the advantage of the shot list is that it gives your picture-story a structure. Just as a conventional journalist uses words to tell a story, a photojournalist uses pictures. You will need a beginning, a middle and an end, and it is useful if you can begin with a 'hook' which catches your reader as a fisherman catches a fish. This can be an image which is particularly stunning visually, or one with high shock or curiosity value, or whatever.

THE FINAL IMAGE

Photojournalists who are shooting for reproduction usually take great care with colour matching, using colour-matching 'marque'

lenses and staying with the same 'family' of films as described under the 'FILM' heading below. They will shoot a mixture of horizontal (landscape) and vertical (portrait) formats, unless they have been specifically briefed by the editor to concentrate on one format or the other. One of the great photojournalists was questioned about his habit of taking meticulous light-readings under fire; his reply was something to the effect of, 'Well, there is not much point in coming all this way and risking getting killed just to take badly exposed pictures, is there?'

If you are shooting for a slide show, you should pay the same attention to exposure and colour matching, and you should make a conscious effort to shoot all your pictures in the horizontal (landscape) format: swapping between horizontal and vertical pictures is very distracting.

If you are shooting for the family album, consider the impact of different sizes of pictures: even if the majority of pictures are conventional enprints, you can add greatly to the overall effect if you have the best pictures enlarged.

If you are shooting 'propaganda', whether for an exhibition or for publication, you should pay exactly the same attention to quality as if you were shooting for a major picture magazine. Remember, though, that black-and-white stands a better chance of being reproduced: this is important whether you are trying to get your favourite politician elected, or promote awareness of the plight of refugees.

Finally, if you are shooting for reproduction in a newspaper, there is little point in worrying too much about technical quality. Most newspapers can only 'hold' a very limited tonal range, and if you have ever seen any original black-and-white photographs printed for reproduction in a newspaper you may have been shocked by the soot-and-whitewash contrast and the coarse grain. In colour, things are no better: you might as well use ISO 400 (or faster) film, because the loss in quality will not be apparent in reproduction.

SUBJECTS

For the amateur, there are many reasons for applying the techniques of reportage and photojournalism. There is the desire for a fine photograph – many of Tim Page's pictures sell as works of art, even though they were taken by a photojournalist. There is the possibility of earning money, though the chances of doing so with a 'soft' picture story are vastly higher than the chances of doing so with 'hard' news. There is also the possibility of campaigning for your favourite political party, charity or other cause, as suggested above. Once again, I refer you to another of my books: *Photography for Fun and Profit* (David & Charles, 1988).

When you are shooting, make a determined attempt to mix close-ups, long shots and medium shots. For example, you might decide at a fairground to show a long shot of a shooting gallery; a close-up of someone aiming a gun; and a medium shot of a little girl clutching a big teddy-bear prize.

EQUIPMENT

Almost any equipment will do for photojournalism, though the

further you have to travel (and the more seriously you take the work), the more reliable your cameras need to be: this is one of the reasons why photojournalism is one of the last great bastions of Leica-users. Subject to the reservations made elsewhere in this book about the shortcomings of automatic and in-camera meters, automatic cameras can be fine. Autofocus, though, will almost invariably be too slow for capturing 'the decisive moment'.

You do not necessarily need a wide range of lenses: often, a single 35mm or 50mm lens is all you need, and the classic photojournalist's trilogy of 35mm–50mm–90mm is ideal, though for some applications you may also need ultra-wides and long

155 Motorcyclists
Where there's beer, you will usually find motorcyclists. Despite their appearance, these guys were entirely amiable. Whenever you go somewhere special (this is another beer festival), you can often get good pictures if you concentrate on the other people there (*RWH: Nikon F: 50mm f/1.4: HP5 rated at EI 320*)

181

telephotos. Be cautious of using ultra-wides and extreme tele-photo too much: such pictures make excellent seasoning and visual relief, but an unremitting diet of compressed or stretched perspective (or worse still, a combination of both) can be wearing. For 'one-page stoppers', though, unusual perspectives can be extremely valuable.

In good light, many staff newspaper reporters use zooms for versatility (the lack of definition will not show in reproduction), and in poor light they use the 'glamour bottles' to ensure an image. Freelancers, who do not have an organisation to buy their toys for them, use the fastest lenses they can afford. Photo-journalists generally use fixed focal lengths for optimum image quality, though some may use the very best zooms such as Nikon's famed 80–200.

In either case, the watchwords are usually portability and simplicity. I have done a fair amount of this sort of thing, and my 'field' outfit is normally two bodies and three lenses, though I will have more kit in the hotel safe. Because my wife and I work together, we will normally split our kit as follows:

Me	Frances
M4-P and M2 body	M-2 and M-3 body
21mm f/2.8	35mm f/2
35mm f/1.4	50mm f/2
90mm f/2 or 135mm f/2.8	90mm f/2

I borrow her 90mm if I need it, or if I am working on my own; she borrows my 135mm. She does not much care for the 21mm. We may also have 200mm, 280mm and 400mm lenses available for special applications, but they normally live in the hotel safe or in the (securely locked) boot of the car. The 35mm focal length was the only one we felt we *had* to double up on, because we both use it so much, and if need be we swap to give her the added stop.

Tripods are not normally used except for 'set-piece' work, or where we know we shall be using the 135mm or longer lenses in really poor light. We normally carry the Gitzo with the Kennet head, and the Leitz table-top 'pod with a Cullman head. Metering is by Weston Master and Lunasix, the latter sometimes with the semi-spot attachment.

For firework displays, you are going to be torn between a lens which 'gets it all in', and allows a certain amount of latitude in where the fireworks go off, and a long lens to allow tight framing. With 35mm, I have used everything from 24mm to 200mm for fireworks, and I am beginning to suspect that for most public displays something in the 85mm–135mm range is ideal. For support, use a tripod if possible; failing that, use a braced monopod or a beanbag. Secure the beanbag to your wrist with a long strap or piece of string (a couple of feet, say) to avoid losing it.

182

FILM

With monochrome, the fast films already recommended are fine: HP5 and Tri-X are traditional, and can be rated at whatever turns you on (EI 250–1000), but XP-1 is arguably better. For real speed, go for the new generation of ultra-fast films.

In colour, most photojournalists prefer to go for consistency and a 'family resemblance' through a full set of pictures, though Tim Page's approach has already been mentioned. For this reason, it is a good idea to stick to a single film as far as possible, and it is amazing how far you can go with Kodachrome 64. The problem with Kodachrome, though, is that Kodachrome 200 is the fastest you can get; if you then change to an E-6 film, you change to a different 'family' and the whole colour signature is different. Of course, if you are shooting under constant light conditions where you never have to change film-speeds, this is not a problem, but many photojournalistic assignments involve day, twilight and night shots.

If conditions for the various pictures alter significantly, though, any variations between the colour signatures of different films will be swallowed up by the differences in subject lighting and colour, so this objection may be more theoretical than real. Certainly, I have never had anyone complain when I switched from Kodachrome 64 to Ektachrome 400. Even so, I feel more comfortable staying inside the same 'family'.

If you really need faster film, therefore, you may do well to change to another 'family'; and in this case, Fuji offers an excellent range of visibly related films from ISO 50 to ISO 800–3200, the last being the 'P' or 'push' series. As a rule, it is worth sticking with only two or at most three film speeds, to minimise the number of mental (and physical) adjustments required during the metering process. Agfa also offers ISO 50 to ISO 1000, and some people prefer Agfa's colour balance. If you have not tried Agfa's films since the days of CT-18 and CT-21 (when the process was Agfa-unique instead of E-6), you might be surprised.

In situations where you are likely to be pushed and shoved, you obviously need high shutter speeds, and this makes fast lenses and fast film a virtual necessity. Even so, I would stick with my usual conservatism and use nothing faster than ISO 200 if I could avoid it. If I were really unsure of what was likely to happen, I would probably load three bodies: ISO 64, ISO 200 and Fuji P-film, rated (as the occasion demanded) at anything from EI 800 to EI 3200. Or, of course, you can wait until you get there, and decide what to load then. You will still have to carry three types of film, though, if you want the choice.

For fireworks, ISO 64 is usually plenty, and even for close-ups of people with hand-held fireworks, EI 200 should be adequate.

Whatever film you use, be prepared to use plenty. Reportage photographers, sent to get a single picture, will often use two rolls of film (one in each camera) for 'insurance': if one film is wrecked, there is likely to be an image on the other. In photojournalism, *Time-Life* found that an average expenditure of eight rolls a day was usual.

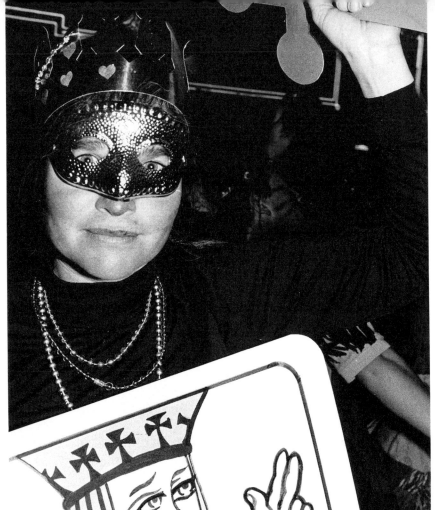

157, 158 Mardi Gras, San Luis Obispo

Steve Alley is less inhibited about using flash than I am, and I have mixed feelings about the results. The results are interesting, sure, but they have a disturbing edge of Diane Arbus-style 'freak shows' to them (*SRA: no technical data recorded*)

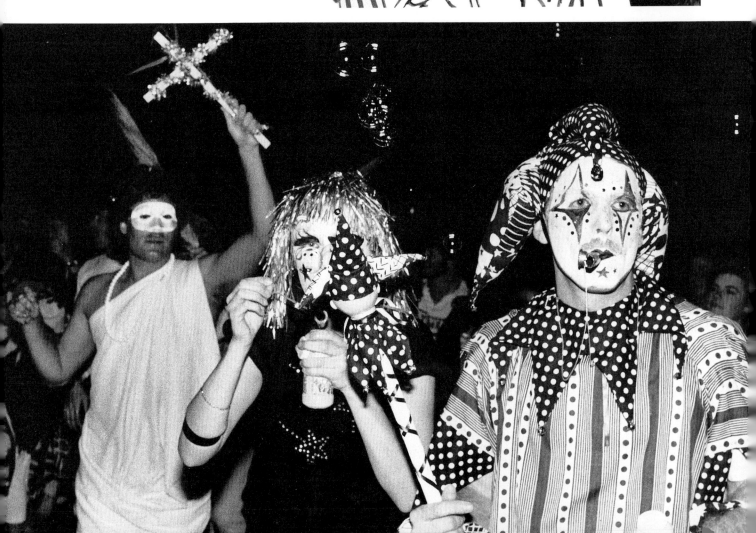

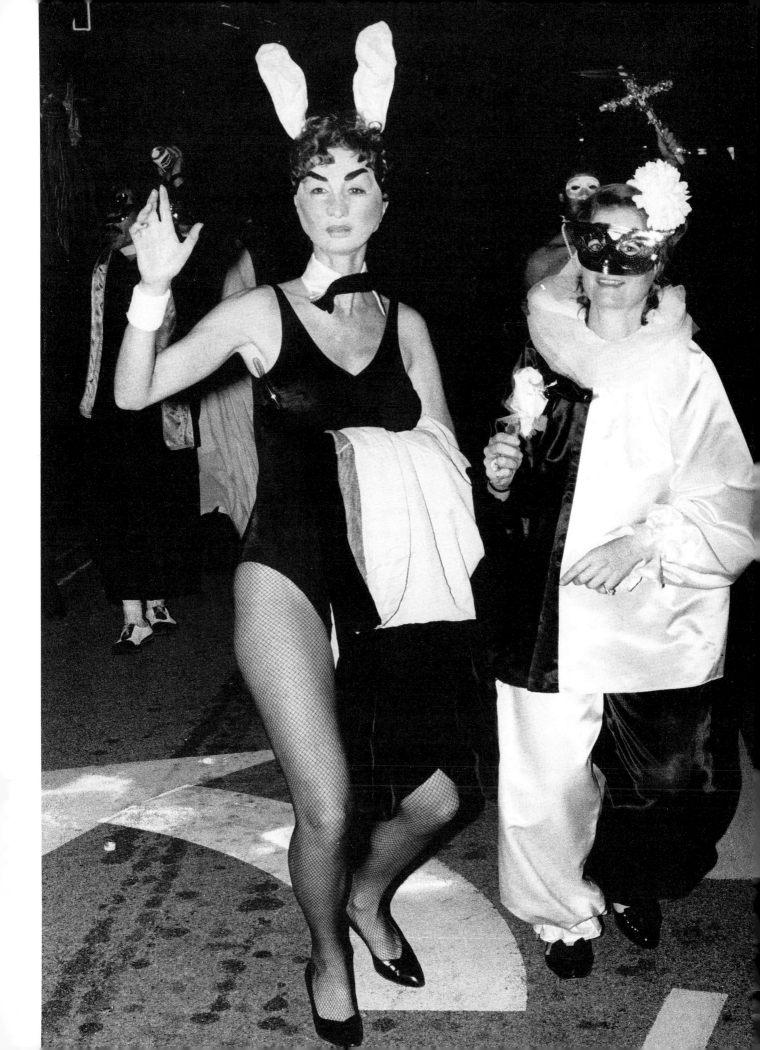

EXPOSURE

Absolutely no general recommendations are possible here; rely on a good meter, of whatever type you like, and experience. Also, bracket furiously.

One special exposure problem worth mentioning, though, is firework displays. Here, you have a wide range of options. Sometimes, you can anticipate an air-burst, and often a set piece will burn for long enough to make a sequence of exposures. Curiously, though, the main thing to guard against is *over-exposure*. All too often, set-pieces in particular will be burned-out on the film; exposures of as little as 1/125 or 1/250 at f/4–f/8 may be appropriate.

For air-bursts, you may do well to stop down to about f/8 or even f/11, and leave the shutter open for anything between five seconds and half a minute; the bursts will register as they occur. If you are worried about over-exposing the foreground, hold a piece of black velvet in front of the lens when there is an obvious lull in launching. Many of the most successful air-burst shots are made this way, with as many as six or even a dozen fireworks recording on a single frame. You will get a certain amount of blur among moving crowds, or you may be able to position yourself in a place where the crowds will not 'read'.

186

POSTSCRIPT

In my previous picture-book for David & Charles (*35mm Panorama*) I wrote a Postscript. In this book, I decided to write another, for much the same reasons.

The most important single thing for any photographer is to have a strong sense of direction. Most of the time, my 'direction' is a short-term affair: a few pictures for this purpose, a shoot for that purpose. Writing a book on a particular aspect of photography is a much longer-term and more intensive matter. For example, I tried more kinds of film for this book than I would normally try in half a decade, and (somewhat to my surprise, for I am nothing if not self-confident) I found that I had a good deal to learn. On the other hand, several prejudices were confirmed: *as a rule*, I still prefer to use the fastest lenses I can afford, and the slowest films I can get away with.

The underlying message, though, is that learning about photography is a tripartite activity. First, and most importantly, you need *hands-on* experience. Go out with your camera, and take pictures – as many pictures as you can stand to take, or at least as many as you can afford. If you are shooting slides, go through them mercilessly when you get them back. Pick out the few that you are really proud of, and put them in a multi-pocket sleeve. Throw out the obvious failures, and leave the rest in the box; you

159 Sunset, Morro Bay, California
Morro Bay is such a photographers' paradise that Steve normally shuns it, though he lives only a few miles away. This shows the virtues of using a tripod, as well as the way in which reflected colours can be even richer and deeper than the sunset itself (*SRA: Nikon FM: Tamron 80–200 f/3.8 zoom: Kodachrome 64: exposure and focal-length setting not recorded*)

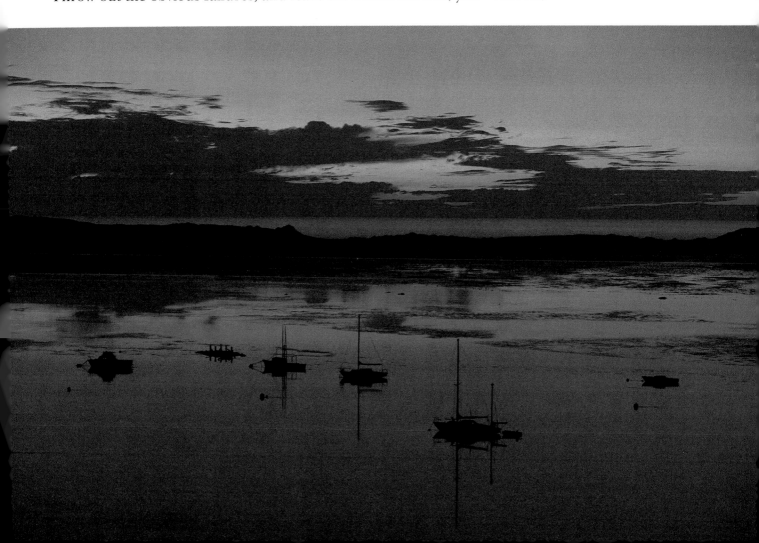

can go through them again, later, to make sure that you have not missed any pearls. If you are shooting monochrome, print the good ones up to at least 8x10in.

The second stage is the books. There is no point in trying to study something until you have tried it: you don't know what the problems are, and you don't even know whether you are interested enough to make serious study worthwhile. If you have problems which you simply cannot resolve on your own, look up the answers. Colour casts, for instance, can be caused by reciprocity failure (page 78); selecting too fast a shutter speed can make a mess of flash synchronisation (page 24). Even if the answers are not in this book, there is a fair bet that they are in some book, somewhere.

The third part of the process is looking at pictures. Not just pictures in books, but pictures in exhibitions; in newspapers and magazines; on posters; even on television and at the movies. We are flooded with pictures, and many of them are pretty unimpressive. Ask yourself *why* they are unimpressive; bear in mind aesthetics as well as technique. Keep scrap-books; haunt the bookstores, especially the second-hand and discount bookstores, for books of *pictures*.

At the end of it all, ask yourself two questions. Who are you trying to please, and are you succeeding? Unless you are a professional, the answer to the first should be 'Myself'; and if the answer to the second is only a qualified 'Yes', you're doing well. Self-satisfaction is not the same as self-confidence, and if you're any good, you'll know that you can always be better.

ACKNOWLEDGEMENTS

As so often, my greatest thanks must go to my wife, Frances E. Schultz. Not only have I used a good number of her pictures; she has also checked the text, kept track of the illustrations, and generally ridden shotgun on me. I could not work without her.

Secondly, I must thank Steve Alley. Steve was only in his early twenties when we worked together on selecting pictures for this book, but he was already a first-class photographer. His work continues to evolve, and I would like to wish him luck, in print.

Arthur Schultz and Cath Milne kindly gave me permission to use their work in this book; they are credited in the captions. David Whyte and Colin Glanfield also supplied one picture, again as credited in the caption.

I must also thank Herb Heyday and Tim Glover of Kodak UK Ltd (aka The Big Yellow Jelly) for useful information and leads on ideas; Canon in New York for information on (and pictures of) ultra-fast lenses; Nikon UK, for the same; the Asahi Optical Company, manufacturers of the Pentax range, for the same; Colin Glanfield, for advice unstintingly given; and all the people who have wittingly or unwittingly been my subjects for low-light photography over the past two decades and more.

Finally, a note on captions. All photographs are credited with the photographer's name, and to save space, I am RWH, Frances is FES, and Steve Alley is SRA. Again for economy, Kodachrome 64 is always abbreviated to KR. Cameras, lenses and exposure details are from memory, because I don't know any professionals who keep exposure records for this kind of photography. Where it is given, information is probably 80–90 per cent accurate. This is better than many photography books, where it is often a figment of the editor's imagination.

INDEX